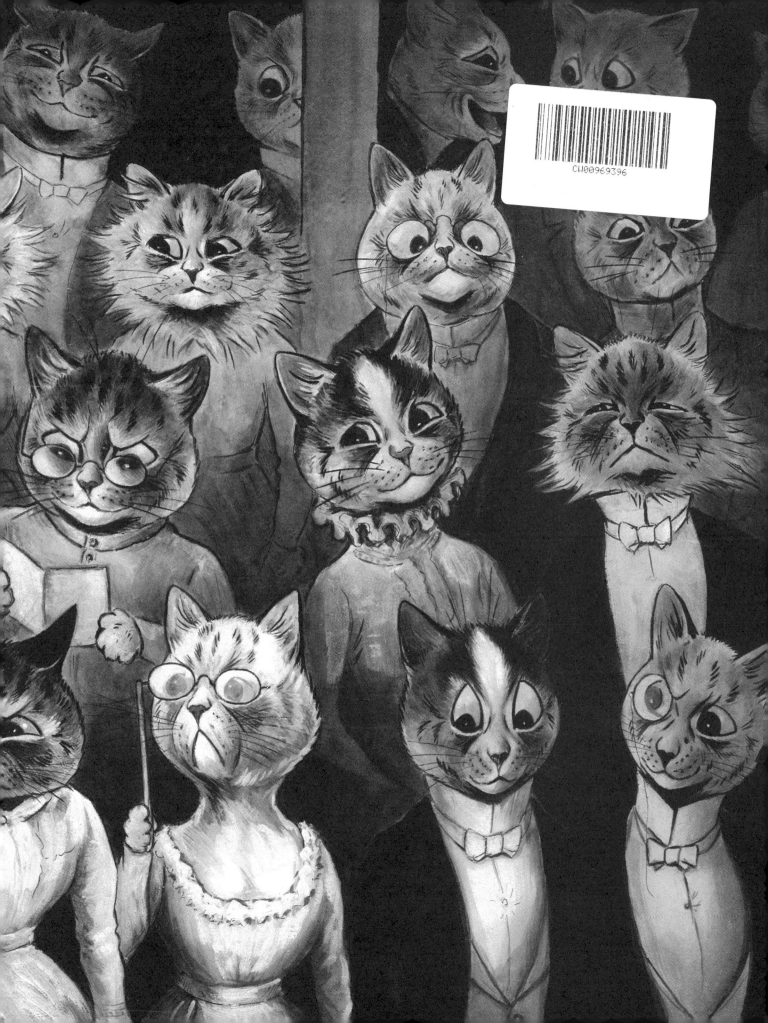

CW00969396

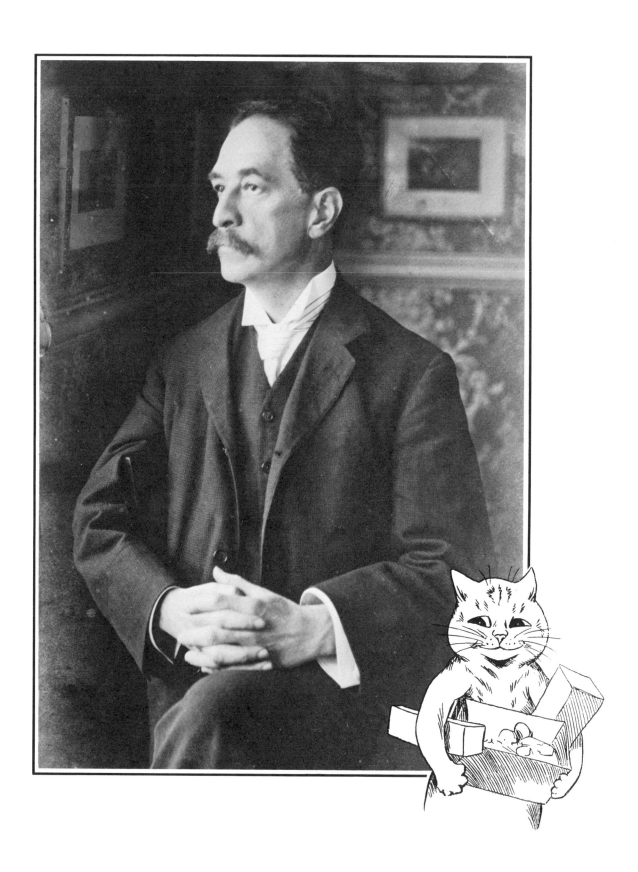

Louis Wain

The Man who drew Cats

RODNEY DALE

CHRIS BEETLES LIMITED

To Judith,
without whose continuing support
it would have been impossible
to write anything

This edition published 2000
by Chris Beetles Ltd
8 & 10 Ryder Street, St James's,
London SW1Y 6QB
020 7839 7551
gallery@chrisbeetles.com

1991 edition published by
Michael o'Mara Books Ltd
in association with Chris Beetles Ltd

Text copyright © 1968, 1991 by Rodney Dale

All rights reserved. No part of this publication may be reproduced, stored in a retrieval system
or transmitted, in any form or by any means, without the prior permission in writing of the
publisher, nor be otherwise circulated in any form of binding or cover other than that in which
it is published and without a similar condition including this condition being imposed on the
subsequent purchaser.

A CIP catalogue record for this book is available from
the British Library

ISBN 1 85479 098 6 (Hardback)
ISBN 1 871136 68 7 (Softback)

Typeset by Florencetype Ltd, Stoodleigh, Devon
Colour separation by Fotographics Ltd, Hong Kong
Printed and bound in Singapore by Toppan Printing Company

CONTENTS

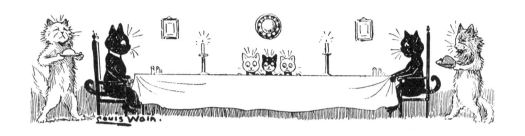

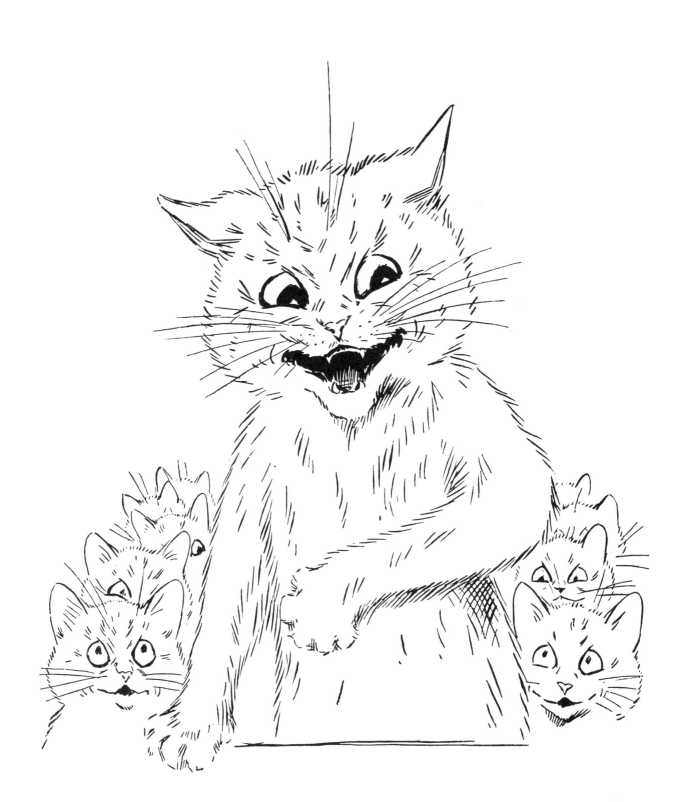

Introduction

'As a man who gave simple pleasure to thousands, Mr Wain deserves to be remembered'

The Times, 25 September 1939

LOUIS WAIN was a man who drew cats.

He was born in 1860 and started to draw cats in his early twenties. By the turn of the century, his was a household name, for he had created the Louis Wain Cat, a special type of mischievous feline which found universal acclaim. But he was obsessed with drawing cats, and when the demand for them eventually diminished, he was not able to come to terms with the situation. He had heavy family commitments, but no one would buy his work – his only means of making a living. His mind failed and he was admitted in poverty to a mental hospital. After a time, he was 'discovered' there, and a number of influential people set up a fund to enable him to spend the rest of his days in comfort. He died in 1939.

I acquired my first Louis Wain picture, almost by accident, in 1966, and was able to find out that much about the artist with little difficulty. But it was not enough: there were too many questions unanswered; too much an aura of mystery.

I started my research, but it took an extraordinarily long time to dawn on me that a biography of Louis Wain had yet to be written, by which time I was becoming equipped to tackle the task myself. It has burnt many gallons of midnight oil. It has brought me into touch (as Louis Wain would have said) with many interesting people, interesting places, and interesting peripheral snippets of information, some of which have found their way into the text.

Thus I began my introduction to the first biography of Louis Wain, which was published in 1968. At that time, comparatively few people had heard of him, though there were still many living who had known him and his work.

My biography was a year or two early, but at least it helped to spark a latent interest in the subject. Three years later Brian Reade, then Deputy Keeper of Prints and Drawings at the Victoria and Albert Museum, sought my help in arranging a Louis Wain exhibition which ran over Christmas 1972, and which turned out to be the largest of his works ever held.

By that time, my book had been remaindered, but requests for copies started to roll in steadily, and have been doing so ever since. Louis Wain's name is now firmly established, his works command sums which have increased many hundredfold, and – perhaps the ultimate accolade – forgers (admittedly third rate) have entered the arena.

I am therefore glad to be able to introduce a new edition of the biography at long last. The text of the first 18 chapters differs little from the original; I have reviewed my source material and am confident that everything that should be in the text has been covered. It is worth adding that, as far as I can see, little which has been written about Louis Wain since 1968 fails to draw on my original work.

The main modifications are to be found in chapters 19 and 20, which I have recast extensively. The original material was provided by the late Dr David Davies, then a consultant at Maudsley Hospital and for some 20 years a Trustee of the Guttmann–Maclay Collection. There has been much discussion of art, mental illness and Louis Wain since Dr Davies made his contribution, and I would now like to shoulder complete responsibility for what appears in the last two chapters.

I have discussed Louis Wain on several occasions with Patricia Allderidge, Archivist and Curator of the Art and History Collections at the Bethlem Royal Hospital wherein the Guttmann–Maclay Collection now resides. Though I do not hold her responsible for the views I express, I believe that she finds much to agree with, and hope that she will soon write the Louis Wain monograph she is so well placed to produce.

Others deserve special thanks. Sidney Denham, whose article in the *Guardian* [102] travelled around in my briefcase for six years, to emerge when I bought my first Louis Wain drawing in 1966, was particularly encouraging. Confident that I was writing the book on Louis Wain which he himself had been planning for many years, he generously gave me all his material, and I was saddened to learn that he died shortly before my book was finished.

Collingwood Ingram and his wife kindly entertained me, and I was privileged to tour his 'garden of memories' at Benenden, and hear his reminiscences of Louis Wain.

William Kimber and Oliver Colman had the faith in me and my subject to publish the original book, and I am ever grateful to them for establishing me as a serious writer.

This edition is supported by Chris Beetles, in whose Ryder Street Galleries I have spent many happy hours, and whose Louis Wain collections give my text the colourful embellishment for which it has always yearned. I am exceedingly grateful to Chris, and to Julia Cornelissen in his office who has co-ordinated the many tasks needed to produce the work. I am grateful to Michael O'Mara Books for the handsome production and particularly Alison Bell who has been as good an editor as anyone could wish for.

The list of books is the work of Ellery Yale Wood, and I thank her for undertaking the painstaking task of tracking down such a comprehensive bibliography.

Finally, I must thank Gina Keene who has retyped the whole of the text and, coming to it with a fresh eye, has made many useful suggestions.

Rodney Dale
Haddenham, Cambridgeshire
January 1991

1

Childhood

JOHN WAIN, of Leek in Staffordshire, was a silk manufacturer. In 1825, his wife bore him a son, William Matthew, who, after a good education, started to make his way in his father's business. In his twenties, however, William was attracted to Roman Catholicism, and eventually became a member of the Roman Catholic Church. His father was very angry, and in order to 'bring his son to his senses' threatened to disinherit him. But, adamant as his father, William turned his back on his family, the family business, and his native Leek, and made his way to London.

He took lodgings, and found employment in the only trade about which he knew anything – textiles. He became a traveller for a firm of wholesale drapers, gradually built up his round in the City, and became a well-known and respected figure in the trade. His father lived neither to forgive his son nor to see that he had made good, though in later years the rift was healed and the members of the family came to be on speaking terms again.

Living in the City, William Wain worshipped regularly at Spanish Place Chapel. With his interest in and knowledge of textiles, it was natural that he should become acquainted with an attractive young girl whom he met there, Julie Felicie Boiteux, whose hobby was designing and executing pieces of embroidery for the Church.

Julie lived in Blandford Street – a stone's throw from the chapel – with her parents, Louis Antoine Marie and Josephine Caroline Marie Boiteux. In spite of their French names, Louis and Josephine were an English couple. Louis' father who, it was said, had been smuggled out of France to England during the commune disguised as a woman, became a naturalised Englishman. Josephine had been orphaned at an early age, and had been brought up in a convent.

Louis Boiteux was an artist, and welcomed William Wain into the family circle as a cultured young man whose company he found most agreeable, and towards whose inevitable betrothal to his daughter he felt most enthusiastic. The marriage was solemnised at Spanish Place Chapel on Saturday 29 October 1859. William gave up his rooms in Hatton Garden, and the couple went to live at St John Street, Clerkenwell.

On Sunday 5 August the following year, Julie bore her first child. He was named Louis after his maternal grandfather, and William after his father. He never made any use of the name William and for the rest of his life was known simply as Louis Wain.

The Wains continued to produce children at regular intervals: Caroline in 1862, Josephine in 1864, a stillborn boy in 1866, Claire in 1868, and Felicie and Marie in 1871. They moved house quite often, but always stayed in the Clerkenwell/Marylebone area of London.

Louis was what was termed a 'sickly child'. He had a hare lip, and in his twentieth year he grew the moustache which he kept for the rest of his life; because of this it was hardly noticeable. He later wrote that the doctor gave his parents strict orders that he was not to be sent to school or,

indeed, taught at all until he was 10. Why, we are not told. By his own account, his childhood was terrifying in the extreme for he suffered to an extraordinary extent from recurring dreams. He later wrote:

'I seemed to live hundreds of years, and to see thousands of mental pictures of extraordinary complexity. . . . But above all, I was haunted; in the streets, at home, by day and night, by a vast globe, which seemed to have endless surface, and I seemed to see myself climbing over and over it, until, from sheer fright I came to myself, and the vision went. To get some small idea of this, take a big ball and try to look all round it with one eye, placing the ball, according to its size, an inch, more or less, away from the eye. These visions were sometimes pleasant, and I remember myself, too, as being quite a little old man, very sharp and capable of reasoning out things in a very concise way: in fact, I seemed to have an acute mathematical faculty, which in later years I have striven almost in vain to resuscitate with any success.

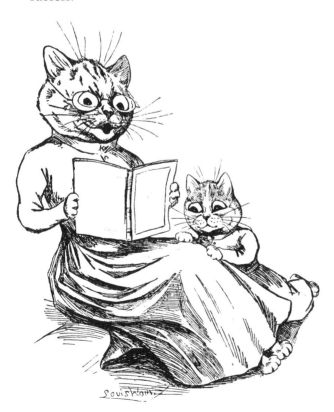

'At the age of six I dragged my little sister through a wilderness of streets to find "the sea full of big ships", the vision of which is still with me. Quite modern babes, we were found and restored to our home. At the age of nine the little old man gave out, for I am told that at that age I was down with scarlet fever. The illness seemed to have burned up all that was bad in my constitution, for I grew strong and very pugnacious, and difficult to control.' [23]

Although it is tempting to correlate this description of his visions with Louis Wain's later illness, it is probably little more than an account of unusually vivid dreams of the sort which often recur in conjunction with the onset of each illness in the gamut of childhood ailments.

As it seems the doctor predicted, Louis Wain was sent to school after his recovery from scarlet fever, at the age of 10. He first attended the Orchard Street Foundation School in Well Street, south Hackney, under the headmastership of William Pratt. By the time he was 12, he had 'fought some heavy fights' for his age, and his nose had been 'flattened to his face'.

Whenever possible, he escaped from the confines of London to the country. 'There', he wrote, 'a natural propensity for climbing trees, particularly firs, had delights and dangers of its own, which was fruitful to many permanent scars; and snake-hunting expeditions, too, with sometimes a litter of lusty porkers to help uproot the frightened reptiles and a thousand-and-one interesting harum-scarum excursions, in which I gathered together a hundredweight of insects, bird skins, twisted wood, stones, nests, etc, and a menagerie of live things in the various vases, boxes and drawers all over the house. These were generally found out, by-the-by, and, I suspect, sold by the landlady's husband, more particularly the trout and roach which mysteriously disappeared from the house waterbutt, in which I also kept a whole colony of water beetles, newts etc.'

Louis Wain was not an easily-controlled student, as he himself well realised. In term time, he found it difficult to enjoy the efforts of his private tutors or of his school. He spent much time at the

old Polytechnic Institution lectures – in those days it was a place of scientific entertainment – and worried himself into fevers over perpetual motion and flying machines. He claimed that he had had the assistance of a working clockmaker to help him with his schemes for 'simplifying mechanical contrivances', but there is unfortunately no record of what these schemes were. He spent day after day roaming round the museums and the docks where, 'by the aid of sundry sixpences', he was never tired of going over ships, and listening to interminable sailors' yarns. He journeyed down to Woolwich Arsenal, with a permit to see the machinery in motion and the turning of the big guns and in 'every conceivable way took an interest in practical matters'.

But when it came to sitting down with his books, it was a different story. He told himself that he could always keep a reference library to find out what was known, but that 'they' could not teach the unknown; thus did he justify to himself his perpetually playing truant. After a spell of this roaming around, he began to suffer from his

childhood dreams again but was saved, oddly enough, by his books.

There appeared just at this time (about 1874) some simple stories of American Indian backwood life, which he read avidly and, clearing his mind of his mechanical contrivances, he became 'a child again, roaming the parks, trying to follow tracks over the grass, just as the Indians did, noting the effects of wind and weather upon the trees and grass, the effect of dew, and a whole bookful of useful nature study'.

A serious effort on the part of his father to make him consider the question of a career brought Louis Wain 'in contact with a master mind of wonderful simplicity and gentleness, a man who would teach with a laugh and make his will felt by taking you into his confidence and practically saying: "I know this or that; I should like you to know it. Now come, see whether I cannot teach you to know it too".' All he had to teach, Louis Wain learned; in fact, he was able to catch up with, and absorb, much of what he had missed. But, as so often happens, such circum-

stances were too good to last. The 'master mind' left, an 'ordinary' master took his place, and school had no further attractions for Louis Wain.

He returned to his London rambles, searching for factories, and there watching the intricacies of the many and various industrial processes which were carried on in the metropolis. Meanwhile, his schoolmaster was writing long letters to his father upon the duties of parents to their children which, fortunately for Louis Wain, were never read beyond the first page. If his father had gone carefully through these letters, he would have

found 'embedded' in each of them the complaint that Louis had been absent from school for months on end.

In addition to his study of mechanics and nature, Louis now became interested in politics. The streets of London in those days were overrun with 'political stump orators of a rather scandalous type' and his feelings were swayed sometimes to pity, sometimes to supreme resentment, when he felt that there was some injustice. He wanted to know something more about the real state of

things than they would rant about, and consequently started to read the newspapers avidly, entering into the spirit of Parliamentary debates as though his very existence depended upon it. Whatever Louis Wain learned about politics, the effect of this concentrated study was to put the *raison d'être* of schooling into perspective, and he soon became a more tractable student.

He was now (1876) attending St Joseph's Academy, Kennington, a school run by the Christian Brothers of the de la Salle Order. Even had Louis Wain's father made sure that his son attended school, I do not think that Louis would have been much better off. It is clear that he was a decidedly strange lad, and his schoolfellows were not particularly kind or sympathetic towards him. When he had received individual attention from the 'master mind' he had responded accordingly. Otherwise, he led a rather unhappy existence, believing that he was teaching himself 'the unknown', but in fact merely whiling away the time. However, if he did not become a mechanical engineer as a result of his playing truant, his feeling that his 'boyish fancy' did much to shape his future artistic life was probably correct. He believed that roaming around taught him to use his powers of observation, and to concentrate his mind on the details of nature which he would otherwise never have noticed.

Louis Wain ascribed quite a lot to his boyish fancy. He wrote: 'As a boy, my fancy trembled in the balance between music, painting, authorship and chemistry. I might in one sense say that I have had an art training, for I never contemplated being anything but an artist in one form or another.' [18]

If it was his interest in politics which attracted him to school again, it was a new interest – music – which kept him there. For the first time, he chose a career. 'Contact with musical people determined me to devote my future career to music, and easy going masters carried me through a lot of work; and my circumstances allowed me scope to compose a great deal, including an opera made up entirely of choruses, quartettes and duets.' In this sentence, we have an insight into the sort of

world in which Louis Wain felt himself to live. At this time, it is a musical world, peopled with encouraging musical people, in which Wain is 'riding along on the crest of a wave', finishing with the supreme achievement of writing an entire opera. This opera continued to crop up throughout his life, and was mentioned in the press from time to time as another example of his versatility. It may have existed, but whether it had any merit is doubtful. In 1902, for instance, it was reported that 'Mr Wain's love of art finds expression in music as well as by his pencil, and at the Botanic Cat Show he spoke of much time taken up with supervising the production of his opera by the Carl Rosa'. On another occasion he had submitted the opera to Henry Wood (Louis Wain was a great admirer of Henry Wood), to see if he could arrange for it to be performed. Unfortunately, there is no trace whatever of any of Wain's musical compositions, let alone the opera.

It is not altogether certain, whatever he claimed afterwards, that Louis Wain really did intend to become a musician. He himself always claimed that he started on a career as a violinist. His sister Claire said so years later. There seems to be little evidence that he trained as a violinist any more than as a chemist or physical scientist.

According to his own account, he continued to study music but 'could not resist, however, the element of change, and, finding an outlet in drawing (which, besides, brought in some money), I took the advice of many friends, who told me that an artist's career was so much easier than a musician's; and more particularly I found that, however hard I worked in art, I seemed to have the energy to keep to my music, and the many interests – chemistry, medicine, and the study of the physical sciences – which I touched upon spasmodically, without destroying my art instincts. To me it was not a school of drudgery, but a real love for natural knowledge, gained rather through intuition and insight than drilled in, to be forgotten afterwards.' [23]

For two years, Wain studied both music and art, before finally giving up the former and devoting his whole energy to the latter. The decision may well have been further forced by his father's illness. William Wain suffered from cirrhosis of the liver, and had been forced to give up work. Cirrhosis of the liver is often attributed by the layman to alcoholism. William Wain, however, also suffered from chronic jaundice – quite common at that time – which can equally well cause cirrhosis.

The task of supporting his wife and five daughters now fell upon the shoulders of his son. The family lived as best they could on William's savings, until Louis finished his course at the 'very excellent West London School of Art', and was taken on as an assistant master there.

Shortly after he had started to teach, his father was taken to Guy's Hospital, where he died on Wednesday 27 October 1880. He was buried, the first in the family grave, plot 3654, at St Mary's Roman Catholic Cemetery, Kensal Green.

Louis Wain was not really a successful teacher. He was too shy to make proper contact with the students, who might otherwise have stimulated his artistic development. He felt that in imparting knowledge to others he was not gaining knowledge himself. His position as breadwinner for a large family does not seem to have weighed heavily on him, and it is not unlikely that he would have thrown all his responsibilities aside, though whatever his dreams it was to be some time before he made even the slightest impression on Fleet Street.

Whenever he had a moment, he would complete a sketch for the portfolio which he hoped contained the material to start him on the road to fame. At last, his ambitions became too much for him and he left home. He excused his irresponsibility by blaming it on a vision: 'The fateful day when the real work of life commenced was when I broke away from home ties to force my way in the world. It seemed almost the prompting of a visionary *other* being which dangled an insight into knowledge in the skies far ahead, and said "There is your road, there is your goal; now fight for it."'

'Before leaving home, I had been greatly

attracted to a social groove, when my appearance became irreproachable and costly and my existence was limited to, and bounded by, Mayfair. I had many powerful and intellectual friends, whose interest would have carried me rapidly forward in life, in whatever sphere of work I chose to adapt myself to. I was drawing largely, however, upon my mother's resources to sustain my position, and one of those sudden revulsions of feeling to which I was subject at once destroyed all her hopes and determined me to go out into the world and of my own accord fight my way, disdaining all help. I made my determination to fit in with my twenty-first birthday.' [23]

As in so much of Louis Wain's writing, the meaning of this passage is not clear. I find it difficult to believe in the reality of his Mayfair existence, and the many powerful and intellectual friends. They seem to be the 'artistic people', parallel with the earlier 'musical people', who lived in Louis Wain's world at that time. Apart from that, if the revulsion of feeling was against living off his mother, why were *her* hopes destroyed? As it turned out, however, he was not away for long.

2

Emily

THAT JULY (1881) he visited a number of publishers, and sold enough designs for Christmas cards to enable him to take an unfurnished room and to buy a table and chair. For one night, he tried the experiment of sleeping in his chair over the table but it was so uncomfortable that he went back to the big bedroom at home, which his mother had wisely kept ready for him, returning to work in his lonely, bare room each day. He had to ask his mother for money from time to time, but he gradually worked his way to independence and self-support. By degrees he collected around him 'many hundreds of books, more or less of a scientific nature, and a quantity of artistic properties'.

He was a creature of moods, and his tastes frequently led him into the realms of what he was pleased to call science. He wrote that he never tired of tackling some such problem as this: 'of arriving at such a perfect unity of attraction and repulsion as would bring about the constant automatic free reversing of the poles of a globe, or of two, or of any necessary combined number of globes'. [23] I cannot begin to understand what this means, apart from the fact that it is not in itself the statement of a problem.

In another account of this period of his life, Louis Wain says: 'When I was about twenty, I decided to become an artist in good earnest, and to earn my own living. So I left home. In various names, I drew for minor publications, designed for colour printers and so on.'[18] I was most interested to read this because one thing about

Louis Wain was that he seldom omitted to sign a drawing. It would therefore seem out of character for him to adopt 'various names', especially if he wanted to build up a reputation, and the reason for his doing so is not clear.

I had given up hope of finding any evidence of such work, when I chanced upon *The Children's Tableaux*, a pop-up book published by Ernest Nister. It contains several cats in early Wainian style, with no hint of a signature. Then a lady wrote and reported that her elder sisters had worked at Nister in the 1880s, and had brought home Louis Wain prints for the family to cut out and play with. *The Children's Tableaux* is possibly an example of Louis Wain's early anonymous work.

At last, in the winter of 1881, came the beginnings of success. 'The first drawing I ever had published appeared in the *Illustrated Sporting and Dramatic News* of 10 December 1881,' he wrote. 'It was a picture of Bullfinches on the laurel bushes. It was, through a printer's error, titled "Robins Breakfast", and caused me to be severely chaffed in consequence, and I did some 30 others, large drawings before I could persuade the editor to take another one, but persistency told.'[95] At that time, Wain was still teaching at the West London School of Art, but he gave up that uncongenial position as soon as he had persuaded the editor of the *Illustrated Sporting and Dramatic News* to give him a job.

Now that he felt accepted in his chosen career, the glamour of starving in his room began to

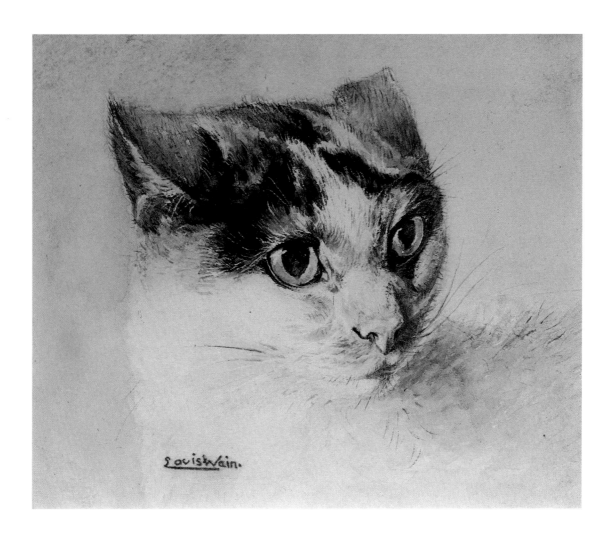

A naturalistic cat study in watercolour, probably done as early as the 1880s.

Above: From an autograph book. Wain loved the effects of red chalk and, despite its technical difficulty, enjoyed working with this medium.

Right: An unusually detailed use of monochrome watercolour for Wain. Note the profuse interior patterns. *Circa* 1910.

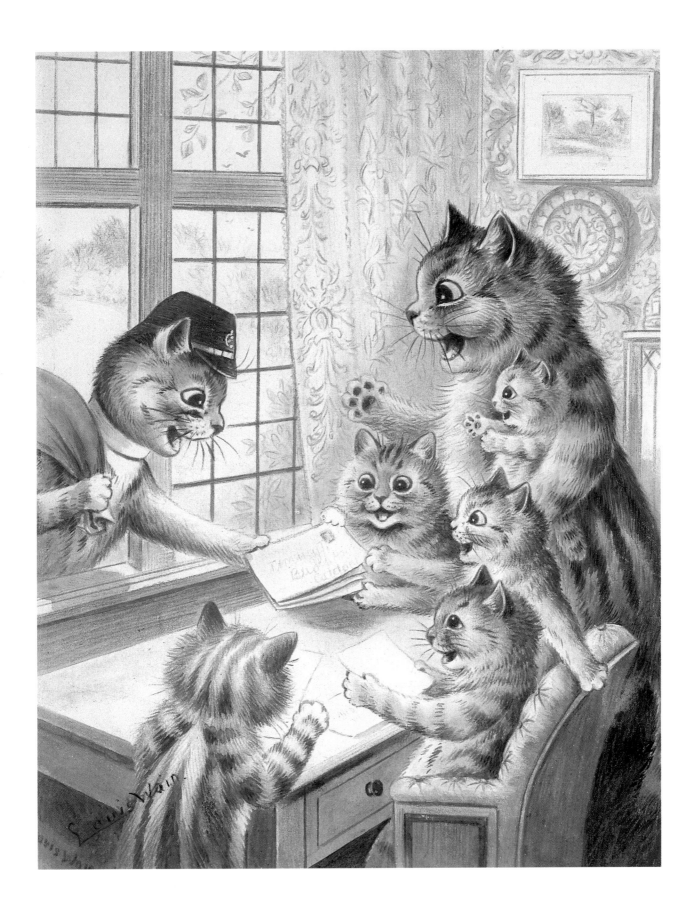

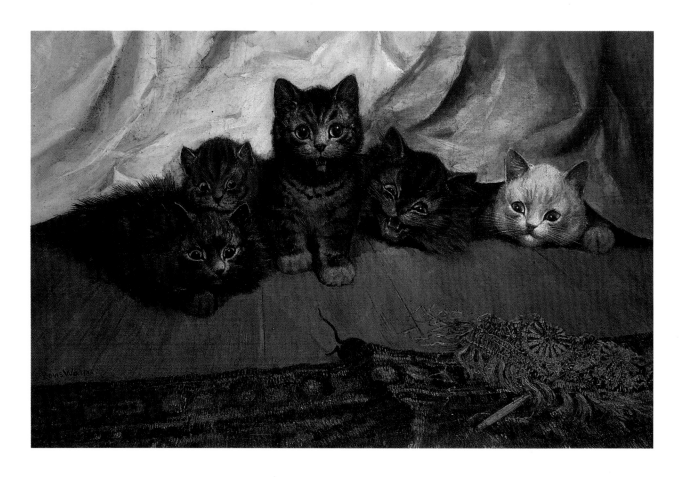

A large oil 16 × 24 inches with the contemporary title 'There she is'.
Painted about 1880, it reflects Wain's admiration for the naturalistic style of
Henrietta Ronner (1821–1909).

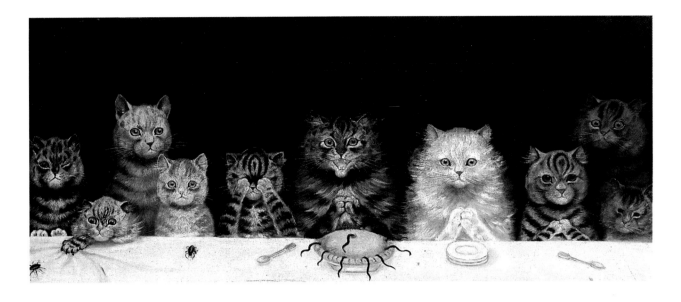

'For what we are about to receive'. This dates from the 1880s; it is one of the most widely reproduced of Wain's works and has hung on many a nursery wall.

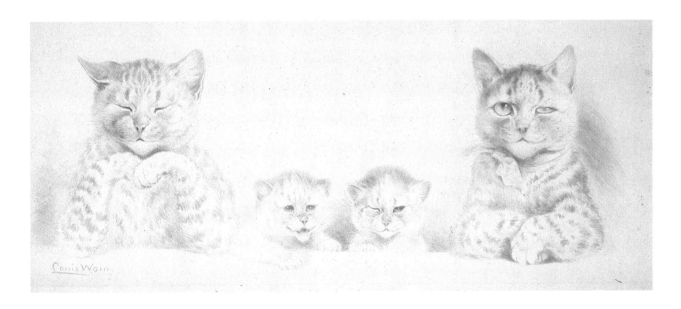

A tabby family done in silverpoint – a difficult medium – showing Wain's remarkable drawing skill in the 1890s.

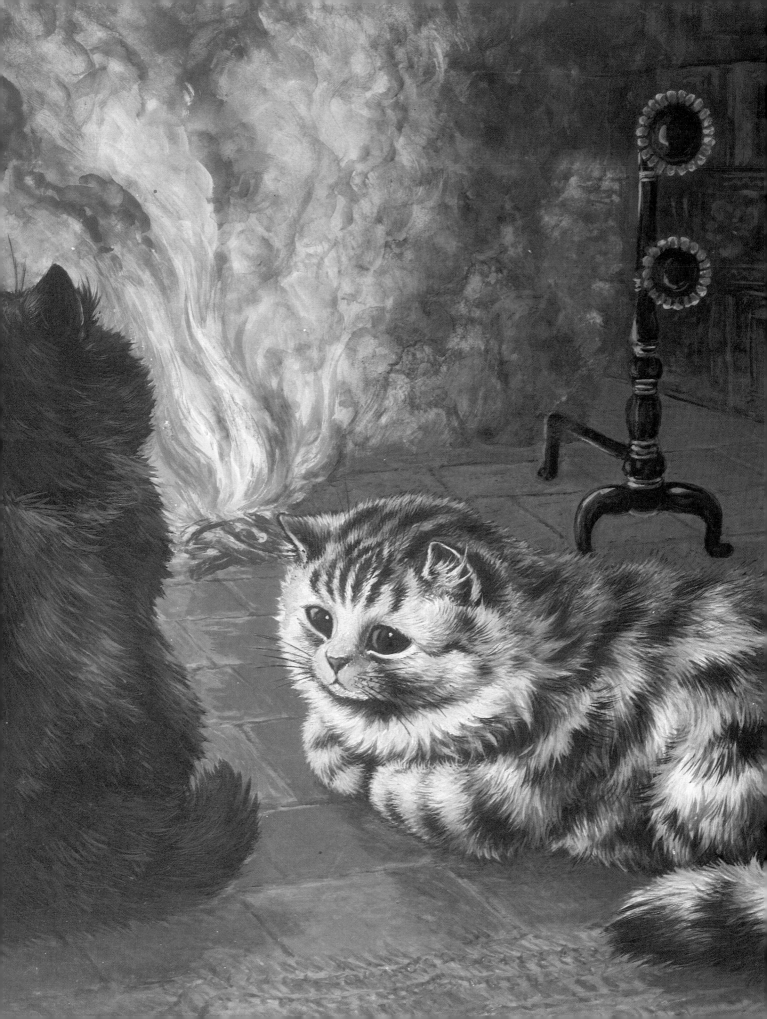

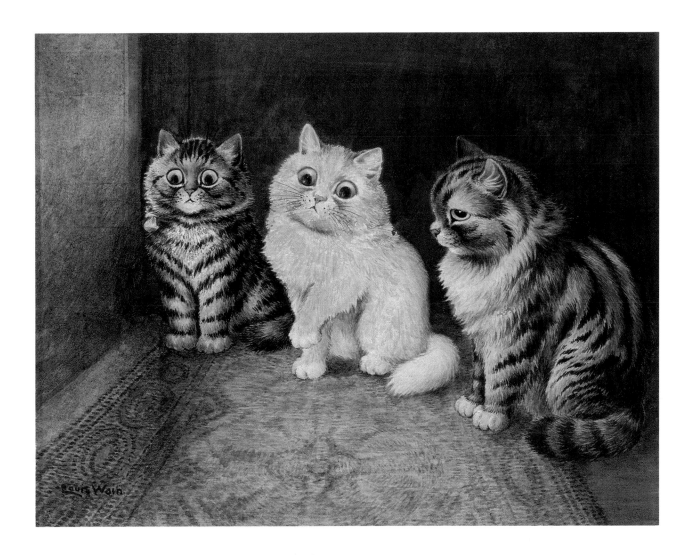

Above: Watercolour and bodycolour drawing from the 1890s, an early appearance of three Wain archetypes.

Left: 'By the Fire' (detail). A bodycolour or gouache drawing from the 1890s (note the Aesthetic Movement firedogs). The postures are natural and well observed but the features show the emergence of the Louis Wain cat.

OVERLEAF:
Cats off to the races from Wain's popular and productive Edwardian period. Note the wealth of incident and character.

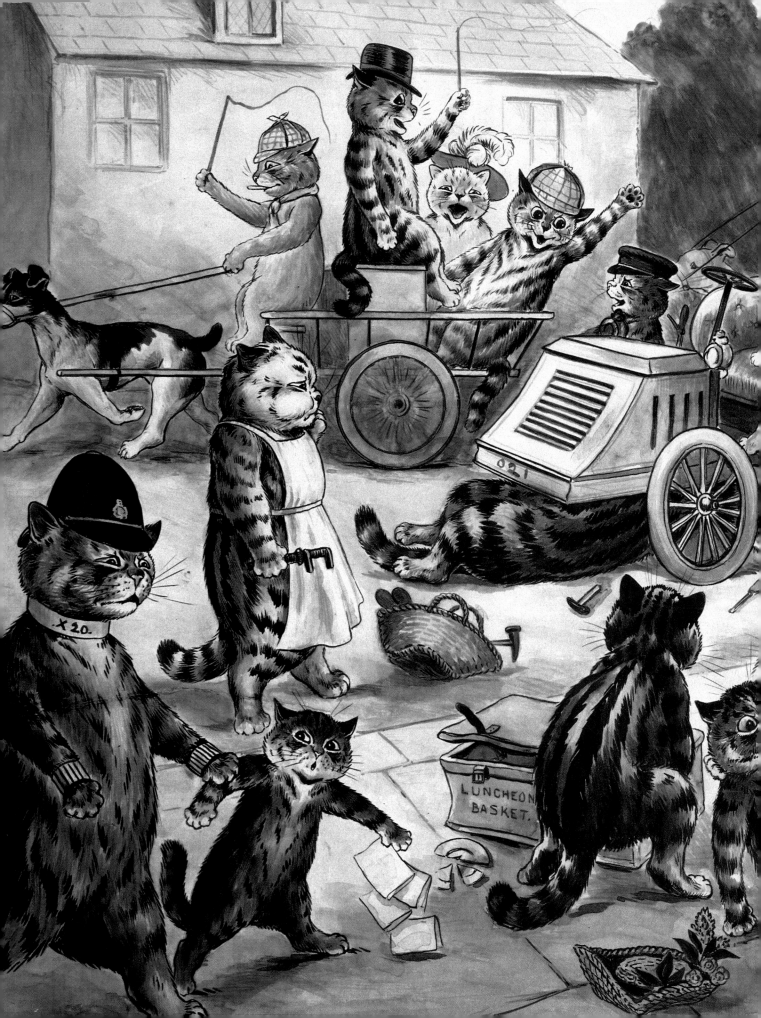

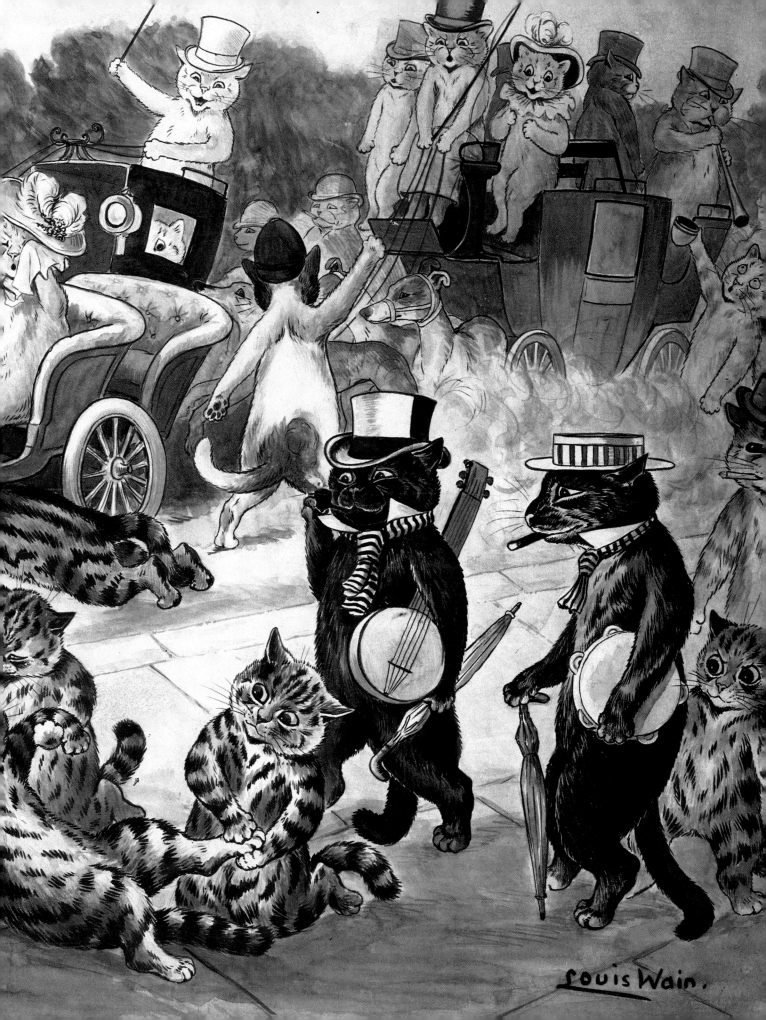
Louis Wain.

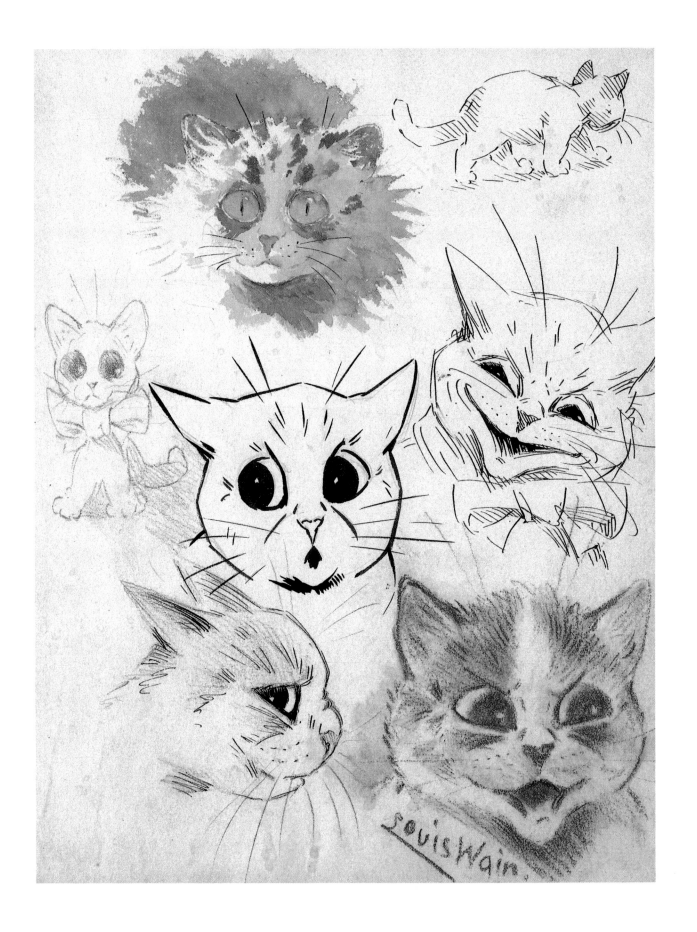

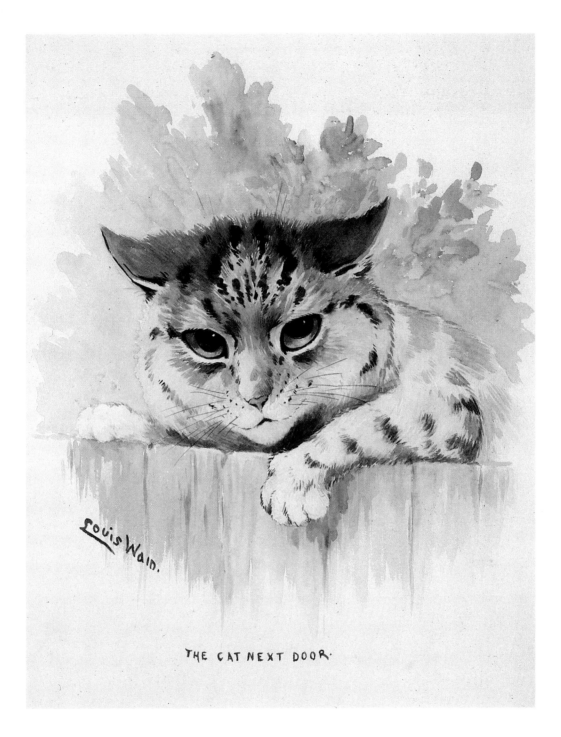

THE CAT NEXT DOOR.

Above: 'The Cat Next Door'. An unusual use of pure watercolour alone.

Left: A collection of typical catty caricatures in different media.

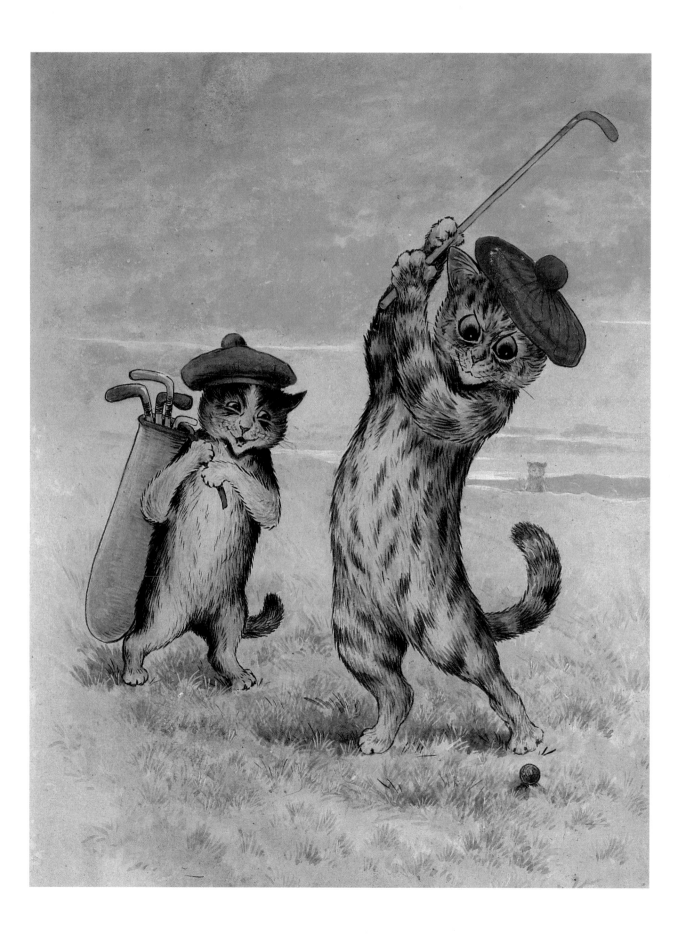

Above: 'What time do you call this?' 'Kiss-Miss time my dear!' Wain's punning
confrontation is typical of the humour of the period – the heyday of the music hall.

Left: 'A Day on the Links'. Watercolour and bodycolour produced about 1910.

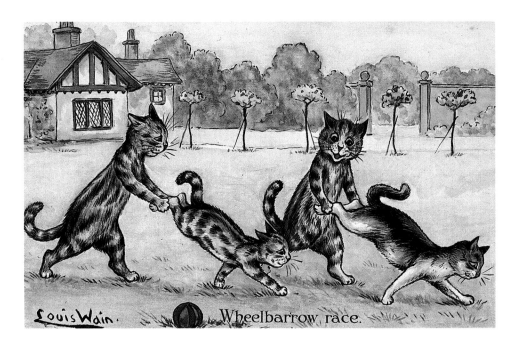

'The Wheelbarrow Race'. Design for a set of postcards based on children's games, published by C.W. Faulkner & Co. Limited in 1904. Note the early appearance of mock Tudor buildings which became a hallmark of his late work.

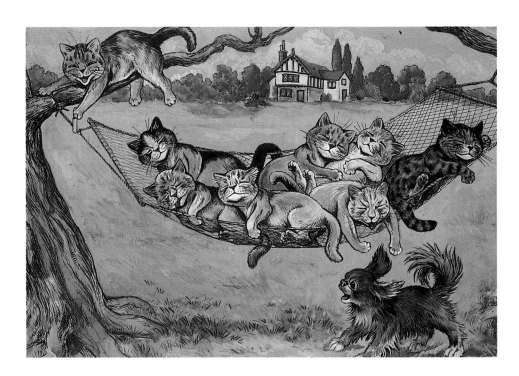

The soon-to-be-disturbed cat nap typifies Wain's recurring theme of cats as mischievous children.

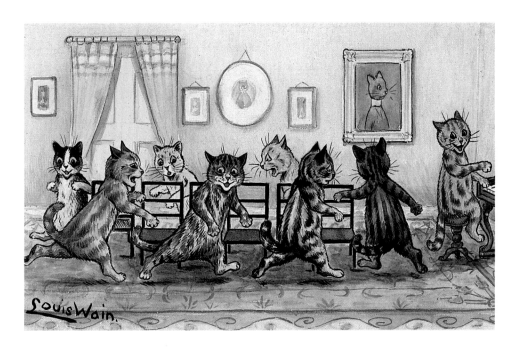

'Musical Chairs' from anther set of postcard designs based on children's games published by Faulkner. *Circa* 1905.

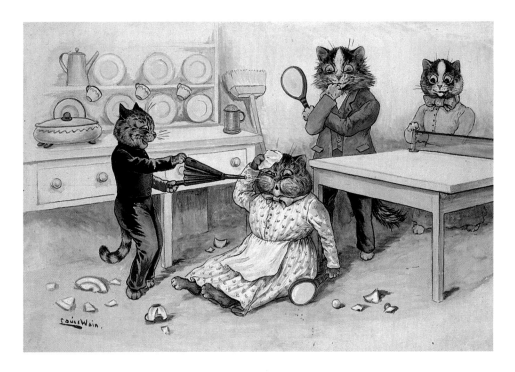

'An Accident with a Ping Pong Ball'. Wain's response to the ping pong craze of 1903.

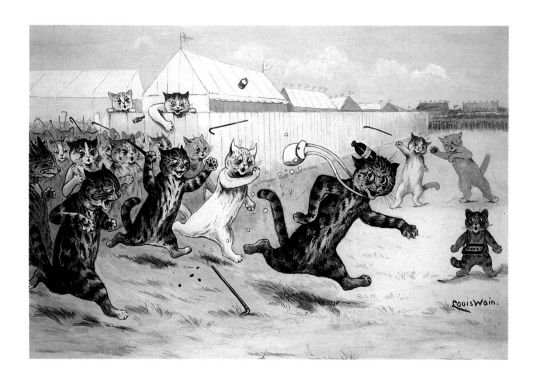

'The Welsher'. Appeared as a postcard in 1904. From a Sporting Series
published by Frederic Hartman.

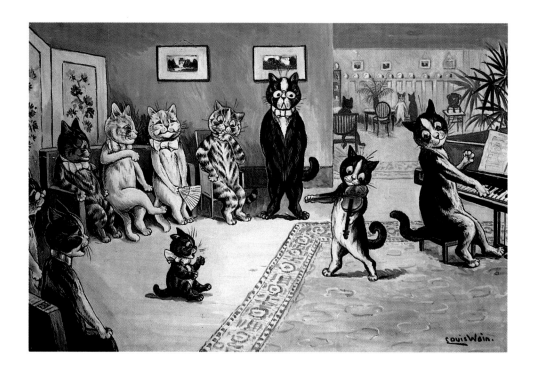

In the typical style of his quality magazine work, this shows a children's recital
with proud parents and perplexed relatives. Nothing changes.

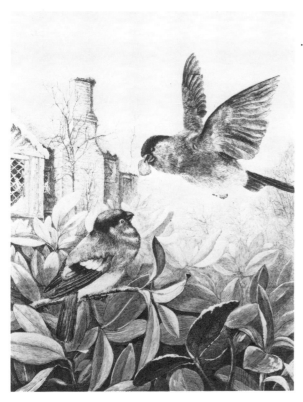

meet again later, who also lived in Hampstead and was as close a friend as Louis Wain ever had.

In the beginning the hopes of the couple were 'as those of children'. They lived within themselves, as it were, their only household companion a 'little shrill piping linnet' which Louis had had for some time. 'Soon, however,' he wrote, 'an addition was made to the household. "Peter", for so he was christened, came to us almost with his first sight of the world; like all kittens, he suffered from an inordinate sense of affection, and so impressed his individuality upon the family mind. Truly, with the linnet, he grew into our lives, and ultimately, when Nature called the little piper's limit, he became the one and only household god.'

But all was not well. Emily Wain was suffering from carcinoma of the breast, though it was then in its early stages. Such a disease is uncommon in a woman of her age, and if she sought advice at all, it may possibly have escaped her doctor's notice. Operative treatment was reasonably well understood in those days, though it was likely

lessen – especially since the arrival in the Wain household of the new governess, Emily Marie Richardson. Emily's father, Thomas Richardson, had been a fruiterer in Shrewsbury, and on his death she had moved to London and found board and employment with the Wains. Louis' youngest sister at this time was only 11 years old. At 23 Louis, although 10 years Emily's junior, worshipped her, and she him. It was a highly unsuitable and upsetting state of affairs. But, like his father before him, Louis preferred to accept estrangement from his own family rather than alter his course. He and Emily left the Wain household and went to live together at 17 Elizabeth Terrace, Hampstead. It was a daring move.

On Wednesday 30 January 1884 they were married at St Mary's Chapel, Holly Place, which stands today in a setting looking very much as it must have done then. Neither the groom nor his bride was accompanied by any family. The witnesses were Matilda Humphreyson and the black-and-white artist Herbert Railton, whom we shall

that the disease would recur. Emily may have waited, as people will, for it to cure itself and found, too late, that it would not. She became confined to the house, then bedridden. Peter was her constant companion.

'With my wife invalided to the house', wrote Louis Wain, Peter 'never suffered through inattention, loneliness or thoughtlessness. His was the genius which gilded many a sorrowful hour, and lightened many a burden. . . . To him properly belongs the foundation of my career, the development of my initial efforts, and the establishing of my work.'

Louis Wain realised that he was not yet in the front rank of press artists, but what he lacked in experience he endeavoured to make up in energy. He had suggested a series of drawings of dog and agricultural shows to the editor of the *Illustrated Sporting and Dramatic News*, thereby letting himself in for some hard work. He would take an early train, generally 5.15, to a country show from 50 to 100 miles out of London, make

his sketches and notes of the show, and return by a six or seven o'clock train. On arriving home, if it was the end of the week, he sat down after a good meal and plodded on throughout the night till six, slept till ten, worked the whole day Sunday and far into the night till he had finished. He then took his drawings in by 10.30 on Monday with his written report of the show.

Sometimes he had four clear days to do the work in, but even then it was a big task, as the drawings were very detailed. However, he felt that the fresh country air gave him the strength to go on and that this tough apprenticeship served him well. He 'got there' in the end.

'The "getting there" came through "Peter"', he wrote. ' I see him now, lying on the sick bed, just as he always was, his paws and body resting on my wife's arm, and I remember well the sigh of relief that came from her as the genial warmth of his body assuaged her pangs and soothed her into peaceful slumber.' This short account is about all that Louis Wain himself ever wrote about his

marriage. It is interesting that he appears to show little feeling for his wife's suffering: the important figure to him is Peter.

By this time, the couple had moved to rooms at 42 Englands Lane, Hampstead. Emily's sister came up from Shrewsbury for a while to help with the nursing, but she and Louis had no particular liking for each other. Peter received a great deal of attention, as he was very comforting to Emily, and Louis started to teach him tricks to amuse her. He spent a great deal of time sketching Peter as well, and filled sketch-book upon sketch-book with portraits of him in every conceivable pose. Emily pressed her husband to offer some of his drawings of Peter to editors, but he did not think that they would be interested – in spite of the fact that there were drawings of Peter hung all over the walls of their flat, which gave rise to delighted approval from their visitors.

Louis Wain's first drawing in his own name for the *Illustrated London News* – 'Odd Fish at the International Fisheries Exhibition' – had been published in 1883 [2]. Sir William Ingram owned both the *Illustrated Sporting and Dramatic News* and the *ILN*. One of the earliest published Louis Wain cat drawings appeared the following year in the *ILN*: 'A New Dog-Fancy: The Basset Hounds' [3], in which there were two cats modelled on Peter, and a third hiding inside a book standing up like a tunnel and appropriately named *Sanctuary*. Another book in the picture is entitled *Tales and Morals* by L. Wain – the signature of the artist disguised. Later in 1884 we find 'Our Cats: A Domestic History' [4], one of the earliest examples of a series of narrative drawings, again starring Peter, this time as Miss Clara's pet who is forgotten when the family goes to the seaside and becomes so out of condition that she is not fit to be sent to the Cat Show at the Crystal Palace, so that the Jones's cat (which has not been so neglected) easily takes all the honours.

Louis Wain continued to report on livestock shows all over the country, and started to execute commissions for animal portraits. His extensive travelling began to earn him a number of friends, a circumstance which was to stand him in good

stead very much later. One such was Gambier Bolton, who wrote:

'We first met at the Ryde, Isle of Wight, Dog Show in 1885 when, as a complete stranger to me, Wain asked to be allowed to sketch one of my prize dogs for a very small fee, telling me what a hard struggle he was passing through in his endeavour to make a living as a canine artist. Watching him as he worked during that day, I realised that he had quite a good general knowledge of dogs, and that his work showed distinct promise; so I gave him an introduction to George R. Krehl of *The Stock Keeper* and heard later that he had been taken on the staff of that journal, and when we next met he told me that between his journalistic and private commissions he was doing quite well.' [55]

It is interesting that although he had spent much time sketching Peter for Emily's amusement, and had already sold some 'catty' pictures, Louis Wain still thought of making his name as a canine artist. It is hard to realise that in those days the cat was far from universally accepted as a pet, though the 'Fancy' was beginning to have its effect. (The first Crystal Palace Cat Show was held in 1871.) Louis Wain wrote in 1909: 'When I first took to drawing and painting [cats] they were treated as despised animals, looked on as vermin by sportsmen. No MP could associate with a cat club for fear of the ridicule of his opponents. The man who would take an interest in the cat movement was looked upon as effeminate.' Perhaps that is why, in the main, he kept his drawings of Peter for the private amusement of his friends.

However, his artistic skill had attracted some attention, and in 1886 he was asked by Macmillan to illustrate a children's book, *Madame Tabby's Establishment*. I once enquired of a certain second-hand bookseller whether he had by chance a copy of *Madame Tabby's Establishment*. He evidently interpreted me incorrectly, for he glanced round furtively, and muttered: 'It's a paperback, isn't it? There should be one in the back room.'

In reality, this book tells the story of a little girl, Diana, who, having found herself accepted in the Cats' Court (her grandmother being the late

owner of the King of the Cats) is sent to Madame Tabby's establishment to learn how to behave like a cat. As a girl's dream, it falls far short of Carroll's *Alice*, and as a manual of feline deportment lacks the observation of Paul Gallico. *Madame Tabby's Establishment* was published in the autumn of 1886 and became quite popular in the Victorian nursery.

Such small successes led Louis Wain to approach Sir William Ingram and ask to be commissioned to produce a humorous cat drawing for one of the Christmas supplements. Sir William was too shrewd a man not to have some idea of Wain's capabilities, and gave him *carte blanche* to produce the drawing. Louis Wain laid out his sketch-books of Peter and set to work.

'A Kittens' Christmas Party' took 11 days to complete and contained over 150 cats. It is a narrative in 11 panels, similar in conception to 'Our Cats: A Domestic History' though far more fanciful. It appeared in the Christmas Number of the *Illustrated London News* [6] and, by all accounts, brought Louis Wain instant fame. He claimed that after its publication he was never in need of work and, though it was some time before he reached the height of his career, he was at least on the road to success. At last he was recognised, and Emily was truly happy, for she had so wanted to see her Louis succeed.

But the couple had little time to share their joy. As her disease worsened, Emily suffered more and more pain, and there was little that Louis could do to alleviate it other than administer a few drops of chloroform from time to time as an anaesthetic. Gradually she became immobile, for the pain and effort of moving were too great. Her breathing became shallower; at last the disease wore her out, and no sooner had she seen Louis started on the road to fame than she died of exhaustion after just three years of marriage, on Sunday 2 January 1887.

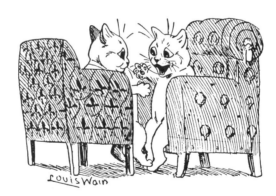

3

Peter

IT IS not, I think, too far-fetched to speculate that Louis Wain's having met Peter changed the course of domestic history. Certainly, the attitude of the general public towards cats, and their feeling (or otherwise) for cats was greatly affected by Louis Wain's work.

Where did Peter come from? In later years Louis' sisters claimed that they had given him to Louis and Emily as a wedding present. This seems unlikely, as relations were exceedingly strained at the time, unless the present was intended as a deliberate slight, in which case the result was more than ironic.

On another occasion, Claire Wain said that the two youngest sisters, Felicie and herself, had given Louis 'a beautiful black and white kitten, which was very frolicsome, as a present on his twentieth birthday, and that from that time he had started drawing cats, sitting on the floor and sketching hour after hour'. [83] This only goes to show how easily one can be wise long after the event. Wherever Peter came from, he was certainly born in 1883, and may therefore have been a belated wedding present. It was in that year that Louis first drew cats, and Emily's illness no doubt contributed to his later concentration on what eventually became an obsession.

Had Peter not found comfort on Emily's sickbed, he would not have made such a ready model for Louis Wain. And had he not received so much attention, he might well have not developed such a personality. Louis wrote:

'My old pet Peter was a black-and-white cat, and, like most of his kind, was one of the most remarkable cats for intelligence I have known. A recital of his accomplishments would, however, have very few believers – a fact I find existing in regard to all really intelligent cats. There are so many cats of an opposite character, and people will rarely take more than a momentary trouble to win the finer nature of an animal into existence. Suffice it to say, that Peter would lie and die, sit up with spectacles on his nose and with a post-card between his paws – a trick I have taught many people's cats to do. He would also mew silent meows when bid, and wait at the door for my home-coming. For a long time, too, it was customary to hear weird footfalls at night outside the bedroom doors, and visitors to the house were a little more superstitious as to their cause than we were ourselves. We set a watch upon the supposed ghost, but sudden opening of the doors discovered only the mystic form of Peter sitting purring on the stairs. He was, however, ultimately caught in the act of lifting the corner of the door-rug and letting it fall back in its place, and he had grown quite expert in his method of raising and dropping it at regular intervals until he heard that his signals had produced the desired effect, and the door was opened to admit him.' [25]

In 1892, Charles Morley, 'a pal of Peter's', wrote *Peter, A Cat o'One Tail*, illustrated by Louis Wain, 'Peter's Proprietor'. Morley was a great friend of Wain's. He had been offered, and refused, the editorship of the *Illustrated London News*, a post which was then accepted by Clement Shorter. Morley, under the astute guidance of Sir

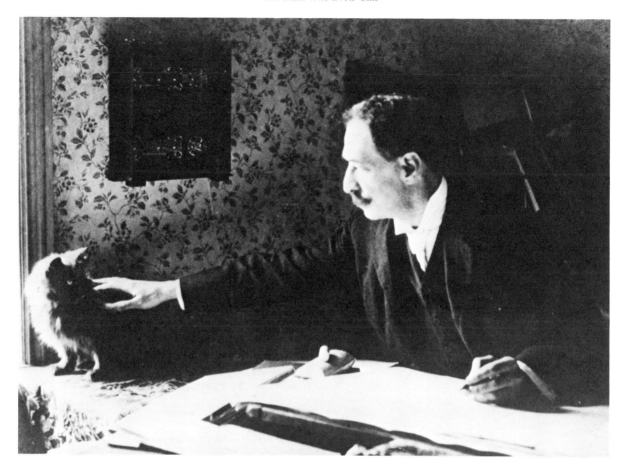

Charles Newnes, was then appointed editor of both the *Sketch* and the *Westminster Gazette*, which Newnes launched simultaneously.

In 1896, one Roy Compton met ' "Peter the Great" or "Good old Peter", as his master affectionately calls him. He is a black and white cat, once distinctly handsome, but the wear and tear of a public life have left their mark. He is of most amiable disposition and undoubted sagacity, and during his thirteen years of life has slowly, but surely, built up a name for the popular artist, who is willing to admit that it was the study of "Peter", and the portrayal of his antics, that first brought him public success and favour. Now the old cat dozes over the fire in peace – his every want attended to, his every wish gratified – a king amongst cats. I wonder as I gaze at him with his eyes half-closed and his two fore-paws extended for warmth through the bars of the fender, if he realises that he has done more good than most human beings who are endowed not only with sense but brains; if in the firelight he sees the faces of many a suffering little child whose hours of pain have been shortened by the recital of his tricks and the pictures of himself arranged in white cravat, dancing at a cats' tea-party, or gaily disporting himself upon a "see-saw". I feel inclined to wake him up and whisper how, one cold winter's night, I met a party of five little children, hatless and bootless, hurrying along from an East-end slum, and encouragingly saying to the youngest, who was crying from cold and hunger, "Come along, we'll get there soon". I followed them some distance down the lighted street, till they paused in front of a barber's shop, and I heard their voices change into a shout of merriment, for in the window was a crumpled Christmas supplement, and Peter, in a frolicsome

22

mood, was represented entertaining at a large cats' tea-party. Hunger, cold and misery were all dispelled. Who would not be a cat of Louis Wain's, capable of creating ten minutes' sunshine in a childish heart?' [19]

This was Peter in old age. In Louis Wain's words, he lived 'to the March of 1898, and died in my hands, a boy kitten again, talking and answering me as of old. It was a few minutes *lived* in the past between us again, with all its memories alive. One would like to think that all living animals have their little bit of *real* happiness in a hereafter before their final effacement, as a reward for the trials and troubles they undergo while subject to the dominion of man. I cannot myself imagine or bring myself to believe that they have souls, which would mean an eternity hereafter, but I should like to hope for a reward for them, especially for my "Peter". It would seem justice that it should be so.' [23]

As a practising Roman Catholic, Wain could not believe that animals had souls. But he had known many animals well, and anyone who has really loved an animal – or a human – will know what comfort is to be derived by believing that the soul of the departed one is 'up there'. Peter especially, who had started him, albeit unwittingly and unknowingly, on his career, and who had meant so much to Emily, had to have his reward.

Louis Wain explained how he reconciled his official and unofficial beliefs in a piece entitled 'Have Animals a Hereafter?' [33] In his opinion,

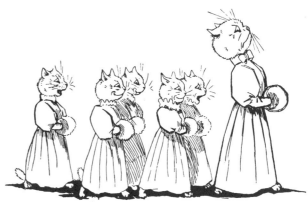

there was no future life for animals, if such a life depended upon their possessing souls. That was in 1905. Some 10 years later, he told a confidant the story of his tragic marriage. He went on to tell of 'the amazing black and white cat' – meaning Peter – which he had owned at the time and explained how it had been possessed with the soul of his late wife.

There were, of course, other cats apart from Peter in Louis Wain's life, but one hears less and less of them individually after the turn of the century, probably because he had so many that he could not possibly work as hard as he did and still have time to make friends with them.

As his reputation grew, more and more people thought of him as an ever-open door for receiving stray cats and unwanted kittens. As one observer put it, he had 'so many cats that their kittens left the house and took up residence in the

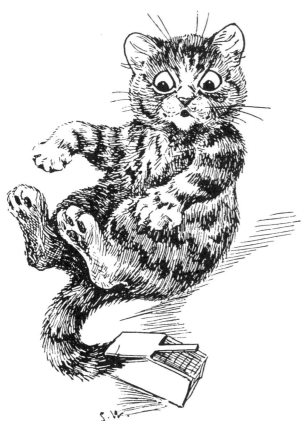

garden, becoming quite wild and snarling and spitting at visitors who walked up the path'.

But in his heyday, Peter was looked upon by Louis Wain as a sort of 'forecat', who ruled the others with a rod of iron. The others were Bigit, Leo and Minna. Bigit was a magnificent Siamese cat, which people imagined to be a puma or some strange wild animal – an enormous creature with sleek, mouse-coloured and cream white fur. Wain often told a story – doubtless exaggerated – of how he was once called to a neighbour's house whither Bigit had strayed. The neighbours did not know Bigit, and 'were mounted on tables and sideboards in an agony of fright, for they thought that he was a wild beast escaped from a menagerie'.

Not that climbing on to furniture would have been much use, for he was, by Wain's account, an extraordinarily athletic cat. He had come from a ship, and after joining the Wain household, 'one day imagined that he was sailoring again, for he climbed all over the outside of the house, making the most marvellous sheer springs of many yards from lower windowsills to upper ones and gathering an admiring crowd in the road'. [18] We are told that Bigit was a destructive cat, but was subdued by Peter's commanding ways.

Roy Compton wrote of meeting Peter and Bigit. Then: 'a beautiful long-haired tabby, Leo, condescended to walk round me with stately grace, and it struck me how dignified all the versatile artist's models were. They impressed you personally with the fact that they were not common cats. You might admire them, but any attempt at familiarity on your part would be instantly resented. Minna, another model, is a little French cat, a veritable La Parisienne, not only in appearance, but in morals [about that familiarity]. And the circle closes with Rag-tag and Bobtail, two [pug] dogs who have already won favourable criticism from the public!' [19]

The Wains kept dogs as well as cats and some visitors to the household remarked that there were no cats to be seen, only dogs, which naturally surprised them. One who visited the family as a child in 1904 recalls Louis as a 'tall, dark, pale man with a moustache. He was very reserved and stood aloof at the far end of the rather dark room, cluttered with furniture and ornaments in the Victorian manner, gazing down still and silent at half-a-dozen dogs who sat in a semicircle, gazing up at their master'. Louis Wain's sisters were left to carry on the entertainment, and they fussed over their brother with great devotion. The young visitor was infinitely disappointed that there was not a cat to be seen.

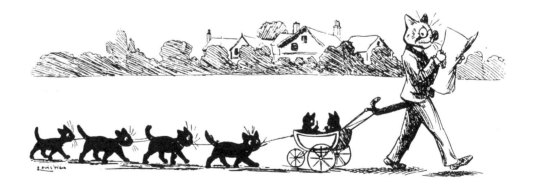

4

Fame

SPRING 1887. Louis Wain had lost Emily, and was out of favour with his family. His only intimate friend was Peter and, as soon as they could, they moved from the flat in Englands Lane to rooms in New Cavendish Street in the house of Mrs Hayes, an old friend.

He turned all his energies to illustration, for he realised that the demand for his work must be satisfied if it was to be maintained and increased. Although he was a very shy, diffident man, he realised that he could not very well further his career unless he kept in touch with the world of Fleet Street. He numbered among his acquaintances many artists remembered today: Herbert Railton (already mentioned), Caton Woodville, Linley Sambourne, Harry Furniss, Melton Prior, Alfred Praga, Phil May and many others.

It was a moderately Bohemian crowd, which used to meet sometimes at Phil May's studio, sometimes at the Angus Hotel in New Bridge Street, presided over by a Mrs Buxton, affectionately known as 'mother'. She used to keep them in order when necessary – and sometimes it *was* necessary during festive seasons. Louis Wain was very generous with his talent, making sketches for anyone who wished. He would often draw them on the gentlemen's starched cuffs, and on one occasion Mrs Buxton indignantly boxed the ears of a man who dared to sponge off a Louis Wain drawing.

A correspondent tells the following story of Herbert Railton and George Augustus Sala, the journalist and war correspondent, also known as 'Fleet Street's most prominent landmark'. 'Sala was at the height of his success whereas Railton, with all his artistic talent, seemed always to be on the rocks. He fell into the habit of "ear-biting"; chiefly the ear of his friend Sala. Ear-biting was the confidential apologetic whisper: "George, old chap, I'm expecting a cheque but it hasn't materialised yet. Could you lend me half-a-crown until Friday?" Half-a-crown was money in those days, and became the weekly stopgap to this non-materialising cheque. Inevitably, Sala was sent abroad on some assignment, and was away for five weeks. On his return, he chanced to meet Herbert Railton in Fleet Street, and greeted him genially: "Hallo, Railton, I expect you'd like your half-crown." In a voice of sad reproach, Railton replied "Oh George! You've been away five weeks – it's twelve-and-six."'

The same correspondent drew my attention to an advertisement of the time; a tramp seated at a table writing a letter. 'Two years ago I used Pears' soap, since when I have used no other.' He remembered some connection between this advertisement and the Angus Hotel coterie. The full history of this advertisement, is as follows. It was drawn by Harry Furniss, and first appeared in the issue of *Punch* dated 26 April 1884, page 197. The model was Charles Burton Barber, the animal painter. Furniss discovered by accident – too late alas – that Charles Keene had been under the impression that the tramp was a caricature of him. When Barber wanted a model for John Brown in a portrait commissioned by Queen

Victoria, Furniss repaid the compliment by sitting for him. [24] The advertisement also appeared on the back of Furniss's own brainchild, *Lika Joko*. This was supposed to be a rival to *Punch*, but only one issue seems to have been printed. Harry Furniss claimed that many famous artists, among them Louis Wain, had contributed to *Lika Joko*, but Wain's contribution did not appear in the first and last edition, so we shall presumably never know what it was.

In 1925, Alfred Praga recalled that he used to meet Louis Wain frequently at the turn of the century.

'I think I first met him in Phil May's studio in the days when my studio was next door to Phil's in the Holland Park Road. In those days, Phil May's studio, on Sunday evenings, was the Mecca of all the artists and journalists of London.

'Louis Wain became a frequent visitor to my studio at the monthly musical reunions we always held when my wife was living. He was passionately fond of music – music of the elevated and classical order – and would improvise at the piano most remarkable harmonies. He claimed to have composed more than one opera, which he hoped one day to see produced. His favourite themes of conversation seemed always to be of a psychic or mystical nature, and I cannot remember him talking very much about his favourite subject of illustration, *viz*, Cats.' [55]

As far as he was able, then, Louis Wain took refuge in hard work, undertaking a variety of commissions for a variety of journals and steadily building up his reputation. As yet, he was neither fully committed to, nor obsessed with, drawing cats. Much of his work was very detailed architectural drawing, and editors, including the editor of the *ILN* sent him on 'sketching rambles'. [7] He tried, as we have seen, to lead some sort of social life, but probably found it difficult to make contact with a large circle of people, preferring the intimate company of those few friends with whom he felt *en rapport*.

He became a member of the Royal Society of British Artists [8] but on only one occasion did he exhibit a painting at the annual show – in 1890.

By the end of that year he had 'discovered' the cat, and put paid to the possibility of a career as a serious artist.

Until 1890, Louis Wain had made little or no attempt to portray cats as anything other than fluffy animals which, though they slept between sheets, or wrote letters with quill pens, were otherwise recognisably feline. The 'Louis Wain cat' had not yet been born. But in 1890, he began to explore the possibility of the comic cat; cats drawn in human situations – or humans drawn as cats, which amounts to the same thing. He insisted that he did not caricature cats, but drew them as he saw them, though his approach makes it clear that he generally saw them as humans. Naturally, then, he studied humans when drawing cats.

'If I want a mild, irresponsible caricature, a grinning cat, then I have to let loose my nature impressions and let myself go on my own account, and it is astonishing what variety one can get in this way, and how one's moods vary from day to day. I have done as many as one hundred and fifty laughing cats at a time, no two being alike.

'There is another way of sketching cats, and this way I often resort to. I take a sketch-book to a restaurant or other public place, and draw the people in their different positions *as cats*, getting as near to their human characteristics as possible. This gives me *double* nature, and these studies I think my best humorous work.' [54]

The foundations of this approach were laid in 1890. That Christmas, there appeared in *Holly Leaves* [11] and the *Illustrated London News* [15] 'A Cats' Christmas Dance' and 'A Cats' Party', respectively. The cats in the former work are less detailed than those in the latter but their expressions are clearly drawn. The picture contains over 120 cats. The 'Party' depicts 23 cats and we can say confidently what each is saying and thinking. The Louis Wain cat is emerging.

By now, Louis Wain was a household name. He was sufficiently famous to be mentioned by M.H. Spielmann (1858–1948), the eminent Victorian artists' biographer, in his monograph on the

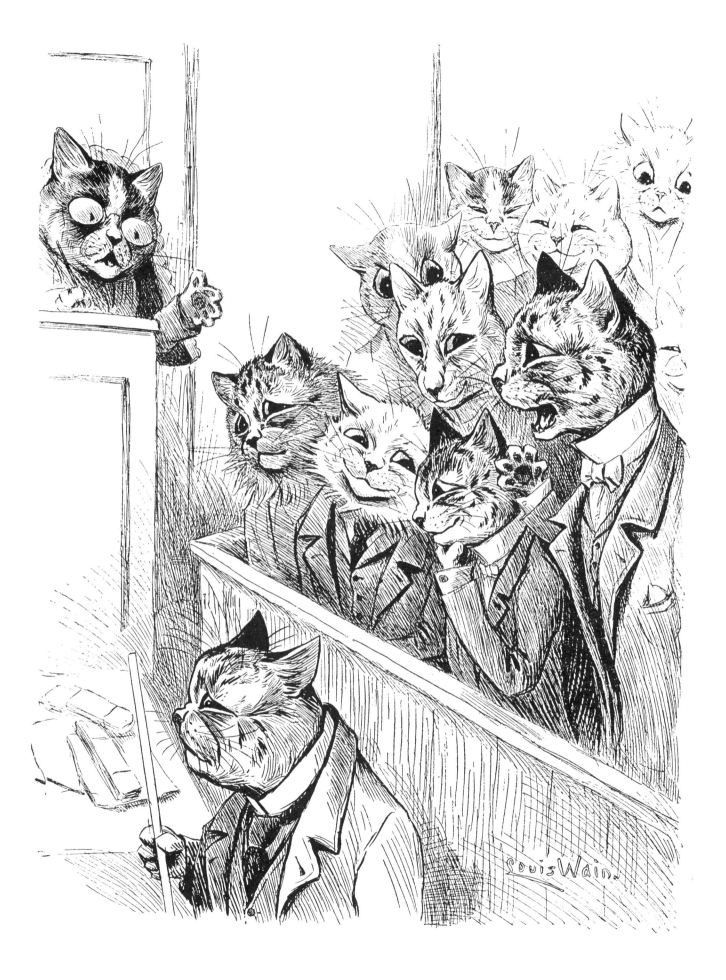

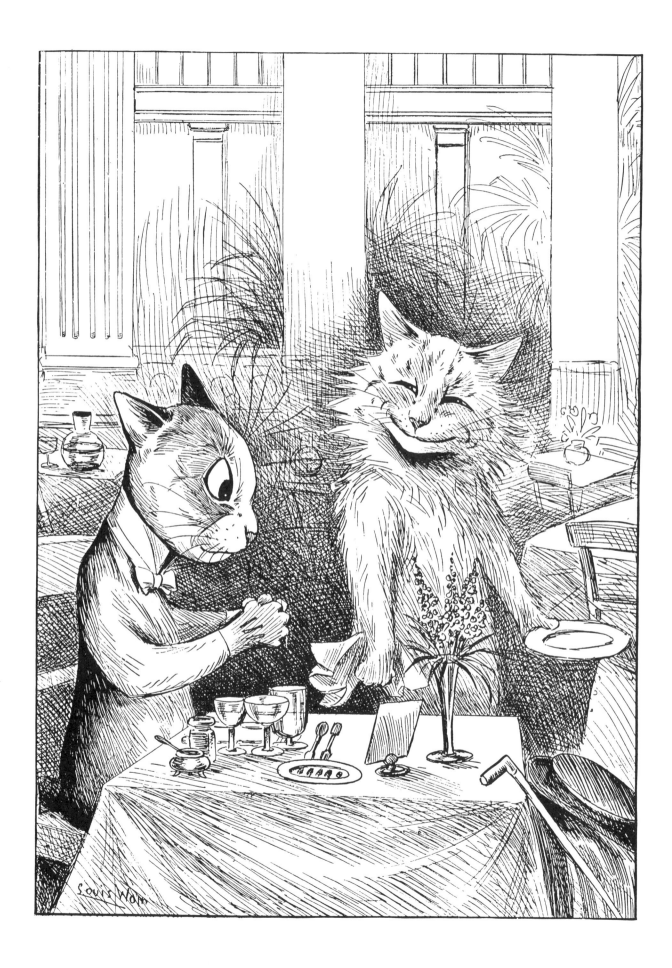

Dutch cat-artist Henriette Ronner [13] in which he wrote: "That after all this lapse of time her work should till lately be practically new to our metropolis is equally a misfortune to art-lovers and an injustice to the artist. We have, and have had, cat-painters of ability here in England; in Mr Couldery, Mr Walter Hunt and Mr Louis Wain we have men who understand and appreciate feline beauty and feline character, though they are not of the calibre of Madame Ronner.'

Praise indeed. Louis Wain, in his turn, was a great admirer of Madame Ronner's works, describing 'one of her prettiest cat paintings' as a 'bright treasure of perfect fur'. [16] Or our minds might turn to the chocolate box.

It is a mark of Louis Wain's fame that in 1890 he was elected to the Presidency of the National Cat Club, following the resignation of Mr Harrison Weir. To paraphrase his words, his studies had created a popular interest in the cult of the cat. He felt that he had helped to wipe out, once and for all, the contempt in which the cat had been held in this country, and that he had raised its status from the questionable care and affection of the old maid to a real and permanent place in the home. Breeding had begun to establish a stronger type of cat, which had little affinity with the unstable and uncertain creatures of the tiles and the chimney-pots.

Louis Wain was acclaimed as an expert on cats. There is no doubt that by keeping them as models he had acquired some knowledge of them, but he held, and continued to hold, some decidedly strange ideas about them. He often spoke of the comprehensive treatise he was planning on the cat, 'treating every possible phase of the subject'. He continued that, in his view, the intelligence of cats had been vastly underrated in the past – of course, they were worshipped in Egypt at one time, and still were in certain parts of Siam – but sufficient pains had not been taken in modern times to develop what was in them. There was no animal more amenable to training than the cat. It had a natural love of the company of human beings, and he had succeeded by absolute kindness in domesticating the wildest speci-

mens, till they had been quite ashamed of fighting, stealing, and so on. Nothing was more wonderful than the part that heredity played in the lives of cats. In the third or fourth generation of domesticated animals the development in manners, intelligence, and facial expression was simply marvellous.

Having dealt with the history of cats, Wain passed on to their care. 'Cats should never be struck. They are, I may say, subject to very few diseases as compared to other animals, and this, no doubt, has something to do with the statement about their nine lives; but brain disease is one to which they are subject, and cats are often driven

mad or imbecile by excessive punishment or fright. You can sufficiently frighten a cat by the tones of your voice, as a rule – mark how any cat shrinks when you speak roughly to it – and the very alertness of the animal's intelligence in most cases tells it that it is doing wrong when you hold it up and admonish it.

'Though you pet a cat, always keep it in its place. Make a nest – a basket with a bit of blanket in it, say – for it to sleep in at night, and in this always keep a small bag of sulphur. If you don't want puss to go into any given place, put fresh orange-peel near this place. Cats will seldom scratch up any flower at the root of which the peel is put, and I have many a time known when they would not even cross a garden wall on the top of which was a continuous line of peel.' [18]

29

I do not know how many generations modern-day cats are removed from those of the 1890s, but orange peel seems to hold no terror for them. If, however, a cat on Louis Wain's knee had been inadvertently sprayed with the fine natural aerosol of the orange, it would surely have given every sign of aversion from oranges. Louis Wain loved oranges, which may be why his cats hated them.

But to return to the care of the cat, or 'Practical Pussyology' as a leading cat journal later called it each week. 'Above everything', Wain continued, 'always have a patch of grass for pussy, even if this be only in a flower-pot, for the animal's health depends on the presence of this medicine. When the grass on the lawn is damp, put a piece of brown paper on it, and see how pussy will fly to this when she wants to take an airing. Cats are subject to rheumatism, and they know what the piece of paper protects them from.

'Cats are most difficult things to sketch, unless they are put under a glass case with a nice, cosy nest inside it, for they seem to get uncomfortable and restless when they see anyone looking hard at them and moving a pencil. I have often seen cats get very angry at the presence of the supposed intruder, when I have displayed to them their own life-sized portraits, and the puzzled ex-pression their faces have worn when they have got to the blank side of the cardboard has been a sight to remember.' [18] Again, our present-day cats seem to have developed somewhat, for they take very little notice of their reflections in a mirror, which are not only lifelike, but animated. Perhaps television has made them *blasé.*

Louis Wain now speaks of the cat as a panacea for all ills. 'I have myself found, as the result of many years of enquiry and study, that all people who keep cats, and are in the habit of nursing them, do not suffer from those petty little ailments which all flesh is heir to, *viz*, nervous complaints of a minor sort. Hysteria and rheumatism, too, are unknown, and all lovers of "pussy" are of the sweetest temperament. When a student at home, I have often felt the benefit, after a long spell of mental effort, of my cats sitting across my shoulders, or of half-an-hour's chat with my Peter.' [19]

Of course it is relaxing to immerse oneself in a conversation with a cat with whom one is on good terms. I wonder, however, whether Wain thought of himself as being of 'the sweetest temperament', or even free from nervous complaints, though these are admittedly only of 'a minor sort'.

What Louis Wain termed 'A long period of

research' led him to suppose that the mixing of colours and marking in all their variations grew ultimately to one of three whole colours without markings – namely, black, dun or grey (the so-called blue) – and the disposition of the blue cat bore out his belief that it was more developed all round in character, both mentally and physically and therefore of more universal parentage than had been imagined. In a long sentence (over 150 words) Louis Wain covers the distribution and domestication of the cat.

'The original parents of all cats, I conceive to have been of an even brown colour, whose fur reflected all the prismatic colours of the rainbow, and whose wide distribution into tribal genera was effected through climatic influences, the mental powers strengthening with each different into varying dependent instincts, subject to dominating influences and surroundings, the constructed instincts, governing and reflecting and adapting their physical needs, and building up into natural propensities and idiosyncracies characteristic of their condition of life, until they come under the dominion of man, who tolerated them while subservient to his wishes, perhaps as a decoy or pointer of game, but who otherwise cast them aside as a toy for women, or a natural instrument in keeping under plagues of smaller rodents, I cannot find any attempt on the part of man generally to treat the cat in any other way than as an accident in his life.'

When Louis Wain said man, he meant man. Man used the cat as a labour-saving appliance where no great effort or patience was needed to tutor it in the required way. But beyond that, 'the whole area of domestication has fallen upon the shoulder of women. It is to women we owe its rescue from savagery and its final place on our hearths. Woman, too, has borne the jeers of man the while she has broken in her pet to dependence on the home; and finally, it is the patience of women which has won over the protective interest of man to her cause, and given to the cat a status it has probably never had before in the whole of its history.'

Louis Wain's favourite hobby-horse was the weak brain of the cat. 'Here is an animal whose brain is in a transitory state of development, whose sensorium in most specimens is not in a condition to withstand the shock of rapidly-changing impressions without a severe mental strain which immediately reacts upon the digestive organs. As a consequence the cat will cling to the original home, to the set of impressions the

sensory nerve is most used to convey to the mind without effort, while it will suffer severe and obvious distress to the sensory organs when the sight is made to convey a number of strange and unusual scenes to them. The digestion suffers, the cat cannot eat well, and very often dies before the brain can recover its equilibrium.' [27]

This may be the result either of nature or of domestication; he was not sure which. He maintained that the cat was a 'glass case' animal, which did not have the same chance as the dog to meet all sorts. You had to be very careful when moving a cat from one place to another, as it was liable to die when it saw its new surroundings, its brain being unable to interpret all the new sensations. The best way to punish a cat, he said, was to clap your hands at him or to rustle paper under him – not too much or you will paralyse his brain, and he will remember nothing.

In spite of all this, Louis Wain continued for many years to be hailed as an expert on cats, and his popularisation of them and the Fancy more than offset the strange ideas which he promulgated about their habits. On balance he probably did far more good than harm, and in the long run, 'pussydom' got a better deal.

5

Reconciliation

LOUIS WAIN'S fame grew, and the strain of living as a bachelor suited him less and less. His mother and sisters had by now forgiven him for marrying Emily and they realised that he needed their care and companionship. He longed for a quiet life with them again; they in their turn longed for him to rejoin them as head of the family.

Sir William Ingram had not a little influence in bringing about the reconciliation and it was doubtless at his suggestion that, in 1894, the Wains reunited and moved to Westgate-on-Sea. Westgate in those days was a quiet, exclusive place, a resort of many famous people, and Sir William owned a great deal of property there.

In spite of the ease with which Louis Wain now sold his work, it was not easy for him to support himself and six others and he was, as he put it, perpetually 'close up'. He paid his rent, as he paid so many other bills during his life, in pictures.

In 1895, the Wains moved from 16 Adrian Square to 7 Collingwood Terrace, part of Westgate Bay Avenue; Sir William named the terrace after his son Collingwood. Number 7 was a large corner house; later they moved to number 10, a smaller house further up the terrace, away from Margate. Louis Wain named both houses Bendigo after the famous prizefighter (William Thompson 1811–1880, nicknamed Bendigo) whose reputation he so admired.

The Wains must have felt very relieved, after having lived for so long in London, to find themselves in a select seaside resort in the beautiful county of Kent. Louis, in his mid-thirties, now found more opportunity for keeping himself fit than ever he had had in London. He took up a variety of sports – walking, running, swimming, boating, ice-skating, boxing and fencing. He took a great interest in gardening, and befriended the head gardener at Quex Park, a Mr Cornford.

His mother and sisters also enjoyed their new life at Westgate. Mrs Wain got out her embroidery once again, and designed and worked many cushions and hangings for the Church. Clare and Felicie, who had much artistic talent of their own, spent more time painting and sketching, though with misplaced sisterly love they were careful that Louis' work always came first. Visitors who remarked on their work usually found the conversation steered away from it, and turned to Louis' latest success.

In spite of the chronic lack of money, the years at the close of the century were perhaps the happiest of Louis Wain's life. There was but one cloud in the sky; his youngest sister Marie had begun to suffer from delusions, and to behave in a very strange way. However, we will return to her in the next chapter.

In 1895, Louis Wain was commissioned to write and illustrate two articles for the newly-founded *Windsor Magazine*. The first, 'The Duchess of Bedford's Pets' [16] describes a visit to Woburn, where he met all manner of pets as well as a wide variety of wild animals running free in the grounds.

It was here that he first met Bigit, 'on the roll of

the tabooed; a sullen Siamese who lives happily enough in exile where twenty-five guinea pheasant are unknown, and the larder door balks his sportive inclinations, and where his liberties are entirely circumscribed to the domestication of home life alone'. Louis Wain named his own wayward Bigit after Her Grace's cat.

He did not lose touch with the Duchess, and from time to time he was called to Woburn to paint portraits of her cats. She later gave him a long-haired cat, 'one of the curious so-called "blue" cats – the tint is a neutral grey really. He was christened Fitzgoblin, after the Duchess's other cat, and the name suits him fearfully and wonderfully. He is a weird creature with glowing red eyes, and he seems to have two individualities – the one possessing the fore part of his body and the other the rear. It is most curious; his long lanky hind legs seem to act as an ever-varying rudder, and he often gets such a pace into them as to jump in front of his fore-quarters – to his evident astonishment. In fact, neither Fitzgoblin nor anyone else can foretell from moment to moment where he is going or how his frolics will end!'

It was also said that the Duchess gave him Prince, who had cost a man his life in Persia. However, Louis Wain was at pains to make it clear that the Duchess did not give him Prince, though he was equally at pains to conceal exactly how he came into possession of him.

Prince 'is a fine old black Persian, astoundingly like the Egyptian effigies of their cat-god – stately, impassive, implacable. He was stolen from the Shah's palace in Teheran, and, as the paragraphist says, a careless attendant was beheaded in consequence.

'Prince is now a lovable cat, but he has a hidden temper and sharp talons. At night he is as fearless as a watch-dog. After his theft from the Shah he was brought to Paris, and there bought by an American. But I need not trouble you with a full account of his adventures until he finally came into my possession.'

Left: Views of Wentworth Woodhouse, 1888–9

However, let us allow Louis Wain to tell us about Woburn in his own inimitable style.

'The first impression the stranger receives on viewing the great home of the Russells is a feeling of absolute repose. Everything combines to produce this effect – the fine unpretentious front, severe in classical massing, backed by elms and the famous Woburn beeches of immense growth and immemorial age, the delightful parkland lying around, the graceful deer wandering undisturbed among the quiet glades, all speak an atmosphere of eternal peace. Passing through the gateway, embedded in firs and laurels, a short walk brings one close to Woburn Great House; but before one even enters the massive old hall, one encounters some of the many pets to which the charming mistress of Woburn is so devoted.

'On a smooth lawn in front from which the thick snow has been cleared, throngs of gossiping, chattering birds are making the most of an hour or two of bright winter sunshine; tits are grubbing about with praiseworthy industry; starlings and thrushes hop superciliously among plebian sparrows, while robins try to sing each other out of countenance on neighbouring branches.'

And so they tour the house and grounds, Louis Wain with his note-pad and sketch-book; the Duchess with her camera.

His second visit on behalf of the *Windsor Magazine* was to the Hon Walter Rothschild's Museum at Tring Park, where Gambier Bolton took the photographs. [17] Gambier Bolton first met Louis Wain at the Ryde, Isle of Wight, dog show in 1885. By now, he had been elected a Fellow of the Zoological Society, and continued to be a well-known figure for many years, contributing a great deal to popular literature on animals.

I was interested to find his account of tattooing – 'Pictures on the Human Skin' [21] – and was amazed to find that he had, as it were, a vested interest in the art, for he had tattooed on his body a sacred Burmese dragon, location unspecified; a spider's web on his chest, in blue-black, red and brown, by Hori Chyo of Yokohama; and a falcon on his back and a snake round his neck, both by

Mr Macdonald. Wrote Bolton: 'it may be said without fear of contradiction that no one in the past, and no man living to-day, can compare with Macdonald in placing really artistic pictures on the human skin.'

But to return to Louis Wain's description of Tring – it is even more poetic than that of Woburn.

'Mist glooms steeping the hill drearily in chill, watery vapours, pass away in rolling undulations before the heat of the early morning sun, leaving the small rural town of Tring clear cut against a wooded background. It is a sleepy nook of brilliant and varied foliage in a land of broad hilly pasturage; of glowing red-gabled houses stacked to the tree-tops with piling chimneys; of timbered and red-tiled ivy-grown cottages; of quaint, pompous-named blind side alleys lined with tar-timbered shanties grouping prettily amid straying rose and sunflower beds.

'Closer acquaintance with the main streets bring to light smart spick-and-span shops and fine houses, which give the older parts of the town a very shamefaced appearance; it is as though the hand of wealth had been laid upon the place and steadied it in its degeneration, and

of a verity it is so, for walking through a crowd of street-stalls, and a constantly moving mass of humanity and cattle on the market day, we light upon the great wrought-iron gates of Tring Park, towering almost to the height of the side offices, from which the gates are opened automatically, on to a winding avenue of aged elm and chestnut.'

Wain had a way with words, and his writing is both exhilarating and enervating. He and Gambier Bolton tour the museum within and the zoo without. At last it is time to go: 'Finally, a full-grown dog-badger sneaks from shelter in the failing light, who, it must be remembered, has biting designs of big toes; taking this as an excuse to bolt, a hedgerow soon hides the last of the huts from view, the wind, with a touch of chilliness in its breath, rustles the leaves overhead dreamily, the harvest moon rises lazily over the hills, a few gleaners still linger in the fields, but night is falling and all is peace.'

One cannot guess what the editor thought of Louis Wain's original prose, but as far as I can gather it was many years before anything else significant from his pen found its way into print.

6

Science

IN 1895, Jas Gordon Richards, of *Chums*, 'sought out Mr Wain, and the latter diffidently, but with the unaffected kindliness which seems natural to him, not alone consented to discourse on the drawing of animals, and especially cats, but to provide the readers of the paper with a few slight sketches from his facile pencil.' [18]

Mr Wain concluded the interview thus: 'As to how I work? – well, very hard. Twelve to fourteen hours a day regularly, but not at pictures, though I have done some hundreds of these this year already. I paint and draw in the morning, take exercise in the afternoon, study chemistry, work at a humorous story I am writing or sit far into the night on certain mechanical industrial inventions I am patenting.' Life at Westgate with his mother and sisters certainly seemed to suit him well.

Louis Wain's interest in chemistry is puzzling. Earlier in the interview he had said that as a boy he had been torn between careers in music, painting, authorship and chemistry. In 1900, he added to his *Who's Who* entry the recreation 'study of the physical sciences'. No one remembers his ever speaking of this interest, and what he wrote was in general pure nonsense. The free reversing globes have already been mentioned. As another example, let us take his speculation on the soothing effect which Peter had on Emily when he snuggled up to her. 'Peter is a small electrical battery, my wife a larger one, the larger one attracts electricity from the smaller one; the passage of the fluid from one body to another gener-

ating heat. Whether this electricity was positive or negative I worked out in very many ways.' [23] Unfortunately, the reasoning is lost, so we shall never know what polarity the electricity was.

In 1897, Stanhope Sprigg recounts further Wainian science. 'This man, who has made cats the study of his lifetime, never speaks of them in the ordinary routine of his life. For nearly four years I had known Louis Wain before I broke through the reserve with which he has hedged himself on the subject. . . . We were standing on the balcony of a big Ice Palace that had sprung up fairy fashion in the West End of London, taking a final peep at the busy throng of figures and idly dangling our skates. . . . We dropped on to one of the lounges against the rails and, with two or three idle questions, I persuaded the reticent artist nature of my companion to sink into the background, and the late President of the National Cat Club to speak frankly and freely.' [22]

It does not take long, of course, for Louis Wain to explain how the weak brain of the cat stops it from grasping a new set of surroundings all at once. Sprigg asks how it is that cats often find their way home from a considerable distance, and receives the ingenious reply that the goal is so strongly impressed on the cat's brain that it is able to reason out its means and methods in order to reach it, 'in the same way that a carrier pigeon flies back to its own cote'.

'Strangely enough', continued Wain, 'I once had an impression that a cat's tendency was to

travel north, and to face north as a magnet does, and that this tendency had some intimate association with the electrical strength of its fur. In brief, I looked upon a cat as a lightning conductor on a small scale, and that according to its temperament, negative or positive, did it face north or south, or just as the points of its fur were attracted by the negative or positive poles of the earth. I was led to this by some observations I had made some years previously in a London suburb. Then I noticed that the cats of that particular district had a tendency to walk in particular directions on the walls that faced the north rather than to walk on the walls that ran east and west.' This is very interesting – one feels that the cat population of Sutherland and Caithness should be enormous – *cf* the *Daily Mail* 20 March 1905: "Irishmen from every quarter of London marched Westwards yesterday in units or battalions to attend the first great Gaelic service held in the Westminster Cathedral to celebrate the feast of St Patrick."

However, let us return to Louis Wain's cat lore. 'As to the idea that cats are good weather gauges, I do not credit that. I believe the reason that a cat washes itself over its ears or not is bound up with the particular method by which the particular animal cleans itself. Its main object in washing, to my mind, is just to complete an electrical circuit, for by so doing it generates heat and therefore a pleasing sensation in its fur. A strong cat, remember, will always clean itself better than a weak cat.' It is difficult to believe that Wain took all this seriously, though he certainly did. Clearly, Stanhope Sprigg was so impressed with his sincerity that he did not ask whether perhaps cats just liked to keep themselves clean.

Interviewed in 1898, Wain claimed that he read all the Proceedings of the Royal Society, and specialised in toxicology. He had found that poison might, with care and attention, be extracted from everything in the vegetable world, 'a truth', commented the interviewer, 'which one fancies has its parallel in the world of morals'.

Louis Wain, in common with many other people at the turn of the century, was much excited by the experiments of Hertz and others, who had demonstrated the possibility of transmitting waves through the ether. Nikola Tesla, for instance, built his famous oscillator and demonstrated, *inter alia*, 'the lighting of electric lamps with but one metallic connection, and that held in a person's hand, causing Geissler tubes to light up without any metallic connections whatever, making gas at ordinary pressures luminous, and causing a lump of charcoal in a closed glass vessel to become red-hot while the vessel is merely held in the hand'. [28]

Tesla himself said that 'space and matter are equally impermeable to ethereal undulations when these are tuned, so to speak, to the proper frequency.' Wain drove *his* speculations about the possibilities of the 'new electricity' even further.

'Why not try and read the planets through a more comprehensive study of long life in the surroundings of our own planet. Now, just as the sun is the principal factor in bringing into action and active being those elements which go to build up different states and stages of life, so may we consider that its rays, diffused into space, are a dominant factor in quickening the long life prin-

ciple into active energy and constructive attractions and repulsions. If we could discover the life principle developed to a stage which would in its constructed state, remain quiescent under given conditions, without its active energy or capacity to develop, under other given conditions being destroyed, we might impel and radiate life in this dormant form into space electrically, and so diffuse forms of life peculiar to our own planet to the surface of Mars, or indeed, on to the surface of all the planets in our system. It would then depend on elemental conditions and chemical organic and inorganic surroundings and temperature to quicken the dormant energy of the primary factor, life. Implanted in strange surroundings, who knows what might happen then? Imagine a protoplasmic substance or, say, a life cell of exceedingly minute proportions even in its developed state on our own earth, when placed within the realm of another planet growing great and magnificent under more propitious conditions. Or a microscopic creature, weird and wonderful even in his earthly guise, growing to monstrous proportions on Mars! Imagine a man discoursing on and at a multitude of quiescent life cells talking of our life on this earth, and by his efforts impressing his language indelibly on each and every one of those life cells just as he would impress sound on the surface of a phonographic recorder, and then winging those life cells on their journey radiating through space to wake up on a planet into creative life and being, of size and shape, mouthing the language instilled into them to other intelligences who may be perhaps beings having a spiritual nature and a governing independent will like our own, whatever their shape or form.'

This tells us something of Louis Wain's mind-boggling 'study of the physical sciences'. What of his 'certain mechanical industrial inventions'? The *Illustrated Official Journal of Patents* mentions but three. There was the 'Steady Cycle' in 1894, the 'New Attachment to Bicycles' in 1895, and 'Rangefinder' in 1915. All these applications were later abandoned, and all details are therefore unfortunately lost. None of them would appear to be industrial; they seem to be examples of an amateur's gesture of 'taking out a patent' in a flush of enthusiasm without adequately exploring the development and commercial viability of the invention.

It is interesting that the first two patents should relate to bicycles, for Louis Wain's drawings of bicycles show scant regard for practical bicycle construction. Just as he shows little feeling for musical instruments in his drawings of them, so his drawings of mechanical devices reveal a lack of knowledge of mechanics. I cannot believe that anyone who had really spent hours of his youth worrying about mechanical contrivances could produce the drawing of the 'Catville Automobile'.

I believe it to be axiomatic that anyone with feeling for a subject takes care in his drawings to portray that subject accurately. One of the finest draughtsmen to bear out this theory, W. Heath Robinson, was not trained as an engineer, but he did spend much of his childhood making mechanical models. As a result, his devices were in the main workable, though usually impracticable.

Louis Wain's third patent, the rangefinder, may well have been the result of some chance observations which he made while walking on the cliffs at Westgate. He spent much leisure time walking on the cliffs. On many of his walks in the 'nineties', he was accompanied by his young friend Collingwood Ingram, a younger son of Sir William. Collingwood Ingram had even then a tremendous knowledge of the avifauna of Kent, and grew into a noted ornithologist.'

He talked to me about Louis Wain: 'Poor old Louis – of course, I knew him very well. He was a very likable fellow, but as eccentric as they come. I always think of him as an example of the thin borderline between genius and insanity, and in his case, he was a genius. He wasn't very good looking; he had a hare lip and a broken nose which he got through boxing. I never saw him fight, though I know he was quite keen on the sport, and I did once see him with a bleeding nose after some sparring match. He had curly hair and a very sallow complexion – but then, he didn't worry about his health at all.

'His interest in music? Well, he used to improvise at the piano very competently, strange melodies played in a very jerky, nervous way – what I would call *agitato* playing. And he used to improvise wild, fantastic solo dances in the same style. He was quite a versatile chap.

'He never had any money. With his mother and sisters to support . . . well, I don't know what would have happened to them if my father had been less lenient. I remember once, Louis came to me: "I say, Collingwood, can you lend me ten shillings until Monday?" The money was lent, and duly returned. The next week: "I say, Collingwood, can you lend me a pound?" Of course, I never saw my pound again. It was well done, and he was so impecunious that one could excuse it.

'We used to go for long walks along the cliffs. He had a favourite riddle which he was always asking me: "What is the connection between a yellowhammer and an adder?" (pause) "Ah-ha! You don't know *that*, now do you?" Of course, I

didn't, and Louis would never tell me. It was pure invention, like his sea-serpents. Suddenly, he would point out to sea: "Look, Collingwood! A sea-serpent – there – there it is!" I looked, and do you know what I saw? Black common scoters, swooping over the waves, and they did give the impression of a sea-serpent, but I could never explain it to Louis. He often pointed out the sea-serpents to me, and really believed in them.

'I remember another time, years later, in 1922 I think, he came to give a lantern-lecture in the village, and stayed with us here [Benenden]. I was out watering the garden with the hose, and Louis came out and stood by me. Suddenly, he put his hand out, into the spray from the hose, and looked up at the sky. "D'you know, Collingwood, it's *raining*!" Not a cloud in the sky, but old Louis was really convinced that it was raining.

'I liked Louis Wain very much, and was really sorry to hear about his end, though I wasn't in the least surprised.'

7

Art

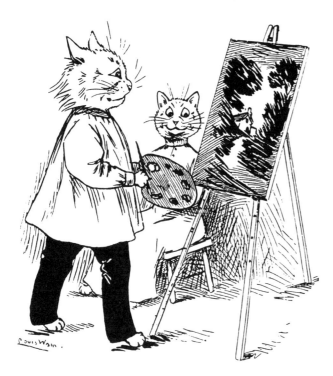

AT THE turn of the century Louis Wain was still concentrating on illustration for periodicals rather than for books. Many popular magazines sprang up towards the end of the Victorian era, and many of them took Louis Wain's drawings, week after week or month after month. He felt that most other artists tended to be their own enemies, for they 'work in a groove instead of entering into the spirit of the age, and being sensitive to all its crazes, advancements, prejudices and teachings'.

'Personally', he continued, 'I work for every paper in turn, for I find from experience that if you work for one editor you get one class of ideas,

and if you constantly change, you avoid degeneracy. A man should never allow his fancy to run away with his judgement. His sketches should be the result of accurate insight into and appreciation of the variety of characters he has to please; he should be a very mirror held up to the nature amongst which he moves'. [19] Yet if ever there was a one-idea artist, it was Louis Wain. One suspects that it was the difficulty he had in being businesslike, and the difficulty which the editors and publishers had in dealing with him which made him 'go the rounds'.

Numerous people remembered Wain as a 'rather sad-faced man' who sat for hours in editorial offices, nursing his folder of drawings, too shy and diffident to bargain. And it must be admitted with shame that those drawings would often change hands for a song, Wain too unforthcoming to bargain for their true worth, knowing that he would see some of them reproduced time after time, having sold the copyright with the drawing.

Louis Wain was visited at the turn of the century by Frank Burnand, editor of *Punch* 1862–1906, who wrote a very favourable and interesting account of him, under the complimentary heading 'The Hogarth of Cat Life'.

'He is – I trust he will not be angry with me for saying it, but his own most vivid account of his childhood sufficiently shows it [23] – he is a neuropath, a keen sufferer at times for a finely and highly strung nervous temperament. The word is, or at any rate was until lately, in evil odour,

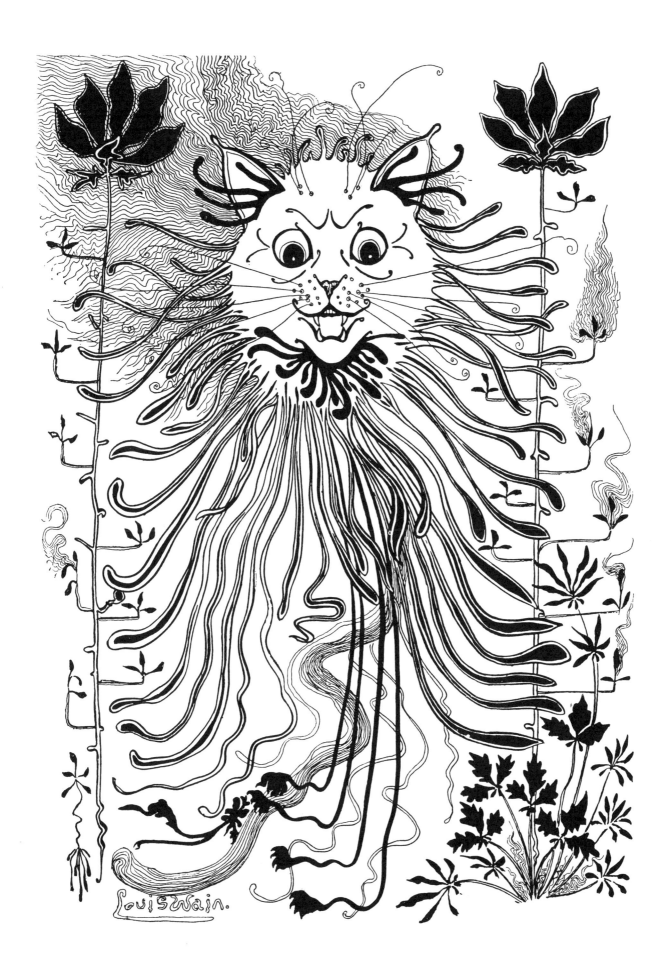

Louis Wain's mother and sisters. Top row: Marie (inset), Claire, Josephine; below: Felicie, Mrs Wain, Caroline.

thanks to the pseudo-psychological twaddle of Dr Max Nordau and his admirers. Julius Caesar and Charles Dickens were neuropaths, but they treated their sufferings with manly contempt. . . .

'When you meet Louis Wain for the first time you are struck with the intense sadness of the quiet, rather drawn, unsmiling face. You feel inclined to say, as the Florentine children of Dante, "Ecco, there is one who has been in hell". It is all changed when he begins to talk. He speaks rapidly, very low, few inflexions of voice, face impassive. He never smiles nor "however animated" does his face light up as he warms to a congenial theme. Whether he speaks of painting, sport, fencing, boxing, or the unseen world on which his reasoning is so original, so imaginative and so reverent, you say to yourself: "Here is a man who thinks his own thoughts, a man who

is determined to live every moment of his life, so that he and others may be the wiser and better for it."

'At the age of thirty-eight, he has a half-a-dozen strings to his bow, and half-a-dozen hobbies. He could win for himself fame in the world of letters equal to that he has won in the world of art.'

I do not believe, however, that Louis Wain's work ever appeared in *Punch*. What Burnand did not know was that Wain's youngest sister, Marie, was even more of a 'neuropath'. They had given up trying to cope with her at home and in 1900 sent her to Kennersbury House, a private mental home in Kent. After about a year, she returned to her family, but was even more unmanageable than before. Apart from the fact that she said she had witnessed a number of murders, and that she

took all her clothes off whenever she was not restrained, she imagined that she was afflicted with the 'deadliest leprosy', and therefore would let no one go near her. She also suffered from lack of dental treatment, and complained that she had 'a microbe at the bottom of each tooth, and when I eat, it pains'.

On 4 March 1901, Marie Wain was certified insane and admitted to St Augustine's Hospital, Chartham Down, near Canterbury. Although she was obstinate, taciturn and unreasonably resistant to examination (because of her 'leprosy') she kept herself clean and ate well. In the language of the day, the diagnosis was 'primary dementia'. There was little change in her condition for some years, but eventually she began to respond to being spoken to, albeit by 'laughing in a silly way'. Then she became less reserved, sometimes noisy, impulsive and fatuous, sometimes sitting in a chair muttering incoherently to herself.

On Wednesday 19 February 1913, it was noticed that she was suffering from pleurisy, and later colitis (staphylococcal enteritis), not uncommon in institutions. She died on Monday 3 March 1913, and was buried at Westgate. The family never spoke of her.

Although Louis Wain's work had appeared almost exclusively in publications for adults, it was by now equally well known to children as well. Between 1886 and 1900 he illustrated but nine books; his life's output was over 100. With the exception of *Our Farm*, a rather bad illustrated poem, his first books for the nursery did not appear until 1896. The first was *Comical Customers at the New Stores of Comical Rhymes and Stories*.

It was published by Nister, and was followed by a series of books published by them, illustrated by Louis Wain, and with verses by Clifton Bingham, which were rehashed year after year until 1908. Two other books were published in 1896, by Thomas Nelson: *Miss Lovemouse's Letters* and *Puppy Dogs' Tales*. Two of the *ILN* 'Kittens' Christmas Party' illustrations of 1886 appeared in *Miss Lovemouse*.

In 1899, the National Cat Club founded its journal *Our Cats*. Produced weekly for some 14 years, *Our Cats* is a rich source of information about Louis Wain's doings as president and chairman of the committee for, as a nationally-known figure, he was 'news'. And there is no doubt that he had become nationally known by the turn of the century, even though he had still not reached the height of his fame.

Writing to a friend about the inaccuracies of interviewers, he said: 'If some of the English interviewers say funny things about me, the Americans are ten times worse. I am fat and fifty, and fat and twenty-one. I am a charming young girl, an old maid, a man who is perpetually laughing and much else. Therefore, you must prepare yourself for an ordeal and take the consequences of your rashness if you come, though I may tell you that all friends receive a hearty welcome at Bendigo.'

When Roy Compton went to interview Louis Wain, however, the artist was not there. 'When I reached aristocratic Westgate, a few days ago, and found myself in the cozy drawing-room of Bendigo Lodge, replying to the kindly welcome of Mr Wain's mother and bright-eyed sisters, I learned that Mr Wain himself was still in London, and the hour of his return was a matter of conjecture.

' "I think, most probably, he will come down by the last train, go on to Margate, and run in from there."

'"Run in?", I remarked, surprisedly.

'Mrs Wain smiled. "Yes, he generally does so when he has had a laborious week; he finds the exercise does him good. So you must make yourself quite at home till he comes."

'It would be difficult, indeed, to single out a more pleasant method of passing a couple of days than in Mr Wain's cheery household at Bendigo Lodge. All the circle are so talented that, as Mrs Wain naively remarks, "They have no time to be fashionable!"' [19]

This, then, was the hearty welcome to which Louis Wain had referred. It is a pleasant reminder of more leisurely days; imagine a present-day interviewer waiting two days for his

'quarry'. But to return to the American inter-
viewers; Louis Wain was not always so ready to
take a joke against himself. He was once asked to
a children's party to do lightning sketches of cats.
There, he was offered a drink, but refused both
tea and alcohol, and when pressed said that he

would like some milk. A joker at the party poured
milk into a saucer, but Louis Wain was 'not
amused'.

However, he enjoyed setting up a little joke for
someone else. A tale is told of an incident follow-
ing the NCC show at the Crystal Palace in 1900.
Wain had spent nine weeks completing 50 draw-
ings which were exhibited at the show, prior to
being sent to the United States.

'The artist himself, who was occasionally flut-
tering round about his work which occupied one
end of the spacious conservatory, was formerly
[*sic*] introduced to Her Royal Highness who
appeared greatly amused and interested at the
variety and humour of Mr Wain's sketches. . . .
The pictures could not be got off the grounds on
the Saturday night, and were accordingly left at
the Botanic over the Sunday. Now the Gardens

every Sunday are visited by a large and fashion-
able crowd, and the conservatory was simply
packed with an admiring throng of visitors. The
old door-keeper at the corridor entrance, which
leads into the conservatory, was much impressed
by the favourable remarks made by the fellows
and members leaving the collection, and as the
pictures were naturally the talk of the place, him-
self engaged in conversation the next day the
man who came to remove them.

'"Wonderful man, that 'ere Louis Wain.
There's no other man", says the door-keeper,
"who can draw cats like 'im."

'"Have you a pencil?" says the man.

'"Yes", says the door-keeper, "and paper.
There's a bit 'ere somewhere."

'And before the door-keeper could count ten, a
curiously humorous sketch of a cat winking its
eye lay on the desk before him. It only wants one
thing to make it as good as the others. And the
man put his signature to it – Louis Wain. The
door-keeper wouldn't sell that sketch for £10.'

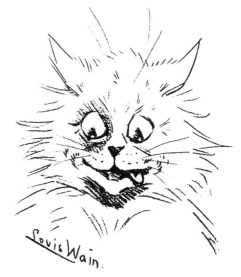

I am rather suspicious of this story, because it
turned up again almost verbatim some years
later, except that the last line read 'the door-
keeper wouldn't sell that sketch for 500/- [£25].'
However, it certainly has a touch of Louis Wain
about it. He was always ready to make sketches of
cats in a moment, and left them with astonished
assistants in banks, shops, cafes and other places,

who generally treasured them for years afterwards.

He was an extremely rapid draughtsman, and could sketch one of his much-practised feline faces, so Collingwood Ingram tells us, in 45 seconds. [105] He often used this gift very generously to raise funds for various causes, from local cats' homes to comforts for the troops. At Westgate, for example, he and his sisters sometimes attended an informal poetry reading group, which met in the houses of its members. There, he drew a 'tremendous lot of comic cat sketches on a blackboard at a terrific rate'.

He was always ready to execute lightning cat sketches on people's programmes at tennis club dances. He visited schools and gave sketching displays. At the Assembly Rooms, Westgate, during the First World War, he gave freely of his talents to aid 'our boys at the front'. He helped to raise funds for the Red Cross, and appeared at the 1915, 'Christmas in Wartime' exhibition at the Albert Hall. An eyewitness on the first night of this exhibition recalls that Louis Wain had been provided with too flimsy a paper, and sheet after sheet tore under his charcoal. He apologised profusely, and promised to get better paper for subsequent demonstrations.

I am told that he accompanied his displays with a very humorous commentary, which is surprising, but well authenticated. Perhaps he did not always mean his commentary to be as humorous as it turned out.

Sometimes he would add to the effect by drawing two different pictures at once, one with each hand. He said that though he drew and painted entirely with his left hand, he could use both hands. Fred Deuxberry, who looked after Wain at Napsbury Hospital, said that he was normally left-handed, but changed over to using his right when the left one became tired. Other witnesses said that he drew with his left and signed with his right. Certainly, on his earlier drawings, the signature is usually on the right, which is where a right-handed signature naturally falls, but later it is usually on the left. Photographs of him working all show him to be left-handed. His cats are

usually right-handed when writing, smoking and so forth, but are often left-handed when they are doing a more unusual task, fishing, digging or playing golf. In such cases, he may have used himself as a model to get the position of the 'hands' right.

He astonished many people by doing mirror-writing as fast as normal writing, but he usually wrote the same couplet

Those with feelings wondrous kind,
Can love with felines ever bind.

His speed may have been through constant practice, as it was with his lightning sketches. This mirror-writing was also done with the left hand.

Quite a number of examples of this strange couplet exists. Wain often wrote it under one of his lightning cat's-head sketches. Sometimes he added his signature in mirror-writing as well.

Paul Klee, we are told by his son Felix, drew and painted with his left hand but wrote with his right. He could also write and draw with both hands simultaneously, working either from right to left or left to right. Paul Klee was also a noted cat-lover.

In 1931, when Wain had been in mental hospitals for seven years, a journalist produced a very strange account of his illness which mingled fact and fiction.

'In a mental hospital of London', it was reported, 'is Louis Wain, the world's most celebrated cat artist and also one of the world's strangest cases of insanity. Wain, though right handed in all other things, for some mysterious reason could draw cats only with his left hand and, until 1925, had produced thousands of delightful drawings of soft, pretty, agreeable purring pussies – all with his left hand. Then, one day, an astonishing thing happened. The artist's right hand, instead of hanging idle, suddenly took the crayon from his left and began drawing cats with a skill quite its equal.

'One might not think that would make much difference, but it was enough to drive away the artist's patrons and drive him into a madhouse. The trouble was that these right-handed cats were different from the lovable, left-handed kitties that all cat-lovers had admired. The new ones were fiendish creatures with a baleful light in their eyes, the kind of hell-cats that are supposed to ride on witches' shoulders to the "Devil's Sabbath". These were "crazy cats" and after a struggle to make that right hand behave or give the crayon back to the left, the artist went crazy too.

'Wain is slowly getting better and now his right hand often allows his left to use the crayon and make the nice friendly tabbies that everybody likes. But, as soon as the picture is finished, the right hand pulls the crayon out of the fingers of the left and draws a bigger cat, with a murderous glare in its eyes and ready to pounce on the nice kitty.' [80]

There is enough evidence from the doctors and nurses who treated Louis Wain, from his medical notes and, most telling of all, from the drawings which he did when a mental patient, to show that this piece is pure fabrication. Its origins are revealed in Chapter 19, 'Louis Wain's Illness'.

Wain's fame, and his ability to execute lightning sketches, often enabled him to avoid incurring some small expense. After the war, when he was very impecunious, he made full use of his talents in this way. For instance, one day he went into a chemist's shop in Farringdon Road and bought a box of lozenges. He then asked the manager to wrap the box so that it could be sent through the post – presumably he was doing one of his strange little kindnesses for a friend with a sore throat. By way of thanking the manager, he asked for a piece of paper, and drew him a laughing cat.

Another correspondent writes: 'In 1921, I was employed at the British Industries Fair at the White City. One day I was standing near an entrance turnstile when a man approached and gained admittance by a somewhat unusual method. Instead of tendering a business card or cash to be allowed in, he asked for a piece of scrap paper, upon which he made a rapid sketch which he solemnly handed to the attendant, who responded by allowing him to pass through the turnstile.

'Being employed there, I was on familiar terms with the attendant and when I asked him for an explanation of this odd occurrence he smiled and said "Oh, that was Louis Wain, he comes here every day". He then showed me the sketch – of an unquestionable Louis Wain cat. I caught sight of Wain several times during the Fair, and one day I invited him to tea, during which it did not take me long to realise that he was mentally affected.'

Most people whom Louis Wain met casually at this time (1918–1923) received a cat drawing and most, while remembering that he was a quiet, charming man, nevertheless remarked that 'he seemed a trifle odd'.

Above: A selection of the 'futuristic mascots' produced about 1914 (see chapter 12). This series is about 5 to 6 inches in height.

Left: One of the larger series of ceramic mascots decorated with 'Miaow miaow' notes. This one stands about 10 inches high.

Below: 'Hold on to me and Fortune will smile on thee'. Wain's motto for another design of a ceramic cat.

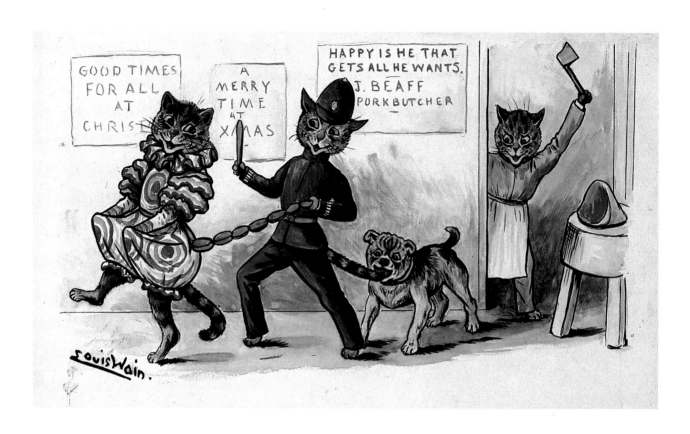

Above: 'Pantomime. We all get what we want.' Wain's chosen title to a bizarre illustration.

Right: 'Sleeping Beauty'. Designed for a Raphael Tuck postcard for New Year's Greetings, 1904.

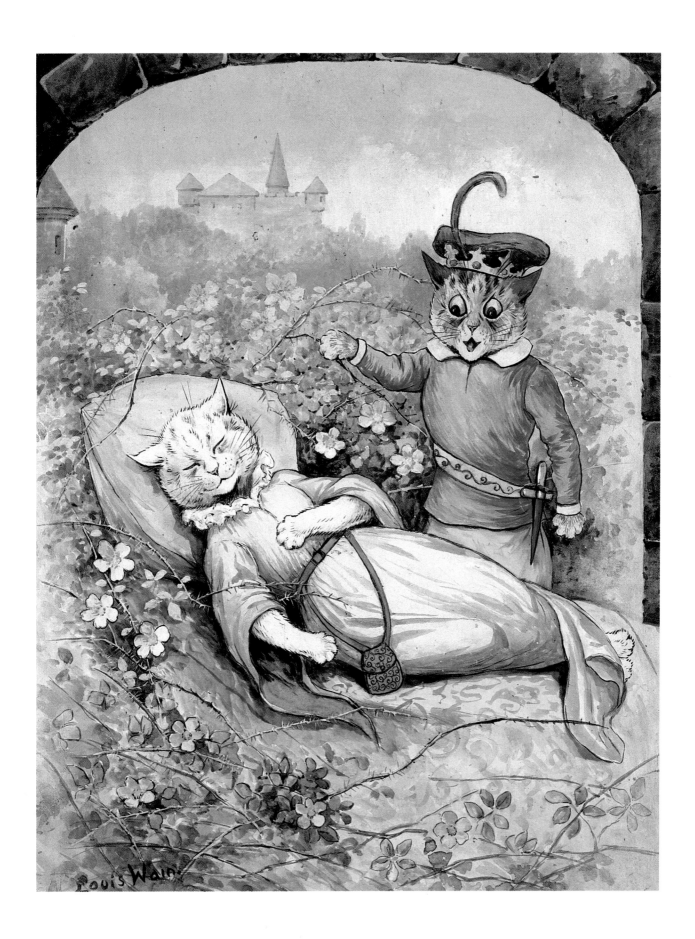

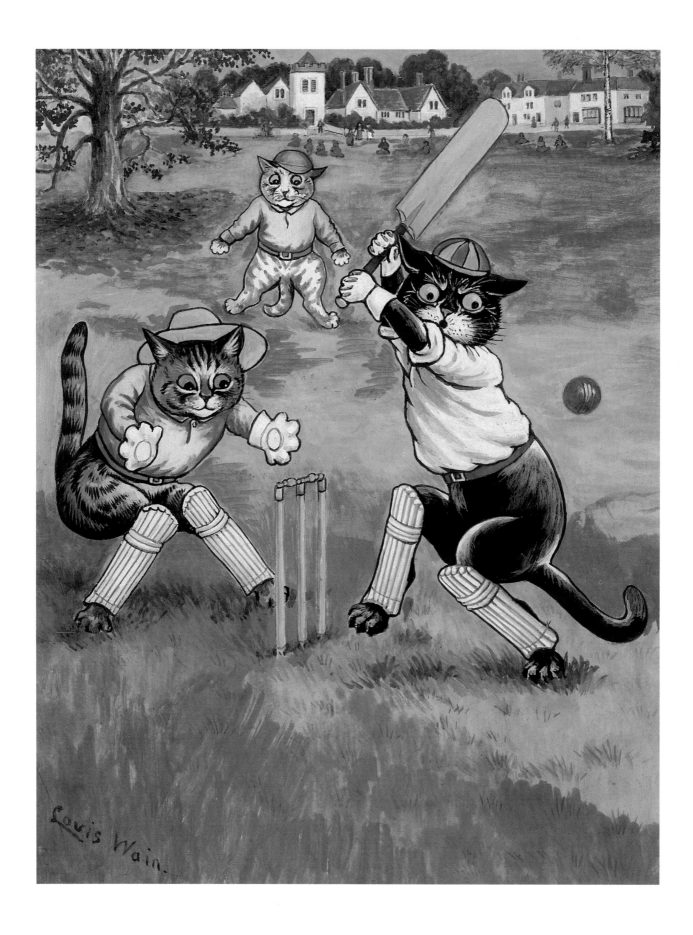

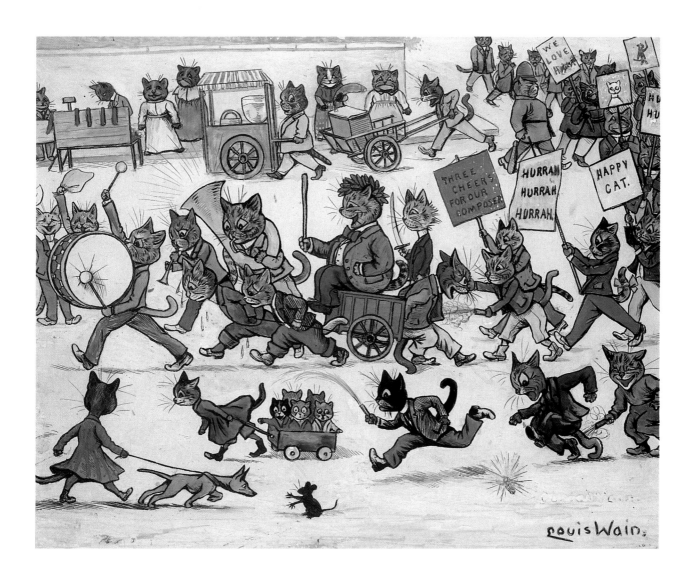

Above: 'Three cheers for our Composer' – who is presumably riding high behind the band in this action-packed street scene complete with refreshments, music and fireworks.

Left: 'Cats Playing Cricket'. Louis Wain's more naive style probably dates from his late period. It is unusual for the cats to be clothed.

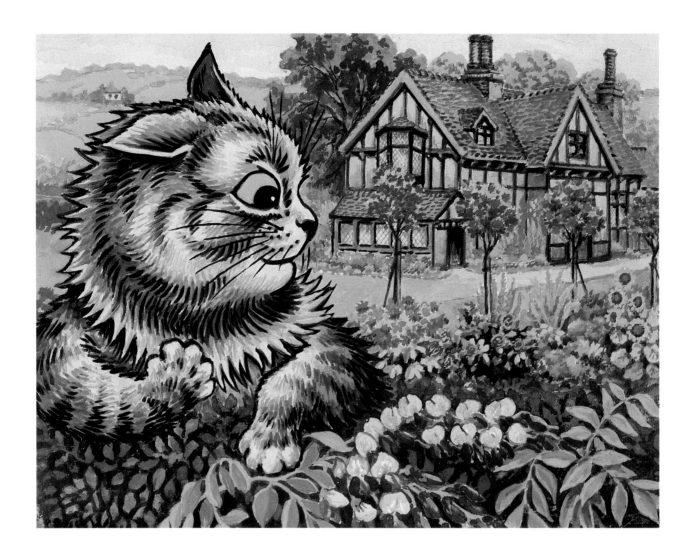

Above: 'Left in Charge'. A typically enigmatic title. A painting from the period of
Louis Wain's sojourn in Napsbury hospital, 1930–1939.

Right: 'Picking Apples'. Again from the Napsbury period and, like the picture
opposite, shows the usual half-timbered buildings and rich flora.

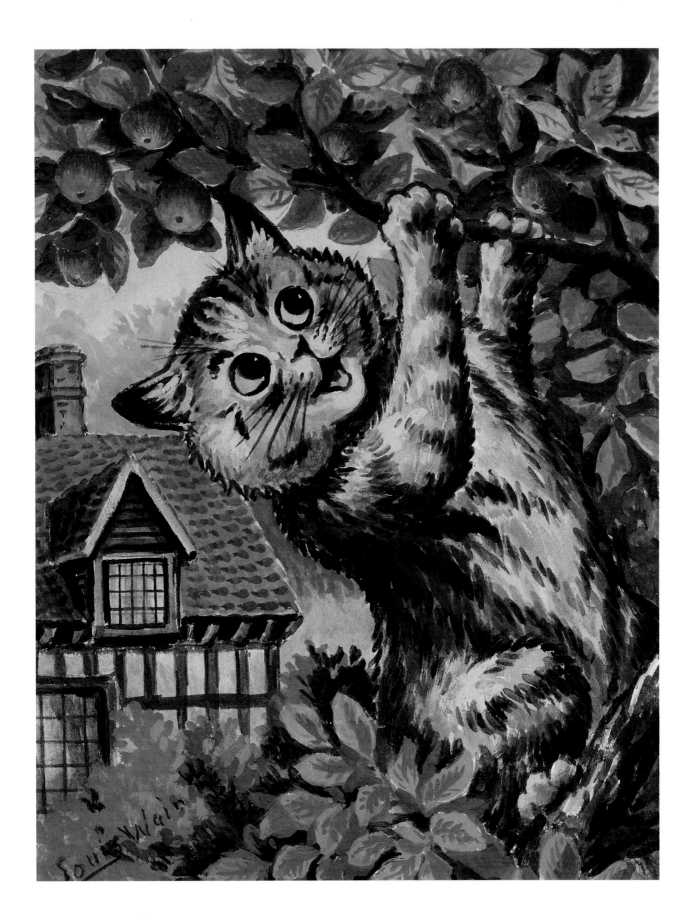

Often in the late stages of his life and illness, the artist drew highly coloured idealized landscapes. Here the botanical details are unusually accurate.

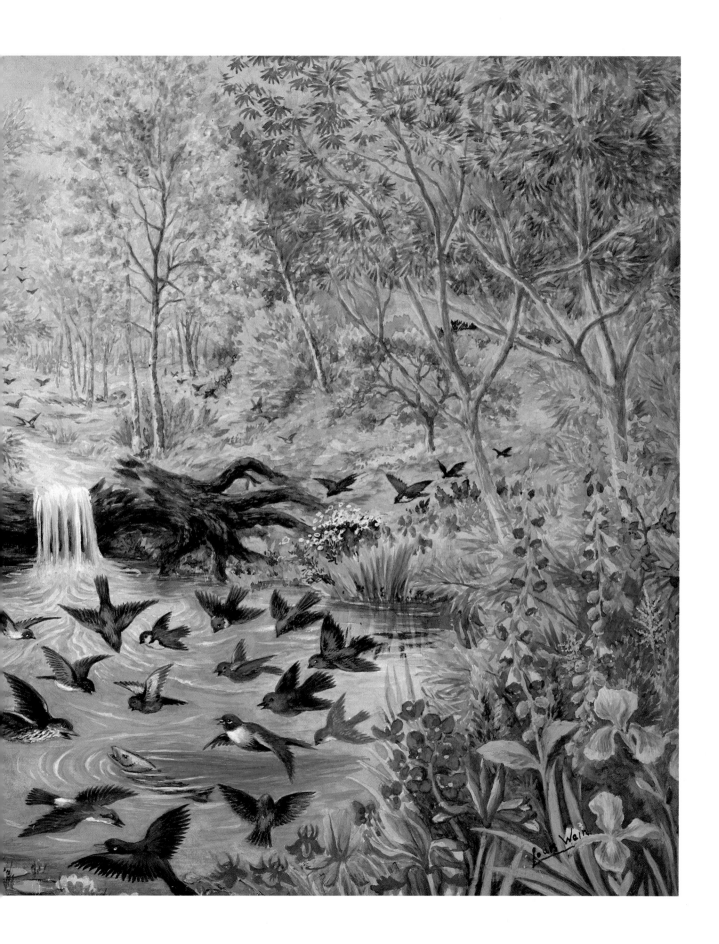

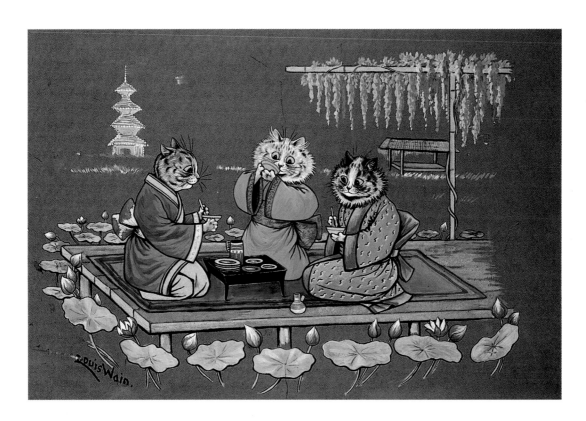

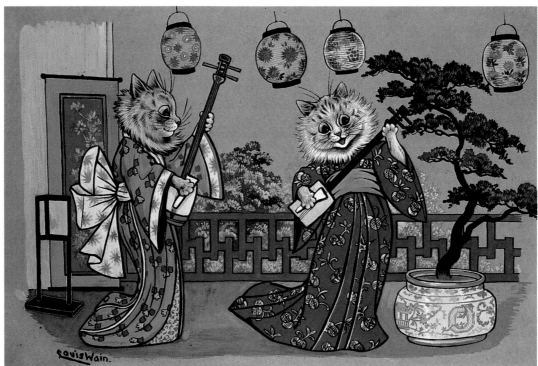

Top: Images inspired by the Japan–British exhibition, 1910.

Below: 'Land of the Rising Sun'.

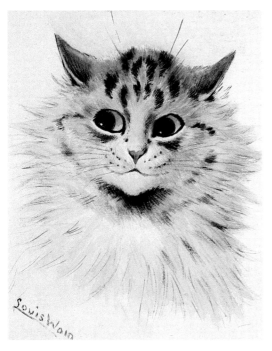

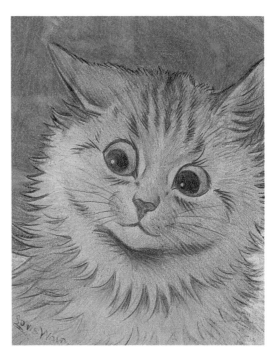

Inspired by the chinchilla kitten belonging to Her Royal Highness the Princess Victoria of Schleswig-Holstein. Louis Wain's cat portraits are unmistakable; one wonders what the owners thought.

Louis Wain often used crayon and pastel with great facility to achieve the soft colourful effects of his animated portraiture.

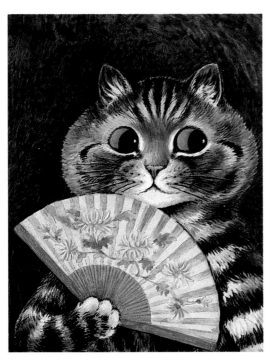

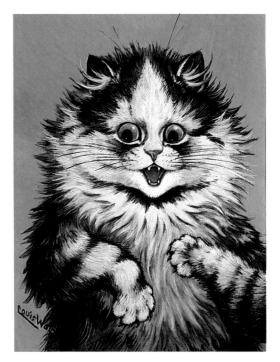

'A Cat at the Opera'. The attention to plush detail sets the scene perfectly.

Full of sound and furry.

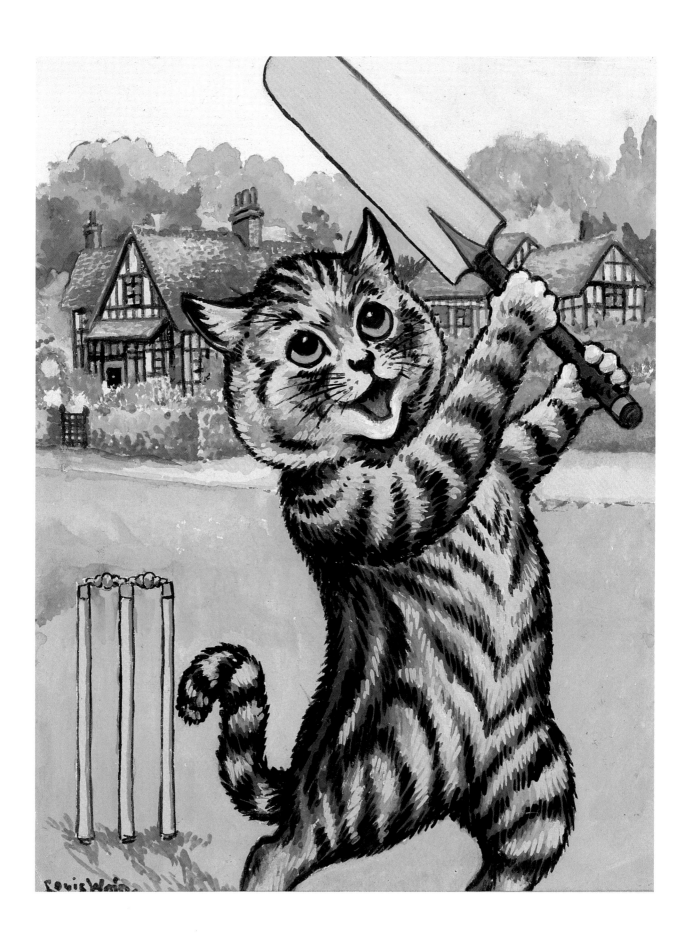

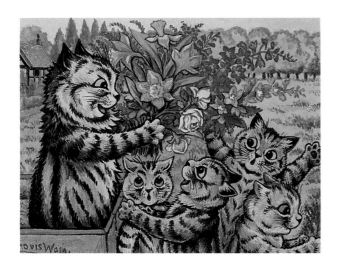
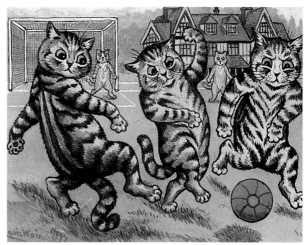
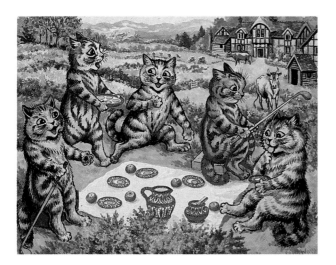
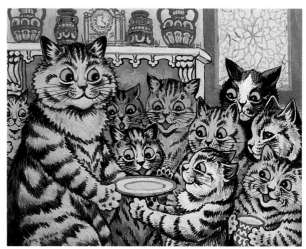

Above: Blue and brown tabby cats recur in the Napsbury images, with their bright colours, sharp design and stylized settings.

Left: Napsbury period pictures often repeated the popular postcard subjects of his heyday.

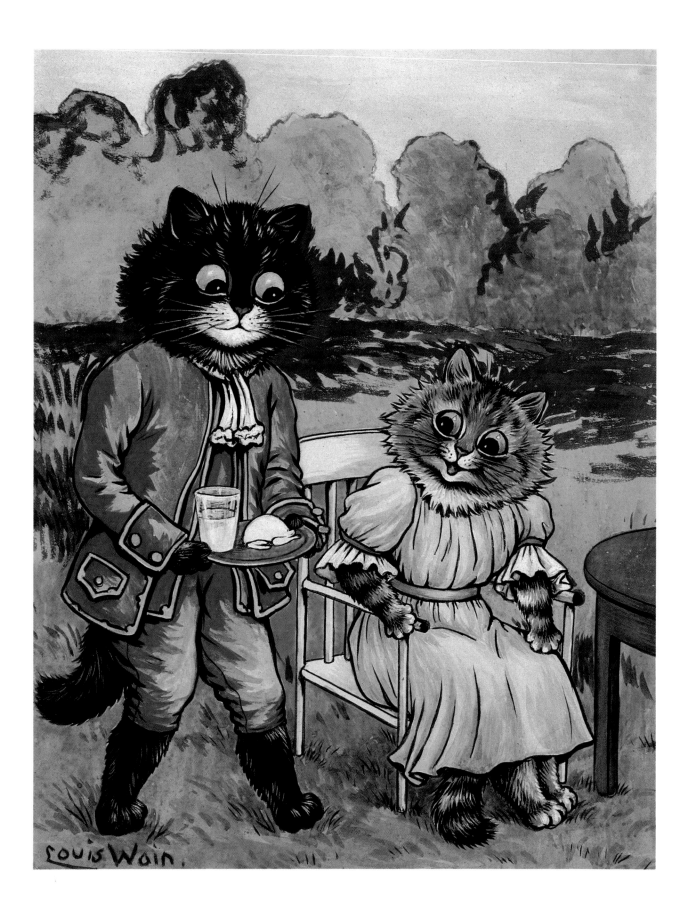

Louis Wain.

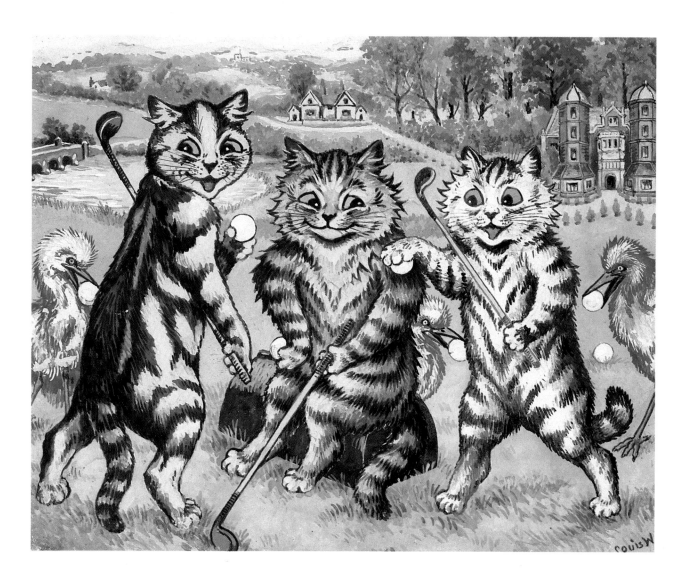

Above: 'A Game of Golf'. A long rambling inscription on the back is
characteristic of Wain's sad thought disorder.

Left: 'Kitty had no food but the lucky black cat brought some to her'.
Reminiscent of the contemporary illustration of the Camp coffee label.

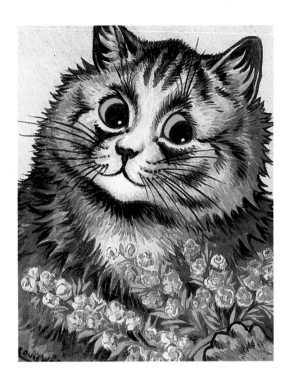
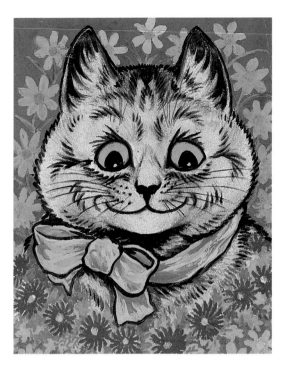

Wide-eyed cats and floral patterning.

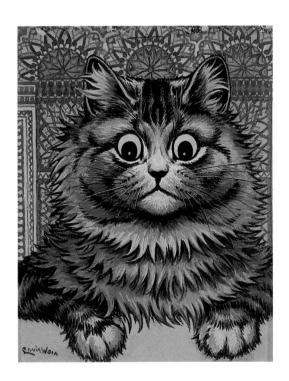
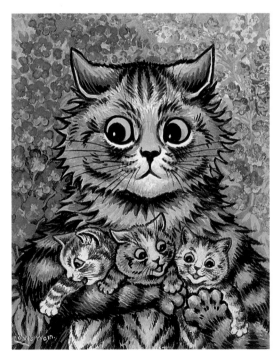

8

Letters

IN 1901, Hutchinson published *The Living Animals of the World*. [25] Such was the fame of Louis Wain that he was asked to write the section 'The Domestic Cat', and was accorded a place on the title page.

'Of the domestication of the cat we know very little', he began, 'but it is recorded that a tribe of cats was trained to retrieve – i.e. to fetch and carry game. In our own time I have seen many cats fetch and carry corks and newspapers, and on one occasion pounce upon a small roach at the end of a line and place it at its owner's feet. . . . It is quite a usual thing to hear of farm-cats entering upon a snake-hunting expedition with the greatest glee, and showing remarkable readiness in pitching upon their quarry and pinning it down until secured. . . .

'Watch your own cat, and you will see that he will change his sleeping-quarters periodically; and if he can find a newspaper conveniently placed, he will prefer it to lie upon, before anything perhaps, except a cane-bottomed chair, to which all cats are very partial. If you keep a number of cats, as I do, you will find that they are very imitative, and what one gets in the habit of doing they will all do in time: for instance one of my cats took to sitting with his front paws inside my tall hat and his body outside, and this has become a catty fashion in the family, whether the object be a hat, cap, bonnet, small basket, box or tin.' Here at least our own cats seem to follow the behaviour patterns of Louis Wain's.

In a lighter vein, also in 1901, and more im-

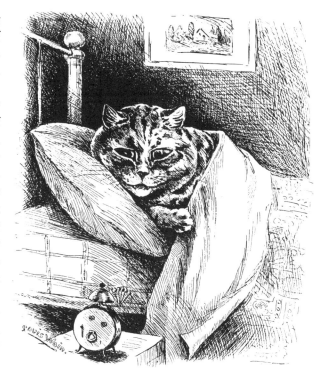

portant to Wain's popular reputation, Sands & Co published *Cats*, illustrated by Wain, and with verses by 'Grimalkin' ('pseud', as the British Museum catalogue coyly has it). *Cats* comprised 21 poems, each faced by a full-page line drawing. It was a very popular volume, and made a lasting impression on children who owned it.

Wain's main work of 1901, however, was the first *Louis Wain's Annual*. The *Annual* for 1901, edited by Stanhope Sprigg and published by Anthony Treherne, was a collection of stories by

many well-known people who were Wain's friends. The stories acted as a vehicle for some 70 Wain drawings, which had little to do with the text. Some of the drawings illustrate stanzas by Louis Wain himself.

It is not clear whose idea the *Annual* was but, judging by its production in the following years, and by the design of its cover, it was a hurried effort. But however, it came into being, it was a huge success, and further increased Wain's fame. It continued to be published annually for many years, and although it hardly seems to us to be a children's book, it was an eagerly awaited Christmas present by thousands of children who 'marked the years by its appearance'.

On the publication of the first *Annual*, Louis Wain was visited by a reporter from the *Daily Express*, who wrote that Wain was 'not in the least like what most people would expect him to be. He is a quiet, rather sad-faced man with a singularly charming manner. As one would suppose, he is a great lover of cats and never ceases studying their individual characteristics with the greatest care.

'He loves cats and cats love him, and he is often to be seen wandering about the beach at Westgate-on-Sea, where he lives, with his four cats quietly walking behind him. He is now busy preparing for the great "Cats'-meat Dinner" at which he will take the chair. He did not start life as a cat artist. He was really intended for a musi-

cal profession, and it is said that he has composed a delightful opera, which will one day be produced in the metropolis.

'He does not keep a cats' home, though people often write to him for advice in dealing with an ailing cat. As a matter of fact, he says that pet cats seldom ail. It is only when they are kept in large numbers that disease begins to show itself. He has drawn nearly ten thousand cats in the last sixteen years, and as a cat artist of humour he stands alone.'

There is no doubt that fact and fancy were constantly mingled in Louis Wain's mind. What he would have liked to do, what he had done, what he thought he had done, all became intertwined until it was impossible for anyone to make out whether what he said was true or not. He certainly did not make things up for fun – he really believed that what he said was true.

In 1902, for instance, he reported that he was 'doing a series of political cartoons for *The Rambler*. Numbers 1 and 2 represent Winston Churchill and Sir Michael Hicks-Beach respectively.' How interesting that first cartoon would have been. And yet, *The Rambler* had ceased publication, after 102 issues, two years earlier. (There was another publication called *The Rambler* at this time, but it was an esoteric continuation of Dr Johnson's publication of the same name. There are no cartoons by Louis Wain in it – nor, for that

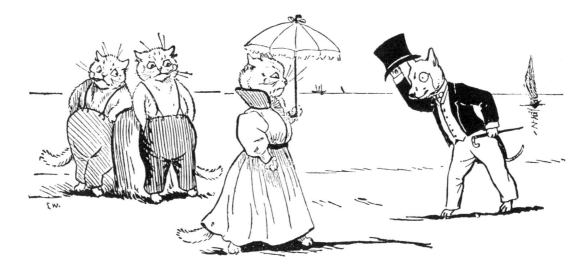

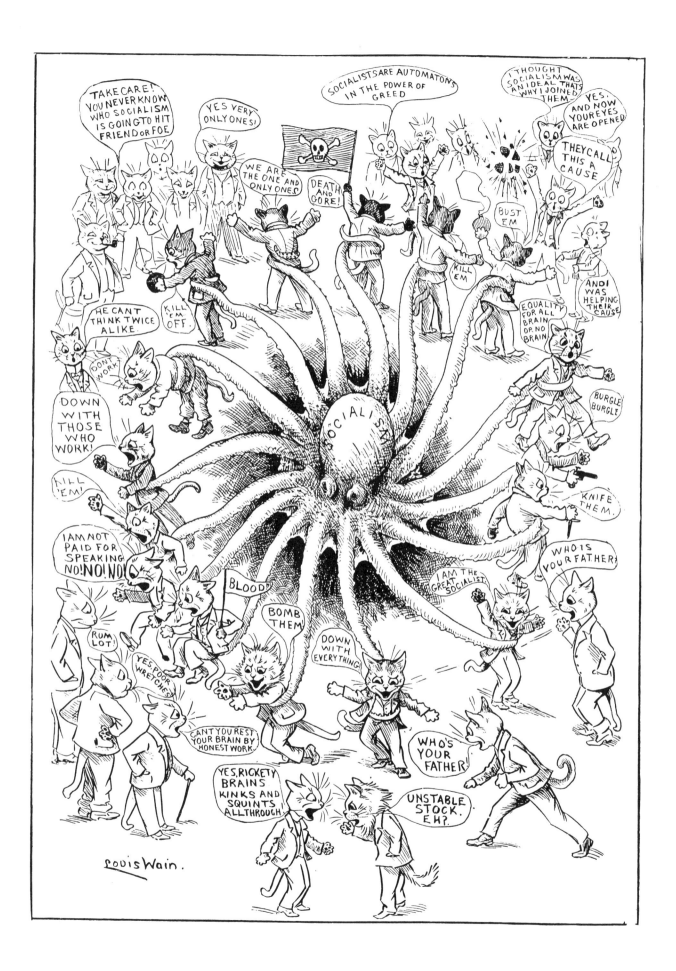

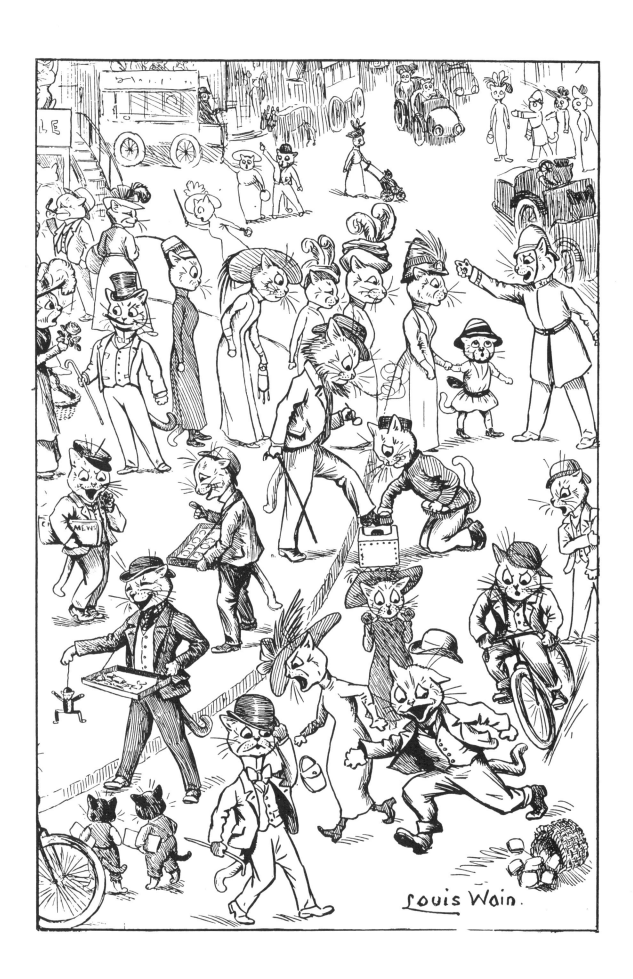

Louis Wain.

matter, by anyone else.) It is clear that Louis Wain dissipated a great deal of energy in making drawings which he sent out to non-existent or defunct addresses, for he mentions more than once that his drawings have come back marked 'not known', or 'insufficiently addressed'.

1902 saw the publication, as a five-part serial in *The Lady's Magazine*, of 'The Kit-Cats', written and illustrated by Wain. [26] This may have been the 'humorous story' which he was writing in 1895 – I have found no other – and he included it in his *Who's Who* entry from 1904 onwards, so he must have been proud of it. It is quite entertaining, but gives the impression that it was evolved rather than planned.

Later in 1902 the *Morning Post* [27] published a remarkable letter from Louis Wain headed 'The Doomed Empire', given in full in the Appendix. This interesting example of his writing covers a remarkable train of reasoning, starting with Free Trade, and ranging through Our King, irregular eating habits, the delicate nature of the cat's brain, the tactics of the Boer War, and then rapidly back through these topics, all as an explanation of how to avoid the Empire's becoming Doomed. Its significance is discussed in Chapter 19.

Louis Wain wrote to the press from time to time, usually in indignation about something, and calling for a body to be set up to right the wrong. In 1905, for example, a Mr Horniman complained to *The Times* that, when he lost a dog, he was unable to gain access to the Battersea Dog's Home easily and, when he did, he found that the dogs were all jumbled up regardless of their sex and state of health.

Louis Wain replied: [32]

Mr Horniman's complaint concerning the management of the Home for Lost Dogs, Battersea, might be extended beyond the scope of the actual home itself, and include the necessity for cleaning the nooks and corners of our streets. It is the foulness of these spots which leads many well-behaved dogs astray from place to place, and no attempt is made to disinfect or clean them. There would be less distemper and skin disease rife in the doggy world, and it would free the Dogs'

Home of one of its most difficult problems, and there would also be a lessened chance of hydrophobia, if this matter were properly attended to by the County Council, or some organised body of sufficient importance in conjunction with County Council aid.

There are doubtless many among the shopkeepers and others in London who would help subscribe towards a fund for the purifying of the streets if they could rely on a regular service being in attendance throughout the year in their several districts.

I am, Sir, Your obedient servant.
Louis Wain

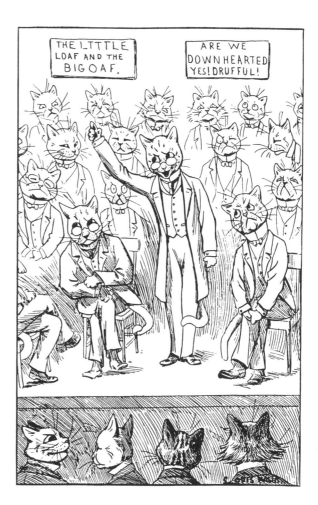

In 1907, his cause was the 'Child Hawkers of Ludgate Hill': [34]

There is no part of the country at this season of the year [Christmas] which is not overrun by singing

troupes of children belonging to classes of the people who should be ashamed to send their children out on what is simply a veiled begging-errand. These same children, too, are perpetually knocking at our doors asking for money towards some snowball or other subscription, producing cards, which have to be signed or punctured for every subscription given . . .

The child with its little tray of goods and handful of money is safe on Ludgate Hill under the guardianship of the police, but directly it returns to the zone of poverty its little tray is filched of its remaining stock, or its weak little fingers are wrenched apart, and its hard-earned capital and profit is stolen by a stronger child than itself if it is a novice at hawking. Once it has learned its lesson it degenerates to the level of its hardier tribe, and in sheer self-defence preys upon those weaker than itself. East-end life is fraught with dangers to the children of the streets, and breeds a race of ne'er-do-wells who are arrant cowards, or fighters who are without morals, from sheer necessity; bullies who lord it over the courts and alleys levying blackmail openly upon the more respectable members of the poor.

The question is one for larger treatment than the City police have authority to undertake. Those who work to regenerate the slums would like to see the poor safeguarded in their homes and pocket, as the city police safeguard the children of Ludgate Hill while under their eyes, for it would make the work of regenerating child life much more practical.

A few sharp police Court examples are of no use against the hooligans; the work must be organised and systematic, and at the same time give confidence to the poor that they are not to be protected to-day and be left to the vengeance of the bully some time in the future.

I am your obedient servant
Louis Wain

These letters afford an interesting glimpse of London at the turn of the century. It is also interesting to see that Louis Wain was not so shy and withdrawn that he knew nothing of what was going on around him – neither was he afraid to bring injustice to the public notice. He turned his thoughts and pen to many problems of the day, and remembering his sporting youth continued to take some interest in the Ring.

In 1911, he called for a Board of Boxing Control: [39]

It does not seem to be logical that the average man who is not a physical giant should not have given to him a means of defending himself against the brutalizing side of humanity, and in fact it is not only the ability of the average man to put up his fists if called upon to do so which saves him from the bully.

You are not going to put the bully in his place by moral suasion only. If you allow him by force to brutalize the weak in the daily walks of life you are going to weaken the power of moral suasion which belongs largely to the physically weak. Is it not, then, wiser to accept the logic of circumstances and endeavour to control the conditions surrounding the boxing ring than to endeavour to stamp out a noble art? . . .

If Lord Lonsdale, whose word is all powerful in the boxing world, would lend his support to [the proposal that there should be one code of rules] there is no reason to doubt that it could be successfully carried through, and professional boxing would then benefit immensely from the change both as a science and as an art of self-defence . . .

It is certain that if such an organisation as I have indicated could be brought about many opponents of boxing would become its best friends, and many good sportsmen would join with Lord Lonsdale in his consistent endeavour to keep the noble art of self-defence clean.

> I am your obedient servant.
> Louis Wain

Two years later, after the Wells–Carpenter fight, Louis Wain appealed to Lord Lonsdale again: [46]

. . . We are at the parting of the ways. On the one hand we have the relics of the trickery of the old-time ring and all its unsavoury fake fights, cunning fouls, and trickery, its public scandal with all its attendant evils; on the other hand we have the National Sporting Club struggling for better things but apparently powerless to make its influence felt beyond its own body, by the very reason that it cannot sufficiently awaken public interest in its doings beyond its own sporting *clientele* . . .

A great deal has been talked about a boxing control, but without the authority to act from some organized body it would carry no permanent weight. Lord Lonsdale has done so much practical good in the boxing world that one always looks to him to take the initiative where its interests are at stake, but one cannot expect too much from him until the question of the future of profesional boxing has been thoroughly thrashed out on its merits with a view to paving the way for the establishment of an association whose power would be felt wherever the love of clean sport is paramount.

> I am, Sir, your obedient servant.
> Louis Wain

9

The National Cat Club

THE WINTER of 1902–1903 was a trying time for Louis Wain, President of the Committee of the National Cat Club. At the end of October, the honorary secretary and treasurer of the Club resigned 'for the third time', as she 'could not do justice to the Club' nor to her family, nor to her own health, by remaining. On Saturday 3 January 1903, a general meeting of the members of the NCC was held, ostensibly for the purpose of electing a new secretary and a new treasurer, but the proceedings show that the state of affairs was very awkward and worrying.

The previous hon secretary and treasurer had been repeatedly asked to hand over the books, membership list, accounts, and moneys due, but had not done so, and there seemed to be no way of getting her to answer the committee's repeated requests that she should do so. During the last NCC show at the Crystal Palace she had been 'in great distress with two or three physicians in attendance . . . and worn out with anxiety.' She had said that there was a man on the committee who was her inveterate enemy, and who had persecuted her for years. She had said that the Club had deficits year after year, and that the committee made no attempt to wipe them out, but had left her to finance the Club as best she could.

The charges and implications were discussed and refuted, new officers were elected, and the meeting drew uneasily to a close. Towards the end, the chairman, Louis Wain, said: 'When the committee get in proper working order, you will find the work done in a very public way. We have

nothing we wish to hide, and we are likely, under these circumstances, to bring all the different catty interests in harmony, and we shall be able to work together not only for the cat and the good of the Club, but for the good of us all.' It seems from the reports of the proceedings that, although Louis Wain expressed himself in his own inimitable style, he was nevertheless a fluent and commanding chairman.

Hardly had this difficult problem been dealt with, than the question of the amalgamation of the Cat Club and the National Cat Club arose once more. A voting paper had been sent out by the Cat Club asking for an 'aye' or 'no' to amalgamation without any reasons being given for it.

Louis Wain was very much against amalgamation, and said that 'in answering [the questionnaire, the majority] simply voiced the general wish that the troubles which have distracted the cat world for the past few years should come to an end – *this and no more.*

'Recent events have proved that the NCC has, for the past year or two, been at the mercy of any opposition, but the strongest opposition has proved itself weaker than the NCC itself has been. There is no actual merit in holding cat shows: anyone can do that by paying for it. The mere holding of cat shows alone is no valid reason for the existence of any club which invites the patronage of the great, and works under the aegis of a powerful social prestige. We are pretending to help the cat, to foster honesty and fair dealing in catty matters, to hold ourselves up to

the world as the judicial authority in all matters pertaining to catty interests. It is because this has not been properly undertaken by either club that both have become embroiled in the pettiest of small quarrels. In consequence, the NCC having

at last forced itself into order, is to be asked to weakly plunge itself into the mire again. . . .

'The committee of the NCC have set themselves a task which all have entered upon in the best spirits and goodwill and, personally, I do not

intend, as the oldest authority in the Club, and after twelve years of experience and waiting, to lose the opportunity of helping to solidify and work into practical shape the many ideals which our best friends have hoped, and worked, and wished for.'

In a lengthy and detailed reply, the spokesman for the Cat Club was 'sorry indeed to be in opposition to Mr Louis Wain. He is one in whom all catty folk take pride, and for whose genius we have a genuine admiration, but many of us venture to differ from him in club management.' One cannot help feeling that Wain must have put up with a great deal for the sake of the cat kingdom, for it is certain that the prestige of leading the NCC meant little to him. His reply to the Cat Club showed that there was no doubt at all in his mind that the NCC was *the* Club; he said so in no uncertain terms.

The trouble within the NCC, and between it and its competitors, was not confined to the season just discussed. It had happened before, and would happen again. At the beginning of 1901, for instance, Louis Wain had waxed indignant at the Silver Society, 'a very young society, and its officials have not yet been put to the test of stability. It has had no place in establishing a breed of cat, in fact, it has done nothing at all for the cat itself . . . it is really at present only an abnormal mushroom excrescence, as it were, of the parent clubs.'

Towards the end of this letter, Wain once again reveals his altruistic view of the Club. 'The National Cat Club was formed to advance the interests of the cat, and not the interests of individuals, and to foster and encourage all that pertains to the building up of a really stable and permanent animal.'

In 1908, Wain took up his pen against the proposed Cat Fanciers' Association. He was astonished that an attempt had been made to set up yet another body in opposition to the NCC, for the NCC 'has been accepted in and outside the cat world as the judicial authority of the cat world, and once that original authority is destroyed, none of your clubs could take its place, because in all my experience of the cat world, I have not found one club that is above sordid motives, and the letters which have appeared in the fanciers' papers from those to whom the new association proposes to give the power of judicial authority have not shown the necessary judicial clearness and lucidity to warrant the confidence that they know what they are about in struggling for yet another weapon to use against the reigning Club.

'. . . The NCC, despite all its many vicissitudes of fortune, still remains the only club which can hold the cat world together or give it any authority in the eyes of the world.' Finally, Louis Wain hints darkly that he is going to fight this question, but in a different spirit, because he had 'lost confidence in the ability of people to understand even the simple rudiments of what is required of them in public life.'

Time after time, he was faced with the possible growth of rival organisations, time and again he pointed out that the NCC was *the* Club, without which any other would be nothing. He saw competition as a threat only because it diluted effort and debased the very high standards which he was trying to uphold.

10

The Annuals

IN CONTRAST to Louis Wain's stern champion-
ing of the cat in the adult world was his playful
treatment of it for the benefit of the children. In
1902–1903, his output of illustrations for chil-
dren's books rose sharply; 1903 was his peak year.

His first association with the firm of Raphael
Tuck seems to have been in 1902 when he illus-
trated *Pa Cats, Ma Cats and Their Kittens*. This was
a large book of cat drawings, with Victorian joke
captions. It proved very popular and, like *Cats*,
made a great impression on many a juvenile
mind.

James Clarke published *The Louis Wain Nursery
Book* that year, and it was reviewed thus: 'Mr
Louis Wain, whose cat studies interest the old and
amuse the young, has been preparing a "Nursery
Book". It will be waiting at the booksellers for the
children on their return for the holidays. And
how many happy hours it will afford for the dark
evenings! Though mainly about cats, this
Nursery book is not all about cats. Mr Wain gives
us a fair proportion of the animals that inhabit
the zoo in his new book. In inimitable attitudes,
too! Every cat, dog, mouse, or even hippopota-
mus seems to be doing something.'

Another review said: 'Louis Wain's cats have a
world-wide reputation . . . he can draw owls,
mice, cockatoos and all the animals of the Zoo, in
an equally irresistible manner. He has also
invented a Louis Wain fish, unlike any marine
monster hitherto known to science or imagin-
ation. He is the children's Tenniel, and this book
alone would prove it.'

In its second year, *Louis Wain's Annual* had as
impressive a list of contributors as before. The
cover design is somewhat more pleasing, except
for the apparent after-thought which led to the
addition of the words 'for 1902' to the design. It
contains a column written by James Boiteux,
Louis Wain's uncle – 'The Young Man Lodger'.
On the same page is a poem by Louis Wain:

THE BRITISH WORKMAN

Oh, for the brave old British workman
With his great, jolly heart of oak;
His splendid way of looking at things,
His propensity to soak!

Oh, for the long time he spends in thought,
For dear "Uncle's" care of his tools
The work he makes for his plumber pal
And his lofty contempt for fools.

59

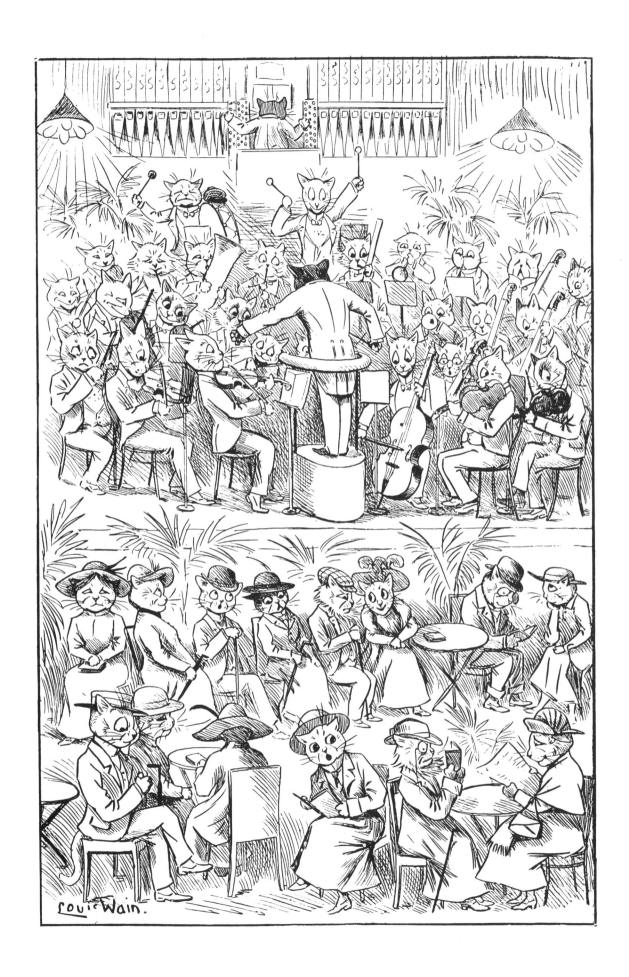

Another poem in the *Annual* also shows Wain's wit, and his perception of a world quite different from his own:

THE CARES OF FAMILY

Of course, I'm indoors,
　Anchored to the family;
Of course, it's the needlework,
　Making a dress for Emily.
Of course, there's Tommy's medicine,
　And Billy's but a kitty.
Of course, it's most important,
　This business in the City.
　　It always is.

But I know where the shoe pinches –
　It isn't only lobster salad
Which goes down to posterity
　In a music-hall ballad.
Where does that smoky coat come from?
　Ah! That is the rub.
And that terribly unsteady footstep?
　I know! It's that club.
　　It always is.

One is immediately struck that Wain has not flinched from using the name Emily here. It would probably be making too much of the poem to point out 'hidden significances', such as being 'indoors, anchored to the family', but it does no harm to read the poem again and speculate for a moment. 'Notes upon books out-do the books themselves.'

Louis Wain's last musical activity of note was in 1902. *Who's Who*, noted that he was 'Hon Secretary to the Earl of Mar's Coronation March Song Competition Albert Hall Concert' in that year. He was certainly an ardent admirer of royalty, and this activity may have been the contribution to the Coronation festivities which he felt he wished to make. He added 'music' to his list of recreations in *Who's Who* in 1903, where it remained until 1939.

We would all like to know more about the Earl's competition, but there seems to be no more to be found. *The Times* carried several critical reports on various pieces of music which had been composed for the Coronation, but there is nothing to

help us there. However, it was interesting to learn that every loyal subject was 'graciously permitted' to stand at 8 pm on Coronation Day and sing the National Anthem.

Louis Wain's peak year for illustrated children's books was 1903. No fewer than 11 appeared, eight with the name 'Louis Wain' in the title. This alone is some measure of the 'draw' of his name. Collins published *Kittenland* and *Comic Animals ABC*; Tuck published *Big Dogs, Little Dogs,*

Cats and Kittens, With Louis Wain to Fairyland, Louis Wain's Cats and Dogs, Louis Wain's Dog Painting Book, and *Louis Wain's Cat Painting Book*; Clarke published *Louis Wain's Baby Picture Book* and Treherne *The Louis Wain Kitten Book*. *Louis Wain's Summer Book* made its first appearance; but this book and the third *Annual* were now published by Hutchinson.

It is difficult to estimate how much Louis Wain was earning at this time. Owing to his dislike of bargaining, and failure to retain any reproduction rights in his work, the moneys he received were but a fraction of what he could have commanded. He still had his mother and four sisters to support and the house at Westgate to keep up, though he never paid a penny of rent in hard cash. A lady who knew the Wains in those days – her father was an artist friend of Louis – recalls how 'Louis' sisters were proper old maids. Apart from the fact that they weren't very good looking, their main peculiarity lay in the way they dressed. Louis used to buy them second-hand clothes and make them wear them. But they were a united and contented family, though rather a joke with the other Westgate residents. The girls didn't go out much, and never went away for a holiday. This was probably because they couldn't afford it, but even when they were in the most

straitened circumstances, Louis used to go out and buy knick-knacks for the home.

'He used to love dancing, and would go to the Tennis Club dances all dressed up in white tie and tails, but he couldn't dance for toffee. The family were quite musical, as many families were in those days. One of the girls played the violin, and of course Louis played the piano. They were very nice people.'

Louis Wain had some notion of how the people of Westgate felt, for he later wrote to a friend: 'If I send you a frock coat suite, do you know anyone who would care for it in your district, if so, let me have word, and I will send it on. People down here are too well off, even the fishermen, to take it, and clothes down here get moth eaten with damp even in one winter.'

An example of Wain spending money he didn't have on non-essentials was the notepaper he had, diestamped in red, proudly showing the telephone 'No. 1 Westgate'. However, when his first

batch of notepaper ran out, he thought better of ordering a further supply. We can guess what must have happened to the telephone.

Through the *Annual*, Louis Wain had met a Mr Chesney, who became a good friend and for many years helped him with the production and distribution of the *Annual*. Wain's letters to Chesney afford another valuable insight into his character.

Hutchinson having published the *Summer Book*, Louis Wain is now preparing for the *Annual*:

Oct 9, 1903

Dear Mr Chesney,

I hear that, you are in with Hutchinson's now, & hope that it is permanent. Can you again send me the addresses of the stall men you sent me before. Some I sent to, but the others I lost the addresses of & could not do so, I hope one day to see you, there is something bigger than the *Annual* coming off, but this is private. It will help you.

Kind regards,

Yours very Truly,
Louis Wain

As we have seen, Louis Wain was not very good at keeping his affairs in order, and addresses were always getting lost.

Here also is a hint of his 'success just around the corner' attitude – 'something bigger than the *Annual*'. It seems that he must have soon met Mr Chesney, and reveals his secret private venture – postcards.

Nov 3, 1903

Dear Mr Chesney,

Am doing the drawings right off. By the way, suppose I printed a series of postcards myself, do you see any chance of running them partly?

Yours Truly,
Louis Wain

Nov 6, 1903

Dear Mr Chesney,

Keep the postcard business very quiet, it may turn out something good. When will you be in town, I will try & meet you when you are.

Yours Truly,
Louis Wain

How are Hutchinson's treating you? & do you know any of their travellers.

Treherne's are doing a Kitten Book (Dumpy Book)

The British Museum copy of *The Louis Wain Kitten Book* is dated 3 November, so it must have been published by the time this letter was written. Although the authorship of the verses is not explicitly stated, there is little doubt that they are by Louis Wain. It is the only book which he wrote and illustrated all himself. It is three inches square, and contains a number of couplets each referring to a picture opposite. It opens:

The kittie plays the fiddle and the frog begins
 to dance.
This curious sight we sometime see in the
 pleasant land of France.

Next:

This is how they cake-walk in baby-kitten land.
It is very very clever if the ground is made of
 sand.

And finally:

> We'll sing a song of threepenny bits and you
> can keep the change
> You can take the high notes, and the rest we
> will arrange.

For some reason, I find this little book one of
the most charming of Louis Wain's works – it is
probably something to do with the haunting fasci-
nation of those strange verses.

Meanwhile, Louis Wain worked on, though not
with tremendous success, as his next letter shows.
This, by the way, was the occasion on which he
tried to dispose of the 'frock coat suite'.

Dec 7, 1903

Dear Mr Chesney,

I sent drawings to all but three Waterloo people &
these I did not do because my stiff paper ran out. The
Holborn man drawings came back insufficiently

addressed J. Looker Homelands London Lane on the
back of the drawing is written 'not known at London
Lane Hackney' . . .

Yours very Truly,
Louis Wain

Am leaving the postcard business till after Xmas.

As it turned out, the 'postcard business' was left
for ever. Although Louis Wain doubtless thought
that he could make a lot of money by privately
printing and selling postcards, it is certain that he
was not the man to make a success of such a
venture.

The year 1904 started with another piece of
incompetence, but with high hopes for the
future:

January 30, 1904

Dear Mr Chesney,

I have again mislaid the addresses of the Waterloo

station men can you send them to me. I have got my original drawings back from Hutchinson's.

I shall have something good and permanent for you sometime this year I think I will try and again get you the 'books'.

Did you give out the last drawings in the books you sent?

Yours Truly,
Louis Wain

In the meantime, however, Mr Chesney had been having some trouble with another publishing house, but Wain consoles him in a rather 'small boy' sort of way:

Feb 2, 1904

Dear Mr Chesney,

That is characteristic of 'those publishers'. However you will have something very much better than they can give you sometime this year. Yes, by all means, send any names you like and I will send to them. No one knows of the bookstalls. It is building up for some-

thing bigger, the 'Annual' and the 'Summer Book' contracts may be signed this month.

I am rather close up this month or I would send you a present in money, but I must wait a little longer, both the 'Annual' and the 'Summer Book' will work into very big things of themselves and be worth all the trouble taken over them.

[Those publishers] did not advertize to any extent or they would have had a very big run. Nothing goes big without advt.

Yours Truly,
Louis Wain

Forgotten to post this.

It is indicative of the way in which Louis Wain was exploited that, with at least a dozen of his very popular books current, he should be 'close up'. His complaint to Chesney that certain publishers 'did not advertize to any extent or they would have had a very big run. Nothing goes big without advt.' is one of the very few occasions

when Wain hints that any lack of success was someone else's fault, and, of course, he may well have been right in this case. It is to his credit that he seldom complained about hard times or failures, and even less often blamed someone else for them. In spite of addressing things wrongly, even when he did not lose the addresses, he was always optimistic that things were going to go well in the future.

In 1904, Partridge published *In Animal Land with Louis Wain* which carried on its introductory page a picture of the artist, looking far younger at 44 than he did at 30. Beneath this photograph is an interesting introduction, which reads:

'Come boys and girls, short and tall; lads and lasses big and small; dark and fair, merry and – no, not sad at all; for none of you are glum I'm

There was no *Summer Book* and no *Annual* in 1904. In spite of his expectation of signing the contracts, he had a disagreement with the would-be publishers and so the books did not appear. Publishers must have found it very difficult to work with Wain, for the 16 *Annuals* and two *Summer Books* were handled by six different publishers, never the same more than twice running. This is all the more astonishing when one considers that the *Annual* was a potentially lucrative publication.

Louis Wain was associated wholly or partly with the illustration of some 200 children's books, produced by more than 40 different publishers, not counting those who produced many of the magazines and periodicals for which he illustrated. Quite a feat!

sure! Come, let me introduce you to Mr Louis Wain – "The man that draws the funny cats". But he can draw more than cats, as you shall see when we go out on our journey through Animal Land. We are to travel with him to places where grown-up people seldom go, but where little ones are always delighted to be taken; places where all sorts of animals do the most unlikely things. And, do you know, it's just the unlikely things that you are likely to like the most. Mr Louis Wain is to draw with his pencil the funny things that happen in Animal Land, and I am to tell you about them in plain words and in rhyme. And you? Oh, you have to do the laughing! That's quite fair, I think; so off we go!' So off we go, though Animal Land, where most of the animals somehow seem to be cats after all.

In 1905 the *Annual* was published by King, and carried none of the adult stories of previous years. The 'signatures' were printed in green, red, blue and brown, and the whole effect, of drawings only, printed on a better quality paper than before, was much more appealing. Concerning this *Annual*, Wain wrote;

Nov 18, 1905

Dear Mr Chesney,

I have given P.S. King & Son your address in case you are free to travel and Bookstall the Annual, about town. I told them 30/- a week and said I did not know what you charged for travelling expenses. If you are free I hope that you will get it.

Yours Truly,
Louis Wain

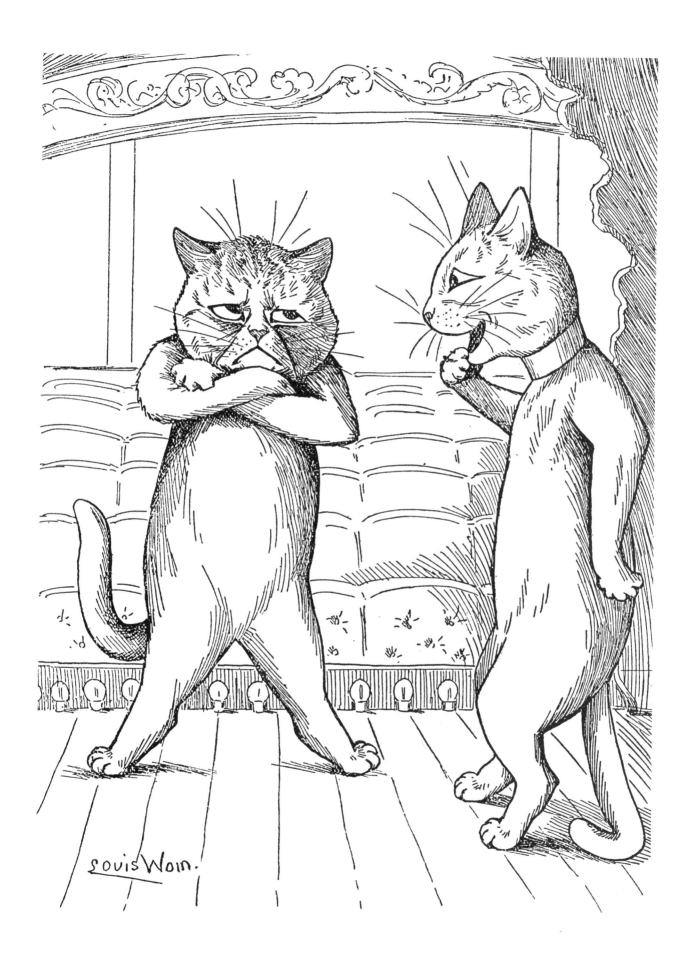

Evidently, Chesney did 'get it', for Wain wrote to him again, from the Golden Cross Hotel, Charing Cross, where he stayed in London:

Nov 29, 1905

Dear Mr Chesney,

Would it be possible to meet me tomorrow at about 10 to 1 at King's, downstairs, at the entrance. Don't trouble if you have a round to go, only I should like to have a chat about things. Sometime. I shall not wait long, but will probably go upstairs to see Mr Hulbert. He says that he has not seen you since you started. We might lunch together.

Yours sincerely,
Louis Wain

Hulbert, it seems, had taken the *Annual* in hand, realising that its appeal lay primarily in Louis Wain's drawings. He also had an eye for publicity and took advantage of sending copies of the *Annual* to some of Wain's royal admirers. Wain was very pleased with Mr Hulbert's approach to selling the *Annual*.

Dec 8th, 1905

Dear Mr Chesney,

The Queen has accepted a copy of the 'Annual', and so also has the Princess Victoria of Schleswig-Holstein, Princess Christian's daughter. The Annual is going well, and King's are very well satisfied with your work.

Yours Truly,
Louis Wain

The output of Louis Wain books in 1906 dwindled still further; only a *Summer Book* (his second and last) and an *Annual* were published.

April 7, 1906

Dear Mr Chesney,

King's have still something owing to you they say, so if you call that way look up Mr Hulbert. I am doing a Summer Book for them I have not done the drawings for the men yet I have had such a close time of work of it.

Yours sincerely,
Louis Wain

Louis Wain's Summer Book for 1906 was to the original *Annual* format with stories illustrated by

Wain. The only difference was that the stories were written for children. Wain dedicated it to 'my mother, who is responsible for most of the stories and verses in this book'. Whether or not Mrs Wain wrote her stories and verses specially for the book is not clear. Unfortunately, Hulbert and Wain had a difference of opinion, and in spite of Hulbert's successful guidance, Wain transferred his allegiance to John Shaw.

Shaw's published the 1906 *Annual* but there is no record of whether or not it was 'bookstalled' by Chesney. It seems that by the time the 1907 *Annual* was in preparation, Chesney had become responsible for editing it. Louis Wain changed his publisher again.

Oct 7, 1907

Dear Mr Chesney,

I have had a talk about you to Mr Wright Bemrose Midland Place Derby and he says write him fully your plans about the Annual, what you should want your-

self, and how long you propose to work on it. I told him you might have to give the men some copies, but I did not know exactly what you wanted, but you had better explain anything to him personally, or the man he askes you to meet, at 4 Snow Hill – Mr Clarke or Mr Hare – I expect it will be Mr Clarke.

I have not done those drawings yet for the men. I gave one to Holborn Viaduct, and to Ludgate Hill Station, but I will send them from America.

Yours Truly,
Louis Wain

I go to New York next Saturday for four months.
You might travel several of Bemroses publications at Xmas.

What made him decide to leave England, at the age of 47, when his mother was well over 70, and he had four dependent sisters and another very ill? Why did Louis Wain, who had never been out of the country before, suddenly seek work in New York?

For some time, as we know, he had been 'close up', and by now there was very little demand for his work. There were hundreds of his drawings in circulation and old ones were being used again and again to illustrate new stories. While it was possible to do this, what publisher would commission new work? It has often been said that the First World War, with its shortage of paper, and change of public mood, put paid to Louis Wain's career.

I believe that he was fighting his own, private, losing battle at least eight years before the Great War began and finally decided to emigrate after a lawsuit in which he became involved in the summer of 1907. Unfortunately, no details of the case are at present available but I have a very strong suspicion that Wain was being sued for debt in the Kent County Court. Louis Wain drew pictures of a pleased cat and a sad cat for his solicitor – 'a mirror of himself on hearing the result of his case', he said, 'whatever the result might be'.

He could not afford to lose the case, but he did lose it. His only hope of raising the necessary money was to accept the invitation to the United States which the *New York Journal-American* had extended to him and his cats. So on Saturday 12 October 1907, Louis Wain sailed for New York.

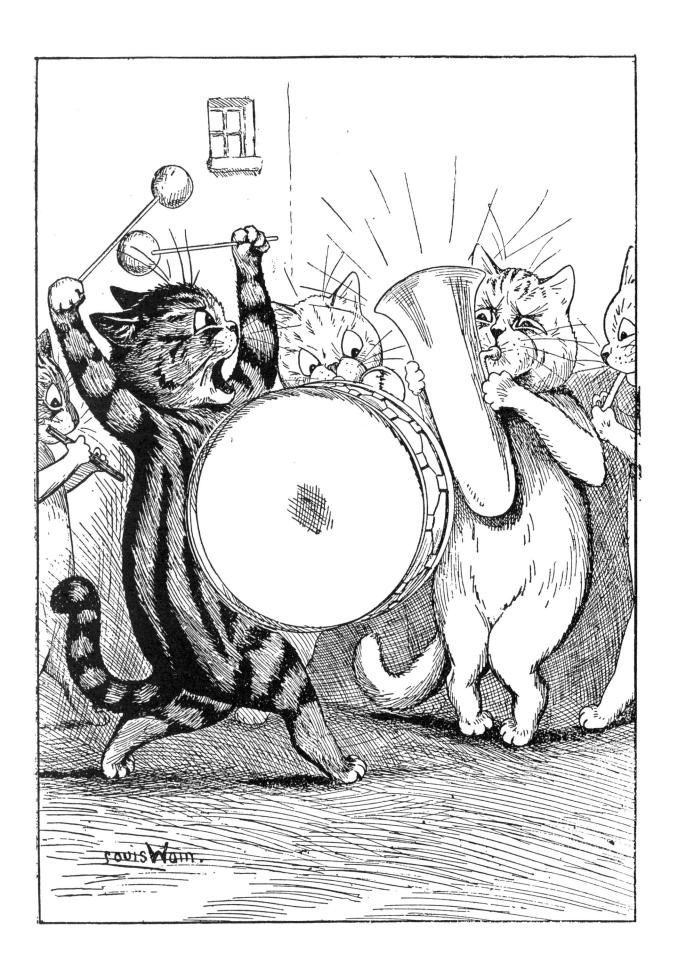

11

America

AS MIGHT be expected, Louis Wain's visit to the United States was considerably longer than the four months which he originally calculated would suffice him to amass a fortune in that rich country. In all, he spent over two years there, but we have only a vague picture of what he did. Luckily, we know what he thought of New York through a letter quoted below. Wain's reputation had preceded his work and he was offered a contract by Hearst Newspapers. As well as other things, he drew *Cats About Town* and *Grimalkin*, among the first of the comic strips which are now a regular feature of most popular newspapers.

There was a ready public for the 'world's most famous cat-artist'. He was welcomed at shows all over the country, and lost no time in relaying his admiration for the American Cat Fancy to the National Cat Club. He kept in close touch with the affairs of his club, and continued to write to *Our Cats* with renewed fervour. He sent home numerous drawings, and a few articles, which were published in various journals. It seems that Chesney often acted as his agent, especially in the preparation of the *Annuals* which were produced while he was abroad.

In spite of all this, we have only a sketchy picture of what he did in America and, after his return, he wrote barely any account of his stay. This was to some extent due to his having 'lost his public'. He had won a temporary renewal of fame in the States, but on his return to England the demand for his work had dwindled to almost nothing.

When he arrived in America, he was genuinely surprised to find himself so well received, both by the general public and by the American Cat Fancy. Four months after he had landed, far from being about to return to England, he was in Chicago, for the Beresford Cat Club three-day show in the Coliseum Annex.

Most Famous Cat Artist in World says Puss is less vain than Woman thundered the *Chicago Evening American*, above a picture of 'Louis Wain and some of his favourite models'.

ENGLISH ILLUSTRATOR DECLARES LITTLE ANIMALS ARE THE FRIENDS OF MAN

Louis Wain, one of the famous judges and students of cats and a pen, ink and brush reproducer of what he terms "humanity's greatest friend" – the cat family – arrived in Chicago today . . . Mr Wain, who has won his way into the hearts of all those who love the feline by his clever illustrations and cartoons of Grimalkin, illustrates for the Hearst newspapers . . . The artist for some years has been the official judge of the cat shows held at the Crystal Palace in London. He is a renowned authority on cats of all sorts and his illustrations are world wide in their popularity.

HOW HE WAS WON TO CATS

The story of how he became so interested in cats he tells with pride. In the same breath he declares he hopes some day to see the cat's intelligence broadened until it can comprehend the human being and then it will have won its highest level. "These poor little animals are humanity's best friend" he said today. "I have studied them for years. They love the man and the

woman. When a person is quiet, the cat will climb into his lap. If the person gets excited, the cat either believes it is time to play or becomes very much frightened and seeks the darkness of the sofa or table."

MOST MODEST OF ANIMALS

"Years ago I was ill. I had a kitten called 'Peter'. It was the most intelligent cat I ever saw. It used to do all sorts of tricks and was so pretty and wise-looking that I tried to make it pose so that I could sketch it. I discovered in this that the cat is the most modest of animals as a usual thing. It is a difficult task to get them to pose. I knew but one whose vanity was as great as that of a woman. Its name was 'Tabby' and it would rather pose than eat.

"I believe that the cat is by far the most intelligent of animals. It is deliberate and careful and it certainly loves the women. To a woman a cat is not unlike a child. You always hear a mother declare her child is the prettiest baby in the world. A woman who owns and likes her cat will declare the same thing, no matter if it is just an alley cat."

AMERICAN CATS DEVELOPED

"I find the American cats, those imported from England, have developed wonderfully. In a contest between English and American cats, I believe America's cats would win. It is a mystery to me how you do it. When I arrived here I was impressed by the bigness of it all, and back of it there seems to be some big mysterious power. This is a wonderful country."

Apart from that last sentence, which sounds like the reporter, rather than Louis Wain speaking, these statements have a strangely attenuated quality about them; he is, as it were, a shadow of his former self.

In spite of all he had said in previous years about the weak brain of the cat, he now claims that he believes it to be the most intelligent of all animals. Following his visit to the Beresford Club show, he wrote to *Our Cats* extolling the virtues of the American Fancy, which he seemed to find superior to his own National Cat Club in many ways.

'I have just returned to New York from the Chicago cat show given by the Beresford Club of America and I do not know what to be more surprised at – the wonderful way in which every-

thing was carried through; the splendid spirit which animates the exhibitors, or the enthusiasm with which all the officials went about their work.'

The following year (1909), however, his notions of American cats seem to have changed. In August, he wrote that 'the cat has greater possibilities than the dog', but that 'it will require the devotion of women of wealth and social position who will give their time and means to it as the English women have done to bring the cat to this exalted position in America'.

'New York cats live in basements', he said. 'In the homes they are kept below stairs, in the factories, business houses, banks and warehouses they are kept in cellars and only come out of their retreats after dark, when they make the night hideous with their yowls. There is no repose for cats in New York, you see, on account of so much noise, rush and movement.

'The weak brain of the cat is not capable of taking it all in, and the animal becomes confused and unmanageable. This makes an underground cat, which has consequently, because of its unnatural environment, grown very uncertain in temper, not to say savage, and as a result the specimens seen about New York are more or less what we call in England "Strays".

'It is forgotten that the cat's brain is practically numb, and all its faults, its distress and its want of attachment to a single human being comes from the fact that it is not capable of sustaining a mental impression for any length of time. The work we have done in England has already awakened new mental energies, and we are on the way to establish a better and a more certain breed.'

After his return to England, Wain came in for some severe criticism in the *Chicago Sun* under no fewer than six headlines:

CAT FANCIER A CRITIC OF MEN
Louis Wain sees New Yorkers Through His Monocle

BITTER IN HIS CENSURE
Declares America Disregards the Struggling Foreigners Here

HE WORKED AS A WAITER

Believes 'Creed of Dollar Is in Babel of Different Tongues'
Gathered Together

Louis Wain, the cat fancier, who spent several months in America recently, passes some criticisms of that country in letters to *Truth*. This weekly publication is now printing a series of articles signed "A Vagabond in New York" which purport to give the experience of an Englishman down on his luck in the great metropolis and who worked as a waiter and in almost any capacity in the lowest strata of the great city.

Wain's picture of Americans and the American way of life are so ludicrously exaggerated in their anti-Americanism that it is impossible for a person of sense and intelligence to take offence at his statements. But he tries to draw a lesson from his experiences for Americans and English alike. [43]

The article then continues to quote from Wain's letter, selecting passages out of context in a way with which we are all familiar. Unfortunately the London correspondent of the *Sun* had got hold of the wrong end of the stick. Louis Wain was not the 'Vagabond', whose 'ludicrously exaggerated' account of American life had appeared, as a series of 12 pieces, in the 'Scrutator' column of *Truth*. [40, 41] Wain never wore a monocle (symbol of the Englishman), and he never worked as a waiter. His letter to *Truth* [42] was more an attempt to explain and excuse the attitude of the other correspondent, the 'Vagabond', than to bear out what he said.

'New York', wrote Wain, 'is quite abnormal. It overflows with emigrants, fighting and scrambling for a footing by every available means, and unless they can be sure of being absorbed into one of the great employment streams, or of being helped along by compatriots, they are thrown back upon a turmoil of struggling humanity, even upon the life of the gutter.

'In New York this latter ends quickly. While the sky is a blaze of perpetual sunshine, the thermometer may register 90 to 102 degrees in the shade, or in winter fluctuate between 5 degrees of frost and zero, and both extremes are remorseless to the penniless.

'While the city grows in lordly grandeur, a crushing out of individual nationality and weeding out of stubborn foreign patriots as undesirables goes on. Americans speak with pride of the money spent by their millionaires for the building of institutes, hospitals, art galleries, etc, but if they were themselves, in the mass, approached to bear a fair share of taxation with the object of further and more systematic developments in this direction, the suggestion would be received as an outrage. The national pride does not consist in giving anything which involves a sacrifice to its pocket. Selfishness comes first, the creed of the dollar. In the babel of different tongues gathered together at the portals of the United States there is a note of bitterness which it would pay the Americans to soften by assuming a more charitable and tolerant attitude to the penniless foreigner. It is the crying evil of the attitude of the common American toward the foreigner which has brought to life most of the 106 private detective agencies – vide the New York telephone book – of the city, and which is responsible, among other things, for the existence of a great crowd of unsavoury fakir fortune-tellers, who gather in every byway of the city. Englishry, however, has its place in New York and, with all its failings, it does some good and it would be to the advantage of the Americans if they could be brought to recognise it as worth cultivating.'

Towards the end of his visit, Wain's interest in the 'physical sciences' led him into trouble. Marion Sheridan Jones wrote:

'It was not only towards cats, however, that his heart was soft. His was a very unsuspecting nature. For this reason he listened to the wonderful story of a miraculous lamp which was to give a burning flame of pure white light at so infinitesimal a cost that it would revolutionise the oil business.

'Louis Wain found the genie of the lamp when he was in America. This Gentleman explained the particular process, and the artist heard and believed. He believed, moreover, to the tune of

all his savings, and the result of years of endeavour faded before his eyes. I understand that the invention has certain claims for consideration, but at the time Wain met its sponsor the process was not fully concluded. It was while the cat artist was on the *New York American* that he was interested in the revolutionary oil process and when his contract with the paper was concluded he returned to England with the inventor, determined to take out a patent. He did, and with the most disastrous results. Time, as well as opportunity, was against him, for the outbreak of the European war killed all possible chance of financial return from the invention, and Louis Wain returned to his pencil and brush a poor man once more.' [55]

I have not been able to discover anything about the lamp. The patent was not taken out in Louis Wain's name, if it were taken out at all. I do not believe that he had money to invest in such a project, so the financial blow could not have been too hard. Moreover, some time elapsed between his returning to England and the outbreak of the war. Therefore the story, recounted in another place [86] that the floating of the company to launch the lamp was precluded by the government's forbidding the formation of new companies upon the outbreak of hostilities, seems to lack truth.

The main blow to strike Louis Wain while he was in the United States was the death of his mother. Mrs Wain was 77, and becoming senile. Hardly had 1910 begun when she was stricken with influenza – the first of the waves of influenza which caused so many deaths in following years, and carried off Louis Wain's eldest sister in 1917.

Julie Felicie Wain collapsed and died on Wednesday 26 January 1910, and was buried at Margate. Louis returned home as soon as he could.

I CAKEWALK. THOU CAKEWALKEST. HE CAKEWALKS WE CAKEWALK YOU CAKEWALK. THEY CAKEWALK.

12

The War

ON FRIDAY 6 May 1910, King Edward VII died. Louis Wain had always admired him as 'the one who loves us all' and felt almost as though he had lost his father again. In 1902, he had written: 'Our King, with a year's hard work, implanted an incentive in the whole nation to go forward'. And later: 'The country is in real need . . . of a more active and united support of the great King who has already sacrificed so much for the good of his people'.

When the Lord Mayor of London set up his Memorial Fund, Wain wrote that the memorial should be 'an academy of painting and music – which will enable genius to crown with glory in the peaceful way he loved the destiny our revered King had planned out for his people. One project which does not seem to have occurred to anybody is to set up an academy devoted to the sister arts: painting and music. Music has no home; it is dominated by the commercial spirit of making ends meet. The genius of our conductor, Mr Henry J. Wood who has worked loyally to purify the orchestra and orchestral compositions is levelled to the needs of a money-making syndicate because there is no academy to help the greatness of his conception of his art.

'Patriotism cannot remain active without the generous fostering of these sister arts in times of peace, for the spirit of commercialism creates envy, and envy debases the soul until the only light it begets is socialism – that penny showman's caravan which is eternally wandering about in continuous storms and downpours and never rises above the level of the oil flare and the big drum.'

That is an explicit statement of Louis Wain's views on political ideals. It is remarkable that his attack on socialism as a facade started as a suggestion for a memorial academy of painting and music.

Wain illustrated few books between his return from the United States and the beginning of the First World War. The 'A. W. Ridler' books continued to feature him only as a joint artist, though his name was first on the list. Most of the other books drew on material whose copyright he had, inevitably, sold. In 1910, Routledge published *Two Cats at Large*, a 'book of surprises, by Louis Wain, with verses by S. C. Woodhouse'. Two kittens, Albert and Tom, meet various strange-looking monsters on their travels, including the Gollifrog, the Grabberchox and the Salleyinour-alleygator. There are some very strange-looking cats in this book as well. The following year, Routledge published *Cats at School*, with verses again by Woodhouse.

Louis Wain's Annual appeared in 1912 and 1913. Wain himself had contributed a mysterious sea-story, 'Where Mystery Reigns Supreme', to the 1907 *Annual*. In 1912 he wrote another, 'The Devil's Dip', and in 1913 'The Mariner's Friend'. These show a lively imagination, and may well have been based on tales which Wain had heard at the London Docks during his childhood. Perhaps his voyage to America first reawakened his interest in nautical matters. They are the only

sea-stories, as far as I know, which he wrote, and it is strange that such vivid ideas took so long to find their way out of his system.

On Monday 3 March 1913, Marie died in the Kent County Lunatic Asylum. Her death does not seem to have affected the family in any way; it was no doubt regarded as a 'merciful release'.

In 1914, Louis Wain turned his attention to the production of what he called 'futurist cats' in china. These were produced by Max Emmanuel and Co, and nine designs were registered. There is an Egyptian look about many of the models, which were really hideous. The addition of the signature 'Louis Wain' to each one could have done little either to sell them or to enhance the artist's reputation. The 'delightful cubist cats' were launched in June, at a private view at Emmanuel & Co's showrooms, and a reviewer gives us a very good idea of what they were like.

'The futurist cat is the latest thing in freak ornaments. It has been evolved from the fertile brain of Mr Louis Wain, the inimitable cat expert, whose idea of applying the tenets of futurism to the construction of china cats has resulted in the creation of some truly wonderful feline fancies . . . It can be said at once that if not exactly things of beauty, they are a joy for ever.

'Yellow cats and blue cats, green cats and pink cats, and even pale heliotrope cats, were grouped on futurist shelves, and they were the quaintest, oddest tribe imaginable. Their faces, designed on crude cube lines, were the limit of grotesqueness, and were calculated to draw a laugh from the most miserable of men.

'One of the funniest of the specimens was the Lucky Road Hog Cat, which bore the cheering words:

"I will drive you to good fortune –
Take it, and make the most of it."

'This odd animal was purple in colour, and was represented in a squatting position with its arms spread out as if it was grasping the steering wheel of a motor-car. Its body was covered with splashes of yellow, intended to represent steering wheels.

As a mascot for motorists the road-hog cat should be in great demand.

'Another comical production was the Louis Wain Lucky Futurist Cat and his "meow, meow" notes. The "meow, meow" notes were printed on the animal's porcelain body – weird sort of music which it would be quite impossible for any but a futurist musician to read.

'The cats are modelled in all positions, and are of all sizes. Most of them are designed to serve a utilitarian as well as a decorative purpose, for their bodies are hollowed out to make receptacles for flowers. The cats will shortly be placed on the market at prices ranging from one shilling upwards. As fun-makers, they have undoubtedly out-Billikened the Billiken'. [49]

Who's Who tells us (1916–1922) that Louis Wain produced '19 china futurist mascot cats 1915' and later '9 china futurist mascot cats 1922'. The Designs Registry tells us that nine designs were registered on June 12 1914:

638312	Statuette	Grotesque
638313	Statuette	Cat
638314	Statuette	Cat
638315	Statuette	Bulldog
638316	Statuette	Dog
638317	Statuette	Cat
638318	Statuette	Cat
638319	Statuette	Pig
638320	Statuette	Pig

The copyright of all these except 638315 was extended on 11 August 1919. The number '19' in the first *Who's Who* entry may be a misprint for '9' which appeared later and which was in fact the number of designs registered. On the other hand, not all the designs shown at the exhibition were registered in the above group.

Just how successful these futurist cats were is difficult to ascertain. Few have survived; perhaps the reporter who reviewed the show was being kind to Louis Wain for old times' sake. I cannot really believe that Wain thought the models had much artistic merit. They look very much as if he had made a deliberately vulgar gesture to draw attention to himself, rather as a child might deli-

berately say a naughty word to see what effect it could create. Rather less fuss seems to have been made about 'true' Louis Wain cats in china. I have seen only one of these which, although signed 'Louis Wain', bore no mark of manufacturer or registration.

Within two months of the launching of the cats, the Great War broke out. It is said that a ship carrying a cargo of them was torpedoed, and with it sank all Louis Wain's hopes of a financial return from the project. The story continues that the china cats were on their way from America to England, but I cannot see why, if Louis Wain had a British firm manufacturing his designs – which were registered in Britain—it was necessary to have further supplies made abroad and brought to this country. It seems more likely that the cargo was on its way to America, where Wain still had some novelty value. I have not been able to find out anything about the ship.

This was not the worst of Wain's misfortunes that year. On Wednesday 7 October he was boarding an omnibus when he fell into the road, striking his head and being knocked unconscious. *The Times* reported:

ACCIDENT TO MR LOUIS WAIN

Mr Louis Wain, the artist, has met with a severe accident. He was thrown off an omnibus and is at St Bartholomew's Hospital suffering from concussion of the brain. [52]

There was one further bulletin:

MR LOUIS WAIN

Mr Louis Wain, who was admitted to St Bartholomew's Hospital last Wednesday suffering from concussion, as the result, it is stated, of a fall from an omnibus, is progressing as satisfactorily as can be expected. His condition is somewhat severe, but he has recovered consciousness. [53]

Perhaps the 'it is stated' added some air of mystery to the accident, but it was probably no more than the cautiousness of *The Times*.

In years to come the fall was to be seized upon and embroidered by journalists, and to be made

the reason for Louis Wain's subsequent admission to a mental hospital. However, the evidence is that the fall had little or nothing to do with Wain's mental illness; in any case, he was not certified insane until 1924. It is a common phenomenon of admission to a mental institution that relatives of the committed will almost invariably produce a physical reason – such as falling from a bus – to 'explain' the loved-one's mental trouble.

As time went on, a cat inevitably appeared in the story of the accident: 'the 'bus swerved and braked – to avoid a cat' . . . 'Louis Wain's first words on regaining consciousness were: "was the cat all right?"' Then two horses added to the confusion: 'The artist was catapulted from the 'bus-top to the street below. Two dray-horses

reared in sudden fright and stamped on him. For more than a week Wain lay unconscious. When he came round, he moaned something about "The cat! The cat!" Not very long passed before he had to go to a mental hospital. Cats had indeed robbed him of his wealth, his health and his reason.' [86] 'Not very long' here means 'nearly 10 years'.

Louis Wain's sisters said that he slipped on the stairs, not difficult on the precarious stairs of those open-topped buses. This being so, it is difficult to imagine how he could have seen the cat; if he had, he would surely have held on tightly in anticipation of the accident. Neither did his sisters make any mention of trampling horses, which is significant, for they would certainly have been an important part of the 'explanation' of the mental disturbance. In passing, it must be noted that October 1914 was unusually dry in London, and that no rain fell on the 7th. This puts paid to any theory about extra-slippery stairs.

Louis Wain was detained at Bart's for two or three weeks, and then allowed to return home to Westgate. He reported his progress in a letter to a friend in London:

Many thanks for your kindly, thoughtful and genial letter, which has given me a day's contentment at a difficult time. However, by absolutely obeying the doctor I shall get through all right, and it will be the beginning of a greater time and will then come back to you prosperously. As soon as I am allowed to take the journey to town I shall see you again, but at the present it is rest, rest, rest! You will understand what it means for the future . . .

What did it mean for the future? The doctors told Wain that he would have to take six months' rest, otherwise he would risk a breakdown, but neither his financial state nor his restless personality would allow him to rest. 'Louis Wain could never feel settled anywhere unless he was free to leave', someone wrote, continuing: 'an ordinary studio has no attraction for him. He prefers to work in an office, in his room in a London Hotel, in his garden at Westgate . . . high walls seem like a prison to him.'

He thus became somewhat impatient at this enforced period of inactivity, and in the New Year wrote again to his friend:

Every good wish to you and your wife and the little ones for the New Year and the greatest prosperity. I am plodding along, getting better bit by bit – but it's a teaser and I get my shocks if I don't obey the doctor, so I *do*. It is going to take a bit of time to throw off the first shock altogether entirely, but it will be all right. I miss my visits so genial and quiet to the old place I can tell you and look forward to freedom again.

But what had freedom to offer? There was a disturbing amount of enemy action at Westgate during the First World War. The demand for his pictures had sunk to almost nothing. There was a great shortage of paper, and Louis Wain cats were very low now on any publisher's list of priorities. In the autumn of 1915 he took out his patent for a 'Rangefinder', inspired, no doubt, by chance observations made while walking on the beach at Westgate, and furthered by patriotism and a feeling of nearness to the war.

At the end of 1916 the Wains decided that they must leave Westgate, their home for nearly a quarter of a century. The enemy action was disquieting, and Louis' health was not improved by

Above: 'Which do I love best?' Another of Louis Wain's enigmatic titles.

Right: Cats never look like this despite the photographic pose but a Wain cat is
more catlike than a real cat. The cat species has something to live up to (detail).

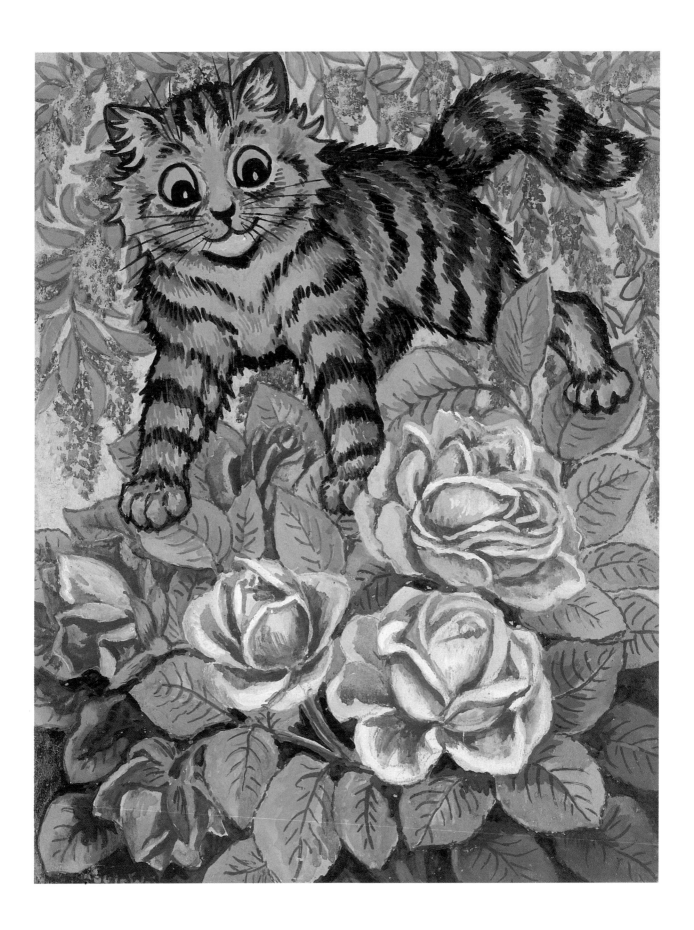

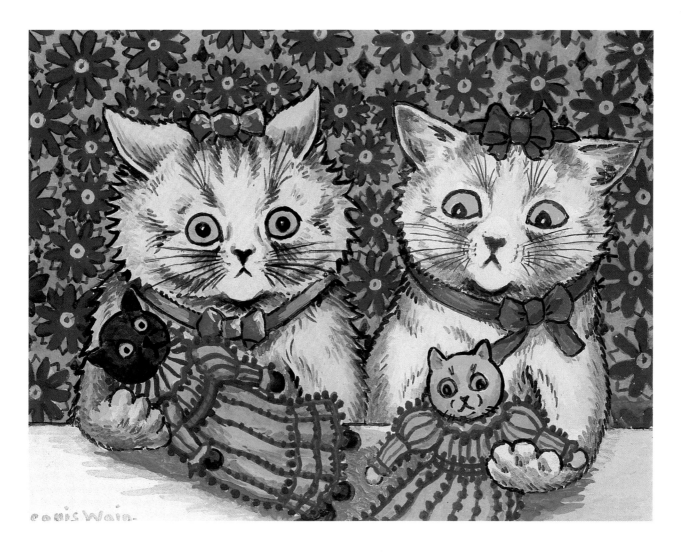

Above: Though Wain's draughtsmanship declined with advancing years his sense
of humour and his sense of design remained.

Left: 'The rose kitty which has no thorns
The rose plant shown does not grow any thorn
When grown perfect in perfect soil'.

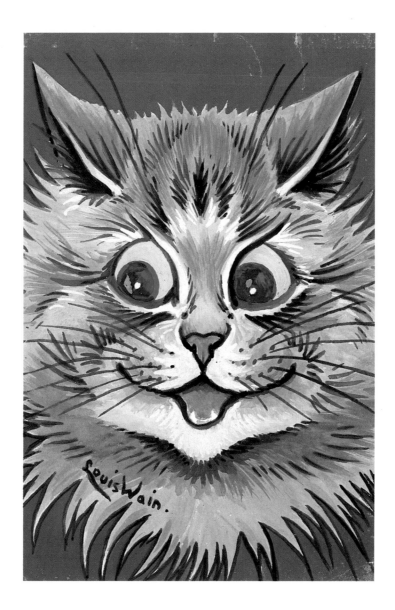

Although Louis Wain gave his cats stock expressions of human emotion they
come in an infinite variety from enthusiastic anticipation to . . .

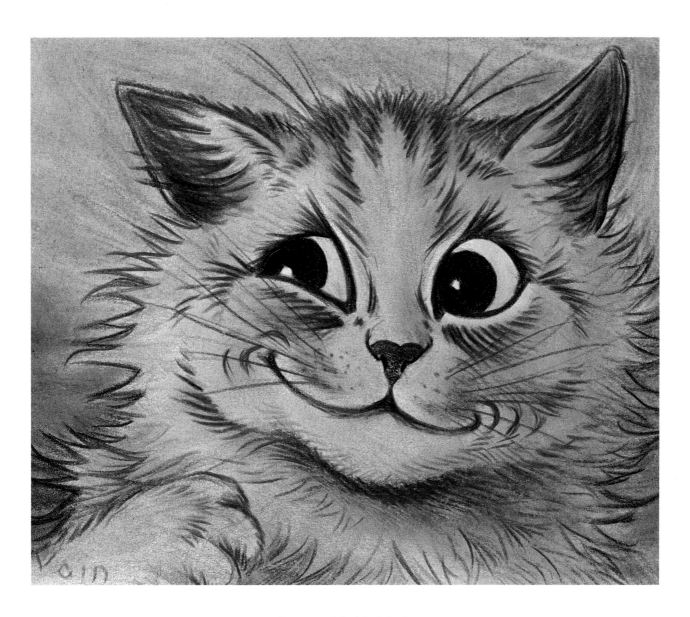

Above: . . . wicked Satisfaction.

OVERLEAF:
'His interest in music? Well, he used to improvise at the piano very competently
– strange melodies – played in a very nervous jerky way – what I would call
"agitato" playing.' *Collingwood Ingram*

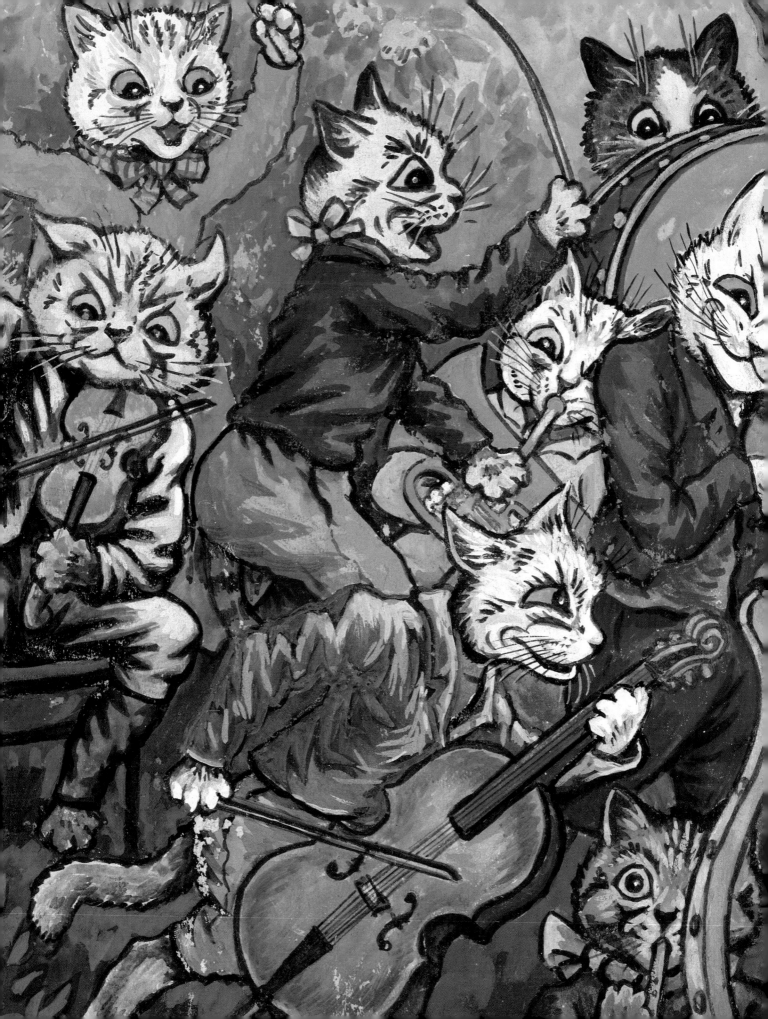

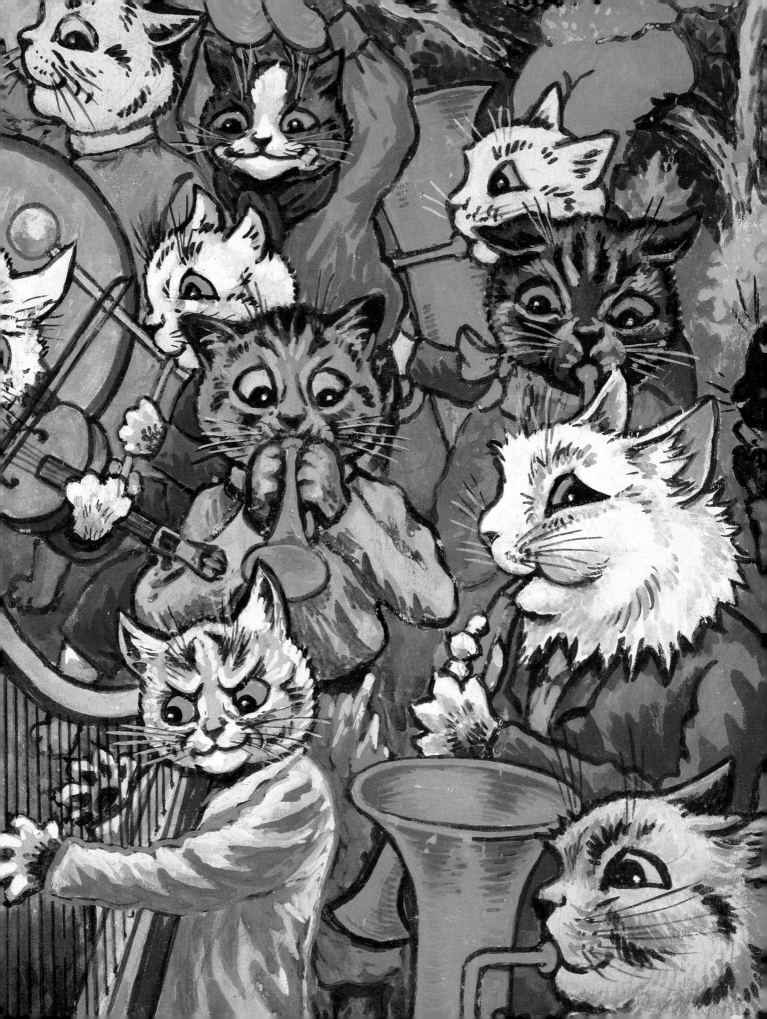

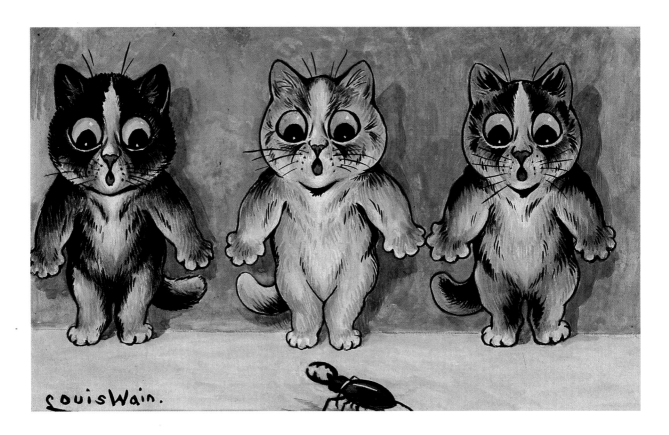

Above: A well-known series of postcard 'Lucky Mascot' cats was published in 1931 by Raphael Tuck.

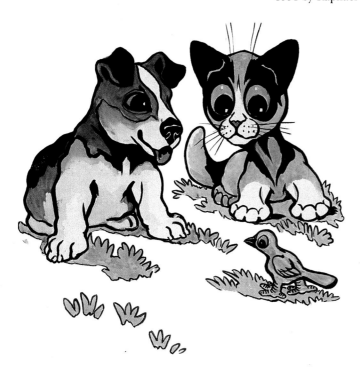

Left: 'The Early Bird'.
This odd 'mascot' type of cat pops up occasionally in the Louis Wain Annuals (1902–14, and 1921) and in other books . . . even the bird has sturdy legs.

Right: Striped smooth cats were a Wain invention. They featured in the Annuals and appeared in a Raphael Tuck 'Stripes to the Front' series in 1916.

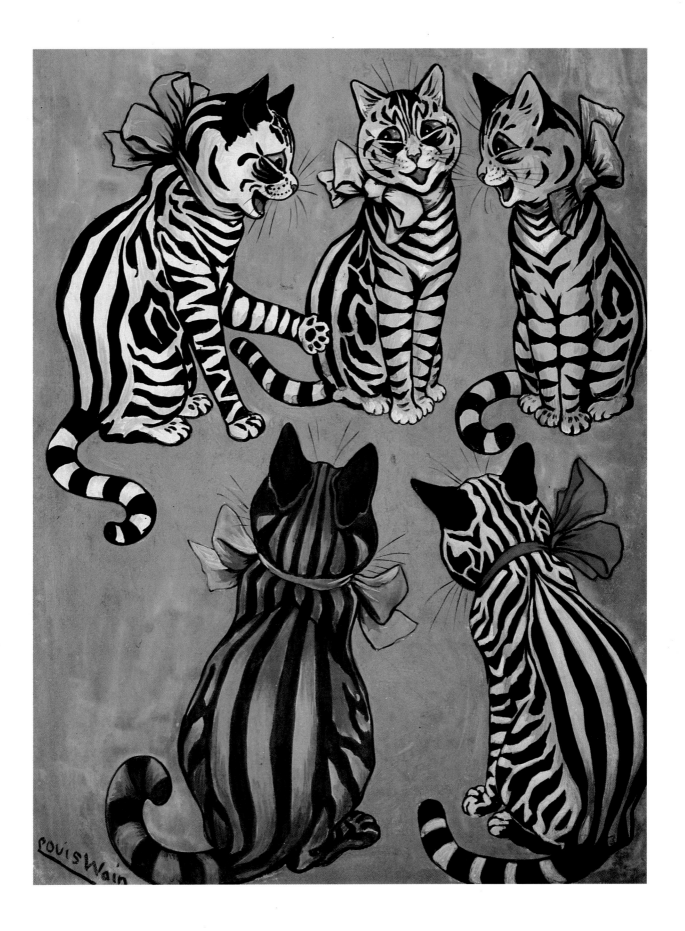

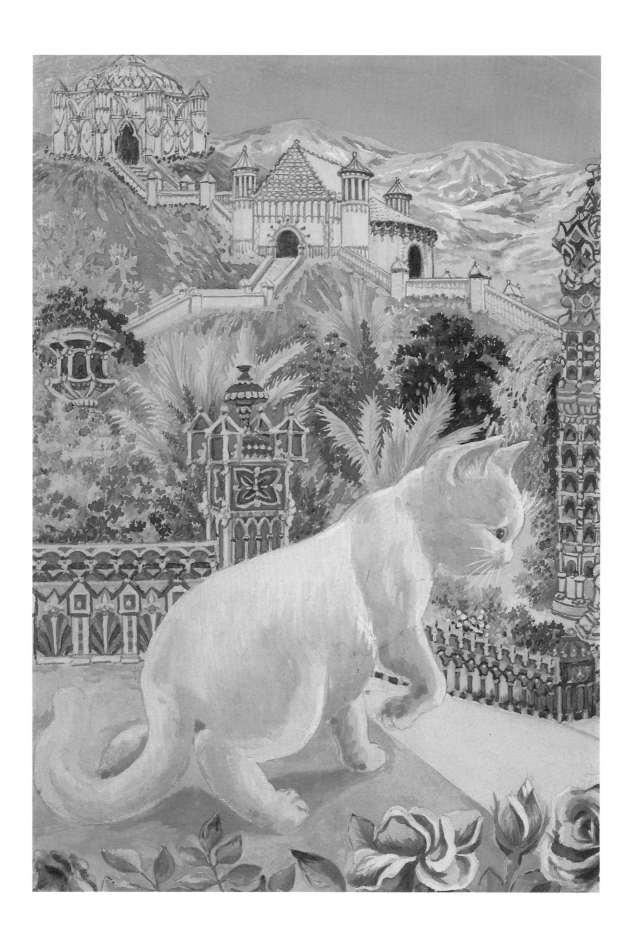

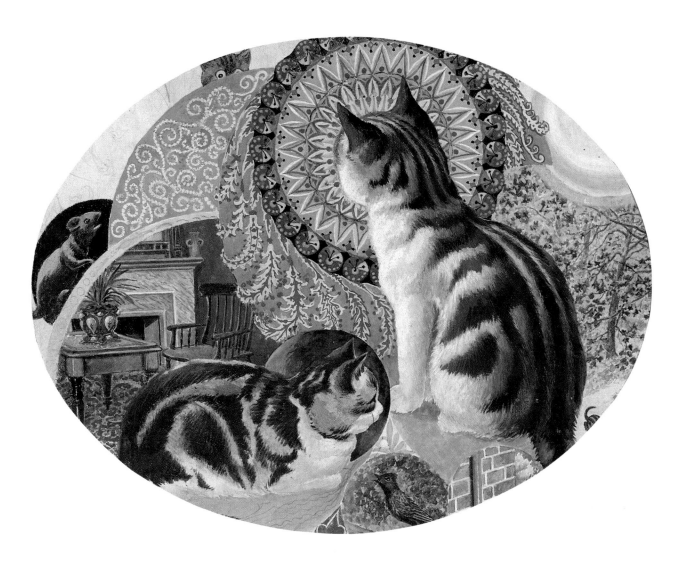

Above: In what appears to be a picture of the pleasant day-dreams of a cat, there are patterns reminiscent of late 19th century textile design: Wain's grandfather had been a silk manufacturer, his father was a traveller for a firm of drapers and his mother designed church fabrics. The association might not be fanciful.

Left: Here the 'Perfect Cat' illustrated as Plate 14 in Rodney Dale's *Catland* (Duckworth 1977), steps into the most idealized of cat palaces, a feline Shangri La.

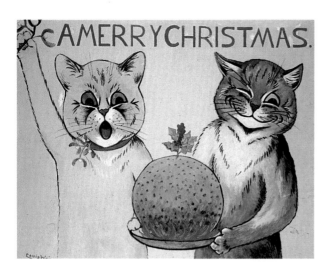

This emphatic Christmas greeting was done for ward decorations at Napsbury hospital.

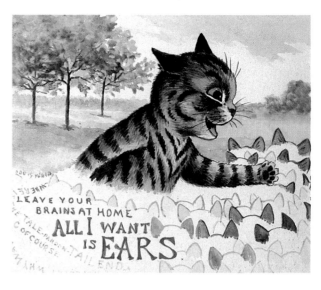

'Leave your brains at home all I want is ears. Where is the tale – pardon – tail end to your speech? Why wagging of course'.

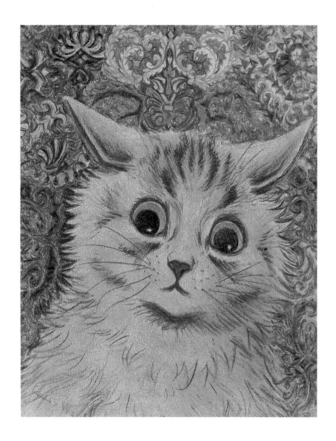

This crayon portrait of a cat with an asymmetrical 'wallpaper' background is similar to one in the Guttman-Maclay collection (see chapter 10).

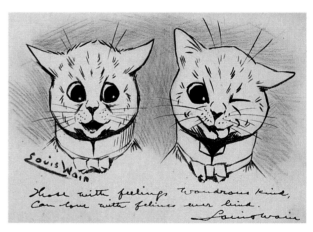

From an autograph book. Wain often used this rhyming couplet (sometimes in mirror writing) when dedicating the gift of a 'lightning sketch'.

Right: 'The Fire of the Mind Agitates the Atmosphere'. In this picture brown swirls emanate from the cats like the lines of force from magnets, made visible by means of iron filings.
The cat on the left is clearly exercizing an influence on the one on the right – and judging from the latter's expression, that influence is not beneficial. Perhaps this was a reflection of the artist's view of the world, that his body was charged with electricity, that ether – the source of all evil – was present in his food, that he was filled with electricity and had magic powers of healing by the laying on of hands.

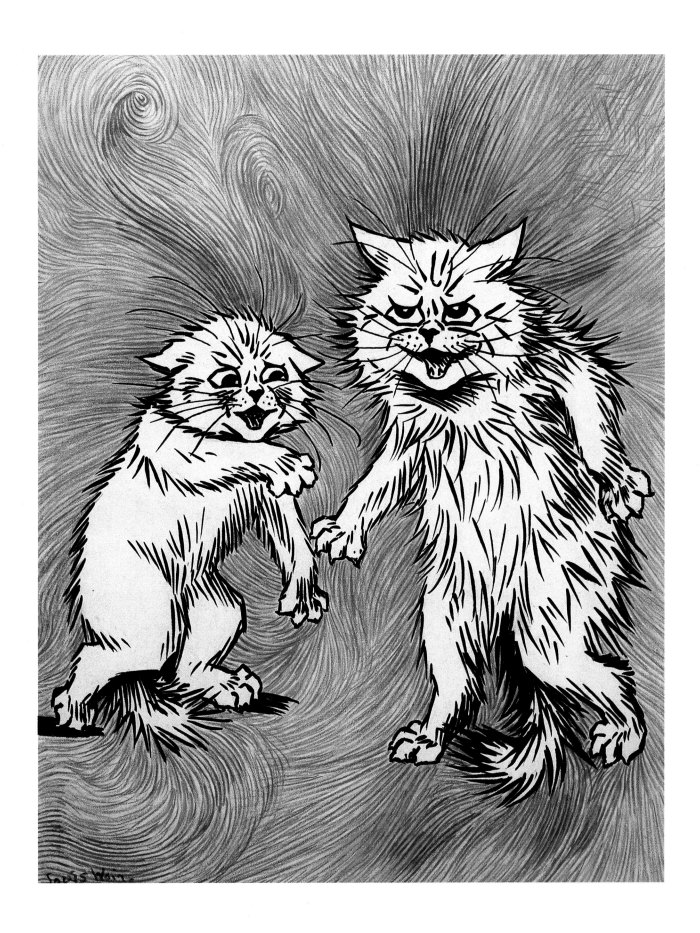

Here the wallpaper is transferred to the cat. A rare and satisfactory
transposition.

frequent trips to London, which he could hardly afford anyway. Much of his time was taken up drawing sketches to appease the rate-collector and other representatives of public bodies.

The first of the many letters I had in answer to my request for information about Louis Wain was from the daughter of such an official:

'The drawing I have was given to my father as a sort of "peace offering" because [Louis Wain] was unable to pay his account. My father liked him, and always said he was a sad victim of circumstances. His cats having had a run of popularity in England, were taken up in America for a time. After their run of success was over he had no other art or any profession to fall back on. I believe he had some sisters to support, and was in such low water that he had to borrow his fare to go up to London to see his publisher.

'His debts caused him acute anxiety, and I believe so preyed on his mind that he ended his days in a mental hospital. My father was for over 40 years Secretary of the Local Gas and Water Undertaking, and as such came across a good number of people who were either unable or unwilling to meet their debts, but I never heard him discuss or criticise them. The plight of Louis Wain I believe really troubled him, as he genuinely admired him and the struggle he put up against great difficulties.'

This letter is typical of many telling of Wain's dire financial straits. Another correspondent writes: 'My uncle . . . was the rate-collector for Willesden and Brondesbury, and I always understood from him that Louis Wain occupied premises in Kilburn. My uncle showed me many pictures of cats painted by Louis Wain which he said he had accepted in lieu of the rates which Mr Wain was unable to afford in his declining years.'

Another tells an equally poignant story: 'Louis Wain came to my house in Teddington when I was a child . . . My late father was a dental surgeon and Louis Wain came to him for treatment, after which he sat at our dining table and painted, using both hands! The subject was a dental surgery, with a very large cat with green eyes and pince nez operating on a pretty "ginger patient". L. Wain was very hard up at the time, and when my father paid by cheque, he very hesitantly asked to borrow cash for his train fare.'

Finally, the head of a publishing firm recalls: 'On one occasion, the day after he had been paid a cheque about £100, he came into the office and asked for me personally, as he wished to speak to me in private. He asked me confidentially whether he could borrow five shillings.'

It says much for Louis Wain that none of the many people who recounted such experiences had anything but the deepest sympathy for his plight, and that all did what they could to help him.

13

Kilburn

AT THE beginning of 1917, the Wains gathered themselves together and moved to 41 Brondesbury Road, Kilburn. Shortly after their arrival, the eldest sister, Caroline, fell a victim to the terrible influenza epidemic. She was only 53. Bronchopneumonia set in and she died on Saturday 14 April. Thus 47 years after her father's death, Caroline Marie Elizabeth Wain was laid to rest beside him in the family grave at St Mary's Cemetery, Kensal Green.

In 1917, Louis Wain nearly made cinema history. He was invited by the film-maker H. D. Wood to try his hand at film cartoon work. As we now know, the animal cartoon had to wait for the genius of Walt Disney before it became a viable entertainment, but Wood saw its possibilities. He thought that Wain, whom he knew to be a rapid worker and doubtless a box-office 'draw', should be approached to produce the drawings of 'Pussyfoot', the first-ever screen cartoon cat.

George Pearson writes: 'Wain was quietly self-effacing, truly modest, and honestly surprised by the demand for his work . . . I did my utmost to help his cartoon work, but the strange technique was difficult for him, though he strove with painful slowness to produce the animation which he knew was essential. Some three or four cartoons were completed, but their cinema success was not great, and in the end the venture was quietly abandoned.' [100] Wain later recorded this unsuccessful venture in Who's Who as 'Cinema Cartoons: 1917–18'. The fragment of Louis Wain film surviving is interesting only for its existence.

Another chance of renewed fame came to him in 1920, when he was taken up by the publishing firm of Valentine. They doubtless hoped that he would 'stage a comeback' and did all they could to help him. They published a series of four little books: *The Tale of Little Priscilla Purr, The Tale of Naughty Kitty Cat, The Tale of Peter Pusskin* and *The Tale of the Tabby Twins*. In appearance, these books were very similar to those of Beatrix Potter; they were the same size, and had the same idea of decorated endpapers. On the other hand, their content substitutes for Miss Potter's timeless charm a robust, almost bucolic approach, which unfortunately did not come off.

The following year, Valentine's published *Teddy Rocker, Pussy Rocker* and *Puppy Rocker* — three books so shaped that when they were opened and stood up they would rock so that the eyes of the teddy/pussy/puppy moved. In 1922, they published *The Kitten's House* and *Charlie's Adventures*, Charlie being a cat who looks wondrously like Charlie Chaplin. None of these books was a great success, for the fact was that the name of Louis Wain no longer held its former magic, and his own particular formula was played out. Ironically, only his later misfortune made the magic of his name known again, and then it was too late for him to benefit directly.

The last *Louis Wain Annual* was published by Hutchinson in 1921. One of the most interesting things about it is that many of the drawings contain patterned fabrics: curtains, chair-covers and carpets. Of course, Wain had often drawn such

things before, but now the patterns were beginning to become obtrusive, almost overshadowing the point of the pictures. This is a possible manifestation of his mental illness, to which we will return.

It appears also that at this time Wain was spending a great deal of time writing, writing, writing, words and phrases, sometimes meaningless, sometimes coherent. At other times, he would pour out beautiful streams of words reminiscent of his past writings but, as always, leaving one wondering whether in fact he meant what one felt he had said. *A tour de force* is 'The Cat's Rubáiyát' in the last (1921) *Annual*, published by Hutchinson. *Louis Wain's Children's Book* – his last – was published also by Hutchinson in 1923.

What was to happen to Louis Wain? For years he had been wandering about, executing the odd commission, but in no sense fully employed with his art. Much of his work, as we have seen, was devoted to paying bills. He became more and more hostile to his sisters, though to outsiders the

family appeared to be as well-ordered as ever. His sisters, of course, were used to his ways, and they were the better able to cope with the situation because of its gradual onset. Being plunged straight into it would have been intolerable. Louis' strange behaviour made them keep very much to themselves; they had few friends, and in any case, there was little money to spend on entertaining.

Josephine ran the house, Felicie took an office job in the City, and Claire began to come into her own as an artist. Both she and Felicie had undoubted artistic talent, which they had for years, unwisely, kept in check in order to further, as they thought, the career of their famous brother. It is easy to be wise so long after the event, but it would clearly have been better for the family as a whole if the sisters had made more use of their talents earlier in their lives.

On Monday 11 March, Louis Wain wrote a kindly letter full of advice to a young friend about to be ordained. It was a typical Wainian letter, full of grand phrases and hopes for the future, but none the less well meant.

It is very gratifying to hear of the progress you have made, and when you get into your parish & make your calls on your parishioners don't fail to remind them that anything they can do in the way of decorating your church is making a sacrifice to God, as all the brilliancy of good decoration awakens the mind to better things & get an "at home" day by invitation to your better class people to bring them closely in touch with your work, and at your "at homes" you might keep to pleasant conversation with a touch of humour now & again & encourage the kindness to animals with them. It all helps to get to their hearts. If I can get to Lichfield I will, but I am just recovering from a long spell of catarrhal colds which are very wearing in night & day coughing & little sleep. but I will try if there is to be no risk of a fall back. A canopy over the pulpit will rectify voice difficulties wonderfully. & throw the voice further. In preaching awaken interest with little touches of human nature, what people have said to each other & dont forget to remind them that everything in life depends upon conscious effort, & that even a little prayer often repeated builds up the mind to see further in life & so avoid its dangers & lassitude –

which are avoiding conscious effort. Keep up the reading you never know when a little fact will tell & win its way to the heart. In the present day of much newspaper & other light reading, people are not so used to concentrated effort in listening for long without change, but there is some solid effort apparent all over the north of England which tells well once you can grip it to you by individual striving & so moving them on.

I dont want to miss your ordination, if it is possible to come and will go to Coate's Tourist office to find out the trains &c. Lichfield, I remember passing through on my way to Uttoxeter to go to an Agricultural show and then onto Leek to see my old grand aunt. I am sorry you could not manage Leek, as it is a town that will rise suddenly to better things once I get into touch with it. I expect that you will come into touch with the agricultural people at Garnel, & they are quietly cute, but like to be made much of as there is a tendency to petty jealousies like little Westgate. but these are easily patched up. If you could build up a good choir it would help you too, & get them to sing at the "at Homes", in the district.

My sisters all send their best wishes for your success, & look forward to hear more of you. We have three cats now, two persians one blue & one black, both high class cats & a siamese & our two old dogs the Japanese Spaniel & the Tibetan Spaniel are living out their last days and looking very well now. Dont forget to keep in touch with me

Yours sincerely,
Louis Wain

Get into touch with all the country house people even if you do not have them in your own church & dont forget to pay complimentary calls on all the clergy round about. & if you can get up little concerts or entertainments or Bazaars do. The main thing is to be certain to solidify your own position by active work first of all & when you are in Lichfield ask the clergy's advice there as to what they consider you might do effectively in a country district to arouse interest in your own work, & keep in touch with them afterwards for guidance in the future as they are a fine intellectual class of men.

Ten weeks later he wrote one of his last letters, again to his young friend:

Yes, send the article along I cannot yet find out yet whether the Annual is to be a childs book only, or whether they are going to make it, as of old, a book for both grown ups & children, anyway let me have it & if it is not to go in the Annual, I might bring you in touch with articles for Country Life . . .

I have had to go through very severe times, but another fortnight will see me through and on the road to a greater career altogether.

Dont forget to collect any quaint dialect sayings & ways of these salt workers, & also to write descriptions of their work & how they live & what amusements they have & what they look up to and how, and get a photo of the Bonnets &c It might work out well for publication.

Yours sincerely
Louis Wain

Make all the friends you can.

It would be most interesting to know what Louis Wain had in mind for his 'greater career' in another fortnight, for another fortnight saw him admitted to a mental hospital.

There is a great sense of urgency underlying his exhortations to his friend, as though he wanted to make quite sure that he had passed on all his ideas before it was too late to do so. It is like shouting instructions out of the carriage window as the train draws inexorably out of the station, slowly gathering speed, until one's companion on the platform is unable to run fast enough and is left behind.

Since Wain had always had some reputation as a quiet eccentric, it took his friends and acquaintances longer than it might otherwise have done to realise that his mind was failing. His sudden interest in the possibility of breeding spotted cats must have been regarded as just another of his schemes. When, however, he started visiting the leading members of the Cat Fancy, and talking to them about the Crystal Palace Cat Show which he, personally, was organising, it did not take them long to realise that something was amiss. There was no such show. In fact, the death of his beloved sister in 1917 had affected Louis Wain deeply, and his state of mind from that time began to take on a more sinister aspect. He believed that his surviving sisters, Claire, Josephine and Felicie, had been responsible for Caroline's death.

It became more and more difficult for his sisters to manage him. He accused them of robbing him, and of stealing his cheques and effects. He made other strange claims: groups of spirits were going about 'projecting currents', so that he was 'full of electricity', and he became preoccupied with spiritualistic ideas.

Since Caroline's death, he had to some extent been kept busy with his film-making attempts, various commissions and the Valentine books. He also produced a lot of work to pay the rates and other demands. But as the amount of work dwindled, he had more and more time to brood on his condition. He spent much time locked in his room, writing about his electrical and spiritualistic theories, and resisting the efforts of his sisters to look after him.

He started to move the furniture about, endlessly rearranging the rooms at all times of the day and night. Sometimes he would wander out into the street in the middle of the night, leaving the front door wide open, to the consternation of his sisters who felt bound to wait up for his return.

He began to become violent. On one occasion, he took Claire by the throat and pushed her out of the house. Another time, Josephine tried to stop him from moving a large picture downstairs. He gave her a mighty shove which sent her reeling backwards, and only a lucky grab at the banisters saved her from crashing down with the picture on top of her.

Not content with all this, he started to write abusive letters about his sisters to his friends. Altogether, the situation became too much for the three ladies to handle, the doctor was called in, and on Monday 16 June 1924, Louis Wain was certified insane. He was removed to a pauper ward at Springfield Hospital, Tooting, the Middlesex County Mental Asylum.

14

Springfield

IT IS not easy to say exactly how long Louis Wain's illness had been developing. It is very common for relatives to attribute mental illness to accidents, which are vividly remembered, even though medically such accidents cannot be so indicted. The Misses Wain were no exception. Louis' fall from a bus in 1914 was always very much in their minds, and they told the doctors at Springfield that they thought that the fall had a good deal to do with his illness.

Later on, however, when Wain was transferred to the Bethlem Royal Hospital, they told the doctors that their brother had made a complete recovery from that accident, and that the change in his disposition had started about two years before his admission to Springfield; this would date the mental illness to the early part of 1922. The patient himself, however, told the doctor who was called in to see him that he had been 'bothered by spirits night and day for six years'; this would place the start of the illness in 1918.

There is no inherent contradiction here. It is very probable that Louis Wain experienced curious thoughts and sensations, which he attributed to spirits, from the start of his illness in that year, and that changes in his outward behaviour were noticed by his sisters for the first time in 1922, and increasingly over the next two years. In effect, the patient's account would fit into the later account given by his sisters, all of them agreeing that he had made recovery from the accident.

One may take the matter a little further. Severe

mental illness, of the kind under discussion here, very rarely follows accidents. It is much more usual for any disturbance of temperament which follows an accident to manifest itself as general irritability and lack of concentration (rather than as delusions and suspicions), and for such disturbances to prove themselves to be only temporary, finally disappearing and leaving the subject very much his old self again.

Putting together the accounts of the patient and his sisters with what is known medically of mental illness, there is very clear agreement that Louis Wain made a slow, complete recovery from the effects of his injuries in October 1914, that some four years later he began to develop ideas that he was being tormented by spirits (which he did not discuss with others), and that his illness was so far advanced by 1922 that it was clearly

zophrenia. There can be no doubt that this was a correct diagnosis, and that Louis Wain's was a fairly typical example of the manifestation of this illness.

At home in Kilburn, Claire, Josephine and Felicie took stock of the situation with mixed emotions. It was a relief that Louis was at last safe, with the specialist care which they knew he needed. Nevertheless, home was not the same without him. From every wall, Louis Wain cats looked out at them, his room was piled with drawings and sketches, not to mention his 'secret' writings, and every nook and cranny was packed with his collection of models of cats. Valuable cats of gold and mummy cats from Egypt rubbed shoulders with cheap Woolworth models – he had collected anything and everything. They started the colossal task of cleaning up.

While Louis had been there to placate debt-collectors with his drawings, they had been content to let him handle the situation. Now, they would have to pay their way with hard cash. Josephine continued to run the household, and Claire and Felicie started to give private sketching lessons, for they felt that they could now use their artistic talents without hurting Louis. Felicie had

evident to his sisters in his speech and general conduct. In 1924, after two years of increasing friction on his account, they were unable to tolerate the situation any longer.

At Springfield, Louis Wain was found to be very deluded. He repeated to the doctors the statements about his sisters' alleged maltreatment of him, and went on to claim magical powers of healing by reason of electricity imprisoned within himself. As is often the case with mental patients, such ideas did not prevent his settling down in hospital, where he seemed well enough content, though on one occasion in August he wandered away to board a tram and had to be fetched back.

He carried on drawing and painting, arousing the admiration of the staff with a display of all his old ability. Throughout his stay at Springfield he gave the impression of a man full of eccentricities, and possessed of many quite fantastic delusions.

The diagnosis made at that time, and never changed subsequently, was, allowing for changes in medical nomenclature over the years, schi-

some success as a painter of miniatures, and Claire developed a technique for painting on glass, decorating bowls with competent floral patterns. She also practised the old craft of fore-edge painting on books, illustrating many works with suitable scenes in this manner, which found their way into private collections the world over.

Every week they visited Louis at Springfield, bearing what little treats they could afford. They supplied him with sketch-books and crayons, but it was not easy for him to keep such things to himself for long. Following their visits, they took away any work which he had produced – unless he had already given it to someone else, for there were always plenty of people ready to take his pictures. He would talk to any of the other visitors who were prepared to listen, and on rare occasions was delighted to enthral children with his animal tales and his sketching.

One day, Louis was sketching in the ward, when the hospital guardians were making one of their periodic tours. One of them was Dan Rider 'the liberal publicist, bookseller, and tenants' champion', who recounted what happened thus:

'I was on a committee that had to make a number of visits to asylums. During one of those visits, I was passing up and down a corridor when I noticed a quiet little man drawing cats. I went up to inspect his work.

'"Good Lord, man, you draw like Louis Wain."

'"I am Louis Wain", replied the patient.

'"You're not, you know", I exclaimed.

'"But I am", said the artist, and he was.' [103]

Rider was astonished to find Louis Wain at Springfield, and quickly decided what to do. With the aid of Mrs Cecil Chesterton (GKC's sister-in-law), an appeal committee was set up, and with the blessing of many influential signatories the Louis Wain Fund was launched at the beginning of August. *The Times* reported on 12 August 1925:

'An appeal is being made by animal lovers and admirers of the work of Louis Wain, who has delighted thousands with a long series of inimitable cat studies from the year 1883 onward till recent years, to enable him to be removed from the pauper wards of a metropolitan mental asylum, where he has apparently been for some years. Few people have known of his plight, which, it is stated, has been due to mental trouble, which gradually became accentuated, while, with what is described as a lack of business acumen, Mr Wain had not retained an interest in his drawings which would still have assured him an income.' [57]

Everywhere the response was the same; how could this have happened to Louis Wain, one of the most well-known popular artists ever? To some extent, of course, the appeal was launched at the right time. Most adults remembered with affection the cats which had so amused them in their childhood, and many felt like expressing their gratitude to Wain by making a donation to the fund to help him.

Mrs Chesterton's appeal was reproduced in many papers not only in Britain, but also in the

colonies and the United States. She began: 'Louis Wain is in a pauper lunatic asylum. This must come as a shock to the many thousands who have loved and admired his work. For years, Louis Wain's cats decorated our hoardings, adorned the covers of our magazines and were familiarly loved by every child and the majority of grown-ups. No Christmas calendar was complete without this artist, no annual was issued that did not contain one of his vivid sketches. And yet, at the age of sixty-five, he is so bereft of means that, in his affliction, he is compelled to accept the hospitality of a State institution.'

Mrs Chesterton went on to explain the tremendous amount of work which Wain had done for animal welfare, and how he had come to be in a mental hospital. She ended:

'To me, it is a matter of almost personal reproach that Louis Wain, who worked for years on the press – known, loved and admired not alone by journalists and artists, but by the vast majority of the general public – should have passed away so utterly from our remembrance. It is a reproach that should be felt by many; but it should not be difficult to expunge.

'For all these reasons I would most earnestly beg those who read this appeal – and they must include many who have enjoyed this artist's work – to respond to the utmost of their capacity. Especially do I urge this upon animal lovers. For surely the man who worked with them, and shared their hopes for the protection of the dumb creatures, should receive the same help he so generously gave now that he is so piteously unable to speak for himself.'

On Monday 17 August, the *Daily Graphic* started a Louis Wain competition week, publishing two drawings each day to be arranged in order of preference by readers 'from the point of view of humour, interest and craftmanship'. The *Daily Graphic* also published each day stories and personal memories of Louis Wain. The first was headed:

SAINTS BEFORE CATS

Some of the romance of Louis Wain's early life was described to me yesterday by Lloyd Maerchant, who must be almost [!] the doyen of stained-glass artists in this country. "Louis and I used to work together in Clayton and Bell's old studios in Regent Street", he told me. "Long hours they were and although he used to live in my house, we often didn't see each other for days at a time. Wain was a quiet, retiring sort of fellow, and used to sit upstairs in his room hard at work sketching. Then one night he came back and said: 'Do you know, I think I'm better at drawing cats than saints' and that's how he started out on his career."

INSPIRED BY A TABBY

"I always like to think that our tabby, Dick, dead twenty years ago, must have been responsible for a good deal of Louis' inspiration", said Maerchant. "But he was always drawing cats, and the Botanic Gardens were one of his happy hunting-grounds."

By 18 August, about £275 had been collected; the original target was £1,000. The Prime Minister, Ramsay MacDonald, was now personally interested in Louis Wain's plight, and it was through his intervention that Wain was transferred to the Bethlem Royal Hospital the following Monday, 24 August.

On Thursday 27 August 'a message written by H. G. Wells was broadcast from 2LO, read by Mr Loraine, the airman actor. Three generations, said Wells, had been brought up on Louis Wain's cats, and few nurseries were without his pictures. He added: "He has made the cat his own. He invented a cat style, a cat society, a whole cat world. English cats that do not look and live like Louis Wain cats are ashamed of themselves." '

The BBC is unable to supply the full text of H. G. Wells' message. Apparently it was an impromptu broadcast, as it was billed that 'Mr Robert Loraine, the actor, will broadcast from London 2LO tonight Thursday 27 August an excerpt from Cyrano de Bergerac which will be relayed to all British broadcasting stations'.

15

Bethlem

WHAT DID Louis Wain's sisters think about all this? So far, they had had no say in the appeal at all and, though they could not feel other than relieved and happy that their brother was now living in somewhat more pleasant circumstances, they did think that they might have been consulted.

When the Fund Committee met on 8 September, members were told for the first time that Louis Wain had dependents. It was unanimously agreed that the fund, which already exceeded £1,500, should be extended to help the artist's sisters, and a new target of £3,000 was set. Grateful as they were, the sisters still did not feel that the appeal was being run properly, and they did not like the treasurer, who visited them at Kilburn and treated them in a very patronising way.

An exhibition of Louis Wain's work was arranged at XXI Gallery from 4 October to 7 November. By this time, he had settled in so well that he was able to produce several works to be included in the exhibition. The rest of the show was made up, for the most part, of his drawings and paintings which had been given by their owners so that they might be sold to aid the artist – which clearly shows the place that Louis Wain held in so many people's affections. Over 80 works were collected for the show, which was a tremendous success. The Louis Wain Fund catalogue, *Souvenir of Louis Wain's Work*, was profusely illustrated with Louis Wain cats, and sold thousands of copies, running into four editions.

The *Souvenir* included much biographical material, not all of which is accurate.

Each catalogue contained details of the Louis Wain Fund Ballot, in which the first three prizes were pictures donated by the artists E. Vernon Stokes, E. O. Lamplough and Herbert Wills. The total value of these pictures was said to be £175 – such was the esteem in which Louis Wain was held by his fellow artists. The response was so overwhelming that the closing date for the ballot was postponed from 23 December to 31 March 1926.

Louis Wain was enjoying life more now than for some time past. The conditions at Bethlem were rather better than those at Springfield; he had some status now that his fame was re-proclaimed to the world, and of course the personal interest of Ramsay MacDonald made him an important patient. Bethlem Royal Hospital was at that time in St George's Fields, Southwark, whence it had moved from Moorfields in 1815. What remains of the buildings to which Louis Wain was admitted now houses the Imperial War Museum.

Bethlem is an ancient foundation, going back to the year 1247. One of the Royal Hospitals, it was privately administered by a Board of Governors which has close historical ties with the City of London. A county mental hospital such as Springfield would normally accept patients with a residential qualification in that county as so-called 'pauper' lunatics. Bethlem, however, accepted patients from a very wide area, some of whom

were maintained at the expense of the hospital, on the free list.

At Bethlem, Wain had a room of his own and, though the door was never locked, he was able to keep his personal belongings in comparative safety. His old collecting instinct came to the fore again, and he kept everything which came his way. When at last his room had to be spring-cleaned, it was said that mice were found nesting in a pile of old newspapers which he had steadfastly refused to throw away.

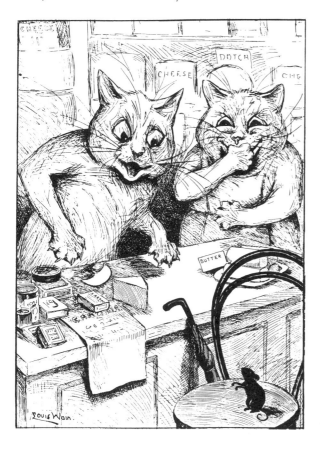

On his admission to Bethlem, he conveyed the impression, by his dress and manners, of a quaint and eccentric man. His courtesy and mode of speech placed him more in the 19th than the 20th century. As at Springfield, he spoke freely of his delusions: he was 'filled with electricity', and had 'magic power of healing by the laying on of hands'. He proved quiet and co-operative in his general relationships, busying himself once again

with drawing and painting, and giving the impression of working close to his earlier high standards.

To some, it seemed at first that he had a grudge against men, which may have been the result of some unpleasant experience at Springfield. Until he settled down, he did not respond well to the requests of the male nurses at Bethlem, but as he got to know them and they won his confidence, they were able to get him to do what they wanted. Later he became more reasonable, responsive to all remarks addressed to him, and demonstrated his unusual but definite sense of humour. He still harboured extravagant ideas of science, health and politics. Although he continued to draw cats, he started also to produce fantastic landscapes, often containing Italianate buildings. His colours are not always all that might be desired: he seemed to have lost some of his colour-sense and much of his work was very crude. This effect, however, is often due to his having to make do with what crayons he had available and he was not, of course, allowed to have a sharpener.

Although described as 'something of a recluse', when he did decide to go out he was always ready to chat with anyone who approached him. He was sometimes much amused by the antics of his fellow-patients, and not above playing a practical joke himself. There was a parson-patient at Bethlem who, when he was not immersed in his Greek testament, delighted Louis with his impromptu sermons. One day, Wain borrowed this testament and approached another patient whom he had noticed reading a German novel. Quickly, he snatched the novel, and thrust the Greek testament into the surprised reader's hands.

'Here you are', he said. 'Exchange is no robbery.'

The other looked at the book.

'But I can't read Greek', he said sadly.

'And I can't read German', replied Wain, 'so that makes us quits.'

It was not easy to resolve the situation.

There were also two doctor-patients, whom he found very amusing. He could never understand why they disliked each other so cordially. At exer-

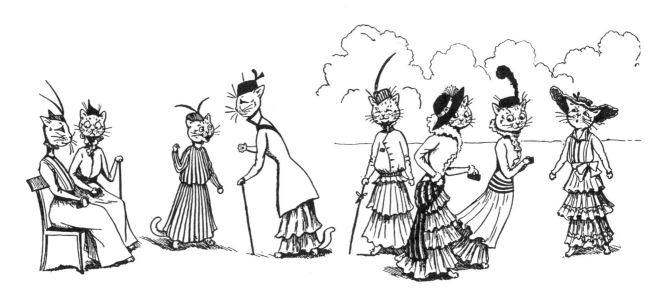

cise time one would stay in the billiard-room, while the other ran round and round the grounds, saying that he must keep fit, as he had a very large practice. Louis Wain laughed immoderately at this, and confided to a fellow patient: 'I think doctors are quite mad'.

His sisters visited him regularly, bringing him drawing materials, and collecting for sale any work which he had produced. Sometimes they would bring him a commission from a publisher, but such work was not readily available as there was no guarantee of when, if ever, it would be delivered. They found the visits rather a strain, as they never knew what mood he would be in; he still had delusions about their hostility towards him.

It was the custom at Bethlem to decorate the wards for Christmas, and a crib was set up in the ward in which Louis Wain lived. The staff invited him to contribute to the occasion, whereupon he went up to the ward mirror, a heavy bevelled glass in a wooden frame, and painted on it a scene showing cats in a gleeful mood facing one another across a Christmas pudding. After Christmas the mirror was taken down and stored away, to re-appear for decoration each Christmas. It is still preserved at the present Bethlem Royal Hospital in Beckenham.

Something of Louis Wain's impression of his surroundings can be gathered from a complaint which he wrote to his doctor on 28 October 1928, from '7 Room 2 Gallery'.

In the central Dining Hall today a patient sitting next to me from our gallery showed that indeterminate condition of a sudden pull at my coat and talk under breath to sit down. As the present uncertain winds bring the change of temperature on the uncertain cases, I judged it advisable to shout in his ear Be Quiet! and Wake up! as sharply as possible. This aroused him into quiet. He was badly steamed while at 6 months scullery work and this has had the condition of recovery made a matter of time as all the morning movements upset him and his difficulty is now to eat his good meal . . . I talked to the chief of the Hall about it so he will know the condition & the result of the few words. My own condition is a constant improvement by constant work and I am enabled to know what is best to be done.

Yours sincerely
Louis Wain

The style of this letter is clearly that of Louis Wain. The handwriting shows no deterioration, and the words flowed from his pen as they had done in the past. There are no alterations or erasures.

What had happened to the Louis Wain Fund? In April 1929, the *Daily Mail* reported that their attention had been called 'to the strange history of the national fund raised on behalf of Mr Louis Wain, the cat artist, and his relatives. At least £2,313.12.11d was subscribed, but of this amount, the Wains, according to the most generous estimate, have received only £639.10.5d or

less than 6s in every £. On the other hand, the general costs of the appeal are given as £539.3.8d; exhibition and show expenses £113.1.10d, and the production and postage of souvenirs and annuals, £630.14.1d.' [74]

If the 'generous estimate' was correct, £391.2.11d seems to have gone astray. The treasurer admitted that he had got into a muddle, but said: 'All the facts have been investigated by the Public Prosecutor, and he has decided there is no ground for action against me.' Which was all very well, but not particularly helpful to the Wains. However, Ramsay MacDonald had by no means lost interest in the case, and the *Daily Mail* the following day reported that the Prime Minister 'wishes it to be known that he will be pleased to receive donations on behalf of Mr Louis Wain, the famous cat artist, and his three elderly sisters.'

The column went on to explain what had happened to Louis Wain and to the fund. Then:

'Mr MacDonald told a *Daily Mail* reporter at the House of Commons yesterday: "If people will give further help I will undertake to see that any money sent to me for the purpose will be properly safeguarded and administered. Mr Wain himself will be as comfortable as his age and health will allow. Some of us have seen to it that he will have every possible care in Bethlem Hospital. Not so much remains, therefore, to be done for the artist himself. But for his sisters, who used to live with him and whom he kept, something further could well be done."

PICTURES AND JEWELS SOLD

Mr Louis Wain's three sisters live together in Brondesbury Road, Kilburn, NW. Miss Josephine Wain, aged 65, is too ill to work. Miss Claire Wain is 68 and an artist of note. She has worked for a firm of pencil manufacturers, drawing at exhibitions with their pencils. Her younger sister, Miss Felicie Wain, who traces designs for a boiler-making firm, fell ill recently and for eight weeks was in bed. Miss Claire Wain nursed her two sisters, though money was very short. Then she in her turn collapsed, worn out with the strain. She said yesterday: "We want to keep the house just as Louis left it. He often asks us about it, and it would break his heart to know that we have had to sell one or two pictures and a jewel or two to keep going. I cannot tell you how grateful we are to the Daily Mail for what it has done for us. I hope now that we shall not have to sell anything more." [75]

It was lucky indeed that the Wains had such an influential champion. Interest in their case was aroused again, collections were taken up all over the country, and the money was forwarded to the three ladies at Kilburn. Ramsay MacDonald was also able to arrange a small Civil List pension for Wain's three sisters 'in recognition of their brother's services to popular art'.

The following year Louis Wain's condition was reviewed, and it was decided to transfer him to Napsbury Hospital, near St Albans. Napsbury is a very pleasant hospital, set in beautiful gardens and surrounded by trees, just off the A5. Louis Wain was moved there on Friday 30 May 1930.

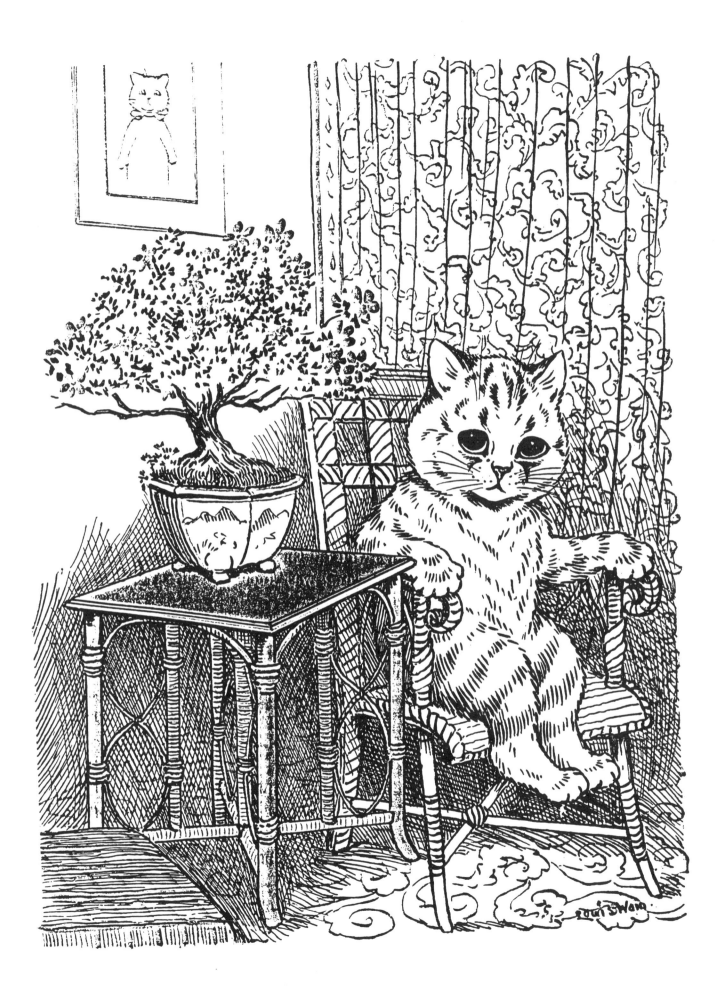

16

Napsbury

It took Louis Wain some time to settle down at Napsbury. He gave the general impression that he was much more feeble than he had been at Bethlem, less in touch with everyday life, and more than ever influenced by his delusions that he was acted upon by electrical and other agencies, and by icicles.

He made mistakes in identifying people and had little appreciation of his situation. His conversation would start off normally, but he would rapidly tire, and lapse into incoherence. His letters were in the same vein; he started to write to the editor of the *Morning Post*: 'Sir, Equality of opportunity is not equal opportunity for opportunity is left for rank and cultivated knowledge to the moment to equal all true to method constant communing . . .' and so on.

Physically, too, he was in indifferent bodily health, and there was some evidence of arteriosclerosis. He was said also to be showing signs of senility. As he settled down, however, he was well able to appreciate the beautiful surroundings at Napsbury, and began to draw again. On 14 June, he was tripped by another patient, fell, and broke his left clavicle. This did not seem to worry him, however, and he carried on painting and drawing, since he could work equally well with both hands. The doctors and nurses liked him well, and felt it a privilege to care for such a distinguished artist.

In 1931, another exhibition of Louis Wain's works was held to aid the artist's sisters. Alex Fraser, secretary of the Brook Street Art Galleries, lent his salon for the exhibition, and undertook to bear the entire cost of printing the catalogue and circularising his regular patrons. He told the *Daily Express*: 'I never knew Louis Wain personally, but I have always been a great admirer of his art. I am sure the public which has enjoyed his wonderful pictures for so many years will welcome this opportunity for bringing aid to his sisters in their distress.'

The Friends of the Poor, whose patron was Queen Mary, undertook to receive subscriptions for a new fund to help Wain's sisters.

The exhibition opened on 20 July, and was to have run for four weeks. According to the *Daily Express*:

People came from all parts to see these wonderful pictures. The story of the tragic plight of Louis Wain's sisters went all round the world and Alex Fraser got orders for Wain drawings from America, India and the continent. The exhibition was so successful that it ran for nine weeks instead of the four originally intended, and Louis Wain, delighted that the world outside still remembers him, continues to paint and draw, pictures which reveal a wonderful new talent. About £1,000 will be available for Louis Wain's sisters, enough to keep his old home intact and remove the spectre of hardship which has been a nightmare to his three devoted sisters . . . And, in the old house in Brondesbury, the devoted women, one almost a helpless invalid, another a gifted artist with a limited market for her art, are wondering how they can express their gratitude for it all!

Louis Wain's fame certainly resulted in his being especially cared for, as the staff never knew

bed, and he wouldn't even take his boots off if he could avoid it. He hated bathing, washing and having his hair cut and beard trimmed. If he was not watched, he would go to the bathroom in the morning with his cap on, take off his glasses, splash a little water in his eyes, and say that he had washed. From time to time, of course, he just had to have a bath and again, if he was not supervised, he would step in one side of the bath and out of the other, and say that he had finished!

He had many curious habits and food fads, which seemed to stem from a preoccupation with his health. Many years earlier, in fact, when offered a drink, he had asked for 'Bovril and soda', which had astonished his host. Now he became inordinately fond of liquid paraffin and, unless he was watched, would not only drink it, but rub it into his hair. Bent as he was on diverse odd activities, he often thought that he was needlessly frustrated. Then he would become irritable, then angry, finally shouting for the police and barking like a dog.

when the 'gentlemen of the press' would call to see how he was getting on. He was therefore always kept as tidy as possible, and allowed to wear a tweed suit of the type normally reserved for 'service patients', rather than the normal hospital uniform.

Although he still suffered from delusions, and spoke in a rambling, incoherent way, his art seems to have lost none of its skill. He began to entertain new ideas about the weather, and was always complaining of the cold. On the hottest July day he would go round shutting the windows saying: 'the icy cold winds are upon us – we must take care'. And take care he did. Even in summer, he would muffle himself up in his thick suit, waistcoat, cardigan, shirt, woollen vest, woollen pants, muffler, gloves, mittens, and a cloth cap pulled down well over his ears. He always wore his cap, even in bed.

Sometimes it was with the greatest difficulty that he was persuaded to undress before going to

But his draughtmanship was hardly affected, though he did not concentrate entirely on cats. He drew other subjects, and designs, some of which contained cryptic stylised cats. He produced landscapes in vivid colours and strange river scenes, with water appearing to flow up out of a well into a river. This may have had some connection with his desire to drink 'well-water', on the grounds that it was good for his health.

Visiting days were Wednesdays and Sundays. Claire and Felicie came most Wednesdays, but never on Sundays. They would bring Louis new drawing materials, and take away any finished work. They tried to coax him to draw what they wanted, but did not always succeed, and became somewhat irritable when he insisted on producing the patterns which they described as 'wallpaper rubbish' for, they said, it was unsaleable. But when they gave a sheet of his 'wallpaper rubbish' to an old friend they said that it was 'very interesting, as it showed the sort of intricate work which he was still capable of doing'.

He wrote less and less. There was a piano in the ward, but he never attempted to play it, as he would have done in better days. When drawing cats, he frequently used magazine illustrations of people whose expressions he wished to catch, transferring these expressions to the cats. It is said that he often used the face of a well-known film actor of the time, Bull Montana, especially for the look of the eyes which he needed. (I found a picture of Bull Montana, but his eyes were in heavy shadow so it was not possible to find out what exactly attracted Louis Wain. When another picture suffered from exactly the same defect, I gave up.)

Wain was passionately fond of juicy fruit, and from time to time friends and admirers would send him oranges, which he loved most of all. It was sometimes possible to get him to start drawing by bribing him with fruit. On other occasions, he would take a drawing to a nurse saying, for example, 'Here you are – a pound of tomatoes, please'.

He spent quite a lot of time out in the grounds, which were so spacious that he could sit and sketch without being disturbed by his fellow-patients. Sometimes, he would talk to children of members of the staff, and give them sketches. They remember him as a quiet, kindly old man with a grey beard.

At Christmas, as at Bethlem, he took part in the decoration of the wards, again painting on mirrors. In 1935, for example, he painted a Christmas scene showing three kittens at a table with crackers and a plum pudding on it. On the left is a large cat dressed as Father Christmas, holding up a little kitten with a strange halo. The celebration is evidently taking place out of doors, for there is a holly tree and a hedge in the middle distance, and in the background a strange domed building and palm trees. It was said that Wain left the halo blank until Christmas Eve, when he completed the picture by painting in the kitten's face. Whether this has any religious significance is impossible to say. This mirror has been glazed and preserved, along with another mirror picture of three singing cats.

The Artists' General Benevolent Institution contributed towards the supply of comforts for Wain. Claire and Felicie continued to visit, taking what other comforts they could afford, and presents from his many well-wishers. It was touching that so many people who had never known Louis Wain continued to send him gifts merely because of the pleasure which his drawings had given them.

The last book to bear his name was published in 1934. This was *Louis Wain's Great Big Midget Book*. The *Daily Express* reviewed it as follows:

LOUIS WAIN STILL DRAWS CATS, BUT HIS STUDIO IS AN ASYLUM

In a house in Brondesbury, three elderly women spend their days in devoted service to a famous brother who, for the past ten years, has been a patient in a mental institution. They are the sisters of Louis Wain, the inimitable creator of cat pictures. By their efforts a small children's book has just been published, containing a further selection of Louis Wain's drawings. It is called Louis Wain's Great Big Midget Book (Dean, 6d). For such a modest volume, it has a big history. Many of

the drawings were done during the past year, at the asylum. Others date from the days when Louis Wain's name was on the cover of every favourite annual.

Louis Wain is aged 75 now. He works with difficulty. But the impulse to draw cats remains with him, and periodically he draws with energy and intelligence.

STIMULATES HIM

Miss Claire Wain, who assisted him in the illustration of his new book, visits her brother once a fortnight. She stimulates his confused mind. "To-day, Louis", she tells him gently, "I want you to draw me a kitten with a ball of wool." Louis listens, and nods his head. Perhaps a week will go by and he will not draw a line. Then one day, he will take a piece of bread from the asylum table, go out into the grounds, and coax the stray cats that frequent them to 'sit' for him. By the genius of his pencil they are transformed into figures of fun.

"'My brother is as happy as he can be", Miss Claire Wain said to a Daily Express reporter yesterday. "He pleads at times to be allowed to come home. But we cannot let him; we could not afford to pay for the attendant he would have to have."

TO FREE HIM

"He spends much of his time making watercolour landscapes. But cats insist on creeping into them."

For 18 years, Miss Wain and her sisters have lived for their brother. They have held exhibitions of his work, and raised money to save him and their home. Now, when they are old, as he is, their energies are directed towards the accumulation of a sufficient sum to make it possible to release him from the institution, and bring him home to spend his last days in their care. [81]

Journalists usually referred to 41 Brondesbury Road as 'the old home', doubtless to make a 'human story' of it.

Coupled with this is the story of Louis Wain's continual pleading to be allowed home, and his sisters living for the day when he could. As far as can be gathered, Wain never spoke of his home with any particular feeling, and expressed no desire to go back to it. His sisters, too, knew perfectly well that they could not look after him, and that he would be a further financial liability. On Friday 20 November 1936, Louis Wain suf-

fered a stroke. This affected his speech, and produced some weakness in his right arm and leg. However, a few days afterwards he wrote four signatures, one with each hand, and two in mirror-writing with the left hand. These appear normal, though the right hand is slightly shaky. He also insisted on drawing a cat with his left hand; this drawing is regarded as quite a good specimen of his work.

In June 1937, an exhibition of 150 of Louis Wain's works, old and new, was held at Clarendon House, Clifford Street, London. It was not overlooked by the critics that his style had changed considerably from that for which he had been famed; some averred that it was for the better. They were pleased to see competent, colourful, imaginative landscapes, where they had expected to see just more cats.

On the reverse of one of his drawings, a 'typical rough sketch of a belligerent tom-cat', as its owner describes it is written:

Me? I am the origin of nothing I came to the
world to try to be the whole of the creation
I was told the world went round
I was told the world went to sleep
I awoke to the truth. I was nothing
Nothing goes round Saw not went not
came not. The Origin was lost to the
world's light. I came and unable it
had no chance to give. It slept the sleep
that nothing could awaken. The Sleep
compels the opening of an eye. The
eye was not there. It was at rest. It
would not open out as it was nothing.
The slumber rested. It was gone abroad
The abroad was nowhere. The rest was
at an end. The miraculous was the
result. Something went to find the opening
for nothing came to life. Life was then
absent. Nothing held sway, the end
being the never condition, it went on to
nothing. The end ended. This gave the
end no chance to finish. It was nothing
The light of God was to finish the evil of all
the evils of nothing. The evils of nothing died
The evils of nothing can only once more come.

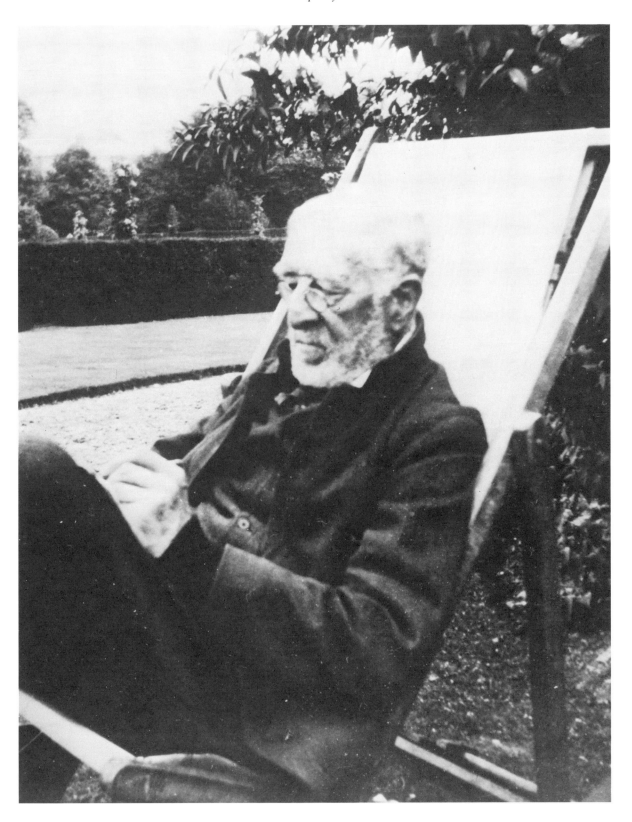

This is probably one of Louis Wain's last pieces of writing, and affords a glimpse of the sort of 'secret writing' which he must have been indulging in many years before. Someone described it as 'cosmic speculation', but it is far too vague to provide us with any insights.

After his stroke, Wain was moved to a different ward and, though he continued to draw and paint, did so less frequently. In November 1938 he became ill, with a high temperature, but made an uneventful recovery. He spent more and more time in bed, became more and more incoherent, and hated being approached.

On Saturday 14 January 1939 his sister Josephine died. She had for many years been housebound with arthritis, and so had never visited Louis. Somewhat unwisely, perhaps, he was not told of her death, but he did ask why she had stopped sending him notes. His sisters were advised that there would probably be no harm in telling him, but they chose not to do so. The deception did not have to be carried on for long.

By the end of May, Louis Wain was confined to bed. He was almost completely incoherent and isolated, and shouted loudly when he was approached for necessary attentions. Occasionally, he looked at a newspaper, or took up his pencil, but his life was drawing to a close. He died of kidney failure and hardened arteries on Tuesday 4 July 1939, a month before his 79th birthday.

The following day, his few belongings and unfinished drawings were given to his sister, Claire. His body was taken to the church he had attended in the old days – the Church of the Sacred Heart, Quex Road, Kilburn. There he lay overnight. The following morning Mass was said, and Louis Wain was laid to rest with his father, and sisters Caroline and Josephine, in the grave at St Mary's Cemetery, Kensal Green.

17

Retrospect

SO ENDED the strange life of Louis Wain, one of the most well-known popular artists of his time. Seldom can anyone so well-known so recently have been forgotten so quickly. It is not as though he had been merely a voice on the wireless, or an image on the television screen. He left behind him something tangible – thousands upon thousands of cat drawings, some in books, some in postcard albums, some in scrapbooks, some framed and displayed. But such is the changing taste of the public that all the good he did, in so many ways, is almost forgotten.

And most of what he did for the public was good. He helped to improve the lot of the cat, and to raise its status. In doing so, he promoted interest in animal welfare generally. Through his art, he gave an enormous amount of pleasure to a great many people of all ages, and gave generously of his talents to help any good cause.

In spite of all this, his private life seems to have been far from happy. He was born with a mental constitution which destined him for an abnormal life, though his first real reverse, the death of his wife, was not of his own making. What effect it may have had on him subsequently, we cannot say, but we have seen how failure and disappointment followed Louis Wain, and were so often the result of his being unable to come to terms with reality. On the other hand, he almost certainly understood what was going on, although he was powerless to control it, and he seldom attempted to make excuses or to blame other people for what happened to him. His Micawberesque belief

that 'something greater' was about to happen constantly prevented him from making the 'conscious efforts' he was always talking about.

When the Press heard of the death of Louis Wain, many obituarists reached for their copies of *Who's Who* and the 1925 *Souvenir of Louis Wain's Work*. The result was that a great deal of inaccurate information was revived, though in the face of the 'hot' news of the day – imminent war, and the enquiry into the tragedy of the *Thetis* – probably little harm was done.

Claire and Felicie stayed at Brondesbury Road for the time being, surrounded with their memories of Louis: models, paintings, drawings, newscuttings, books – his lifetime's work. Claire continued to draw and paint. She had delighted visitors to the Industrial and Decorative Art Exhibition with her work.

VERSATILITY IN ART

No better evidence of the virility of modern art could be obtained than the holding of the recent Industrial and Decorative Art Exhibition. Considerable attention was attracted during the exhibition to the work of Miss Claire Wain, alike for its merit and versatility. Although appearing primarily as a black and white worker this artist had also on view several specimens of painted glass-work in various designs of fruit, birds and flowers – afterwards gilded.

It is very rare in these days to find such widely different techniques handled successfully by the same worker, for the craze for specialization of a very narrow order has extended from industry into art.

Miss Wain, has, however, avoided the dangers which

arise from too narrow a concept of art and, at her studios at 41 Brondesbury Road London NW1 many examples of her work in different techniques may be inspected. Specially interesting are her studies in black and white of cats and various historical buildings, whilst the painted glasswork already referred to is well worthy of close inspection.

Apart from her private commissions, Claire continued to demonstrate for the Royal Sovereign Pencil Co, using their various grades of pencil to draw landscapes and seascapes, thus showing another facet of her 'versatility in art'.

A Louis Wain Memorial Exhibition was arranged in September 1939. It was less of a success than it deserved to be, as most people at that time had other things to worry about. Although the critic of *The Times* allowed his attention to wander, he does give us some idea of what the exhibition offered.

LOUIS WAIN CATS
A MEMORIAL EXHIBITION

Mr Louis Wain who died last July, and is the subject of a memorial exhibition at the Brook Street Galleries was neither a great draftsman nor a subtle interpreter of animal life, but he had a facility, inventiveness and a sense of fun, and he created a type of cat that was distinctly his own. It was not an interpretation of feline character that would commend itself to all cat-lovers, but it summed up some of the more riotous characteristics of the breed, and most of us have at one time or another encountered a Louis Wain cat in real life. An example that comes to mind was "Harry", lord of a Cotswold pub, who, having disgraced his name by producing kittens, got accidentally locked in the cellar where he sampled the beer and ran amok . . .

Some of Mr Wain's earlier work, original and reproduced, such as his very popular "Madame Tabby's Academy" and set of cats golfing, is included, but the majority of the pictures belong to his hospital days.

These are in colour and they show an interesting development – a decorative stylisation, recalling the Malay "Wayang" replacing the slick penmanship of his earlier drawings. The subjects are still mainly cats but they are associated with landscapes and flowers, evidently a delighted discovery of the artist, and some of the designs show a good deal of imagination.

As a man who gave simple pleasure to thousands, Mr Wain deserves to be remembered.

The exhibition, which includes Mr Wain's collection of Cat Models in glazed pottery and other materials, with examples from Egypt, China, India and Czechoslovakia, and decorative glass paintings by his sister, will be open until October 14. [98]

Claire and Felicie, of course, were not young, and the strain of their years of worry had had its effect. Felicie became ill with several diseases: old-age diabetes, arteriosclerosis and kidney trouble. She was admitted to hospital at Willesden, and died there on Thursday 8 February 1940.

There was no point in Claire staying at Brondesbury Road in a huge house which she did not need and could not afford, so she moved to a flat in Dulwich. She was very stout and bronchial and, though she lived in constant fear of illness, found many simple pleasures in life. She lived until just after 'VE-Day', and died of heart failure on Sunday 20 May 1945. She is buried with her father, brother, and three of her sisters.

At the time of her death, few of Louis' possessions remained to her. An elderly lady in a small flat inevitably tidies up and gives much away. Of Louis' personal collection only a few paintings and some of the cat models survived intact. But all over the world, individuals cherish perhaps a tattered childhood book, perhaps a picture or two – and their own special, personal memories of Louis Wain.

18

The Art of Louis Wain

IT WILL have been noticed that, as his career progressed, Louis Wain drew many different types of cat. One feature they all had in common, however – the large eyes. It has often been said that the eyes of the Louis Wain Cat are nothing like those of any other cat, and it has been further asserted that he drew them that way because he was copying from the human eye.

But this is just not true. Observe the human eye, and you will see that the pupil tends to be masked by the upper eyelid. Draw a cat with eyes like that, and it is hardly a Louis Wain Cat. The pupils of the eyes of a Louis Wain Cat are nearly always masked by the lower eyelid.

Obviously, Louis Wain was asked about his cats' eyes on many occasions, and in 1898 answered thus:

'We say that a dog is more intelligent than a cat simply because we don't allow our dogs to roam about the streets at night and pick up miscellaneous companions, whereas the majority of householders, I find, turn their cats out at night to rough it. In fine, they domesticate their cats in the daytime and at night they turn them back again to a state approximating to their natural savagery. It is cruel. The effect of this treatment on the appearance of the animals themselves is most marked. Their noses get long and "snipey", their eyes become almond-shaped, and their form and figure grow more lithe. Directly, however, you keep them in – curtail their liberty, give them more attention and domesticate them, as it were, into the home life – these defects I have enumer-ated tend to change. The eyes alter first. These grow very round and large. The faces follow. The noses become more snub and the contour of the features rounder, while the ears get smaller, the body more compact, the anatomical configur-ation less angular, so that in the end the cat becomes more like a ball of fur than anything else.' [22]

Since one would not expect the bone-structure of an adult cat to change very much if it stayed in at night, the alterations of shape which Wain describes are no doubt due to the better feeding which a well-looked-after animal would have.

'At the same time', Wain continued, 'I am bound to admit that people have often wondered whether the large eyes of cats in my drawings are not somewhat exaggerated. This is not the fact, as can be seen by a visit to any good show and a casual glance at some of the finest animals on exhibition. The real truth of the matter is this: A cat shows more of its breeding through its eyes than it does through any other feature.'

This simple answer – in effect, 'why not look at the eyes of a healthy cat?' – seems too good to be true. We don't believe that cats' eyes are like that, and are surprised when we find to the contrary.

This is not to say that the eyes of Louis Wain's comical cats are always completely true to life, but they are often much more lifelike than they look. We must remember too that the very early cats were drawn from models, and were not 'comical' in the sense that the later ones were, and their eyes are just as large.

Let us turn now to Louis Wain's art in general. For convenient reference I will divide his work into four categories: Animal Portraiture; Humorous Animal Drawing; Buildings and Landscapes; and Patterns. Of course, there is some overlapping of the categories, but the animate and inanimate components of any picture may be considered separately.

Animal Portraiture

Louis Wain's animal portraits have a certain sameness of expression about them: his subjects tend to look very serious and unwell. However, his patrons – who included many members of the Royal Family – kept asking him for more, so presumably they were satisfied with the results.

In 1923, Wain gave a talk, with lightning sketches, to a Surrey Rotary Club. He was noted as being 'apparently down on his luck', and he offered to execute portraits of members' animals for modest fees. At least one commission was offered, but the result (in the opinion of the dog's owner) was not satisfactory.

However, that may have been an isolated failure. Here is a story of a more successful attempt at animal portraiture which in addition tells us much about Wain's method of work.

'This is a very personal memory of Louis Wain. Books containing his drawings, especially of cats, were very well known to my sister and I in our childhood, and his name was "of our household" in every way. In 1922, when I was nine and my sister four years older, we lived in a very attractive thatched house at Birchington-on-Sea, Kent – and Louis Wain called on us! He was staying at Birchington, and was so taken with our house that he asked permission to paint a picture of it. Here my memory is very clear – I remember exactly where he sat to get the view he wanted, and I recall that he said he was going to take the picture to America.

'So Louis Wain came each morning and painted – in watercolour – my sister and I trying to see, but warned by our mother to keep away! Then one morning it started to rain. "Would Mr Wain come in? . . . A cup of tea? . . ." So into the

oak-beamed lounge he came, delighted with the inside of the place. Here we really could watch him at work, cup of tea beside him. And suddenly – delight! – he dipped his brush into his *tea* instead of his little water pot! Thus did he become our family tradition – thus did my mother's injunction "never suck your paintbrush" lose all effect.

'The painting was finished, and he took it away with him. But on the last morning he came, he said that as a present to us he would paint pictures of our animals – Bunty the Chow Dog, Major (called Wozzer) the Yorkshire Terrier, and Moppet our ginger cat.

'Inevitably, the cat was a Louis Wain one, and not a good portrait of Moppet. The dogs were true to life, and we received from Louis Wain a lesson I have never forgotten. We watched him paint the brown hairy face and then he came back to the black body. My sister said "Now you'll want some black". He stopped his work. "Not black. There is nothing black in nature; very dark brown or blue perhaps, but not black. You see – there is no black in my paint-box." And neither there was. So he used some other dark colour, and behold! A portrait of Wozzer!

'There remains for us the memory of a rather fierce-looking taciturn man, who nevertheless became friendly and really informative at our child's level on better acquaintance!'

Humorous Animal Drawings

By contrast, let us read Louis Wain's own description of how he executed his more humorous work.

'I am told that I am very serious over [my humorous work] but as a matter of fact I am bubbling over with interior laughter until I am tired, not of drawing, but of laughing. It is a species of laughter which is very keen and absorbing, and carries one away from one's surroundings, and I often feel afterwards as if I am aching all over.

'Sometimes I get this mood upon me when I am drawing at charity bazaars, when pace comes into my pencil, and I draw an extraordinary

number of sketches in a very short time. But they are keen mind-impressions drawn at concert pitch and full of life, and I sometimes think that I should like to keep these sketches myself, as I cannot draw them under studio or other conditions as I can at these bazaars and I have nothing by me to represent these moods. It is, as I might express it, the quintessence of expressed life, as far as one can go and remain reasonable

. . . Sometimes the mind satiates with pencil or pen-and-ink work, and takes readily to colour as a relaxation, sometimes it is the other way about . . .

'One thing, however, is extraordinary; in drawing my cats, I always commence by drawing the ears first; *in every case I do this*, and if I try any other way the proportions are certain to go wrong. Why, I do not know. Whether it is mere habit, and I have grown into it as a habit difficult to break, or not, it remains the same; any unsatisfactory work comes when the ears have not been the first keynote of the drawing.

'Again, I am in the habit of drawing at a table on a flat drawing-board, and if I take to an easel my work becomes quite different, almost as though it were done by another man. The easel begets greater strength of handling, freer work and better tonality, but not such careful drawing.

'Then there is that wonderful 6B pencil drawing. There is nothing to compare with the comfort of drawing and the freedom and strength of

handling it gives; but, of course, you must thoroughly know your work, and have a firm grip of your pencil when doing it.

'But perhaps the most taxing of all work is marking in red Venetian chalk, a sort of brown red, rich and strikingly beautiful. It pulls on the paper and makes one very tired working it in consequence.

'As my work is done at great pace, and every stroke has to be put in very accurately without correction, one cannot rub as one can pencil, and a wrong line spoils the whole drawing, and one cannot make a pencil study first of all to work over, as the pencil surface is slippery and will not take the chalk readily, and rubbing out with rubber spoils the paper for chalk. Consequently, when at rare intervals I work up to doing a red chalk drawing, I am loath to part with it, because it means so much.' [61]

Many people are surprised to find that Louis Wain drew anything other than cats. There are many books, however, which show a whole range of Louis Wain animals, both real and imaginary. He created Louis Wain Owls, Frogs, Hippos, Fish and many other creatures. These suffered very little evolution throughout his career.

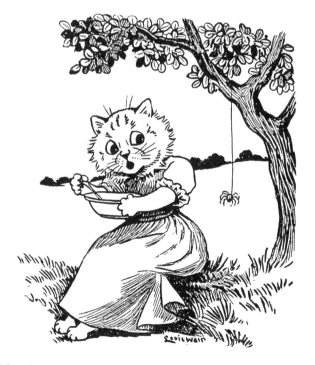

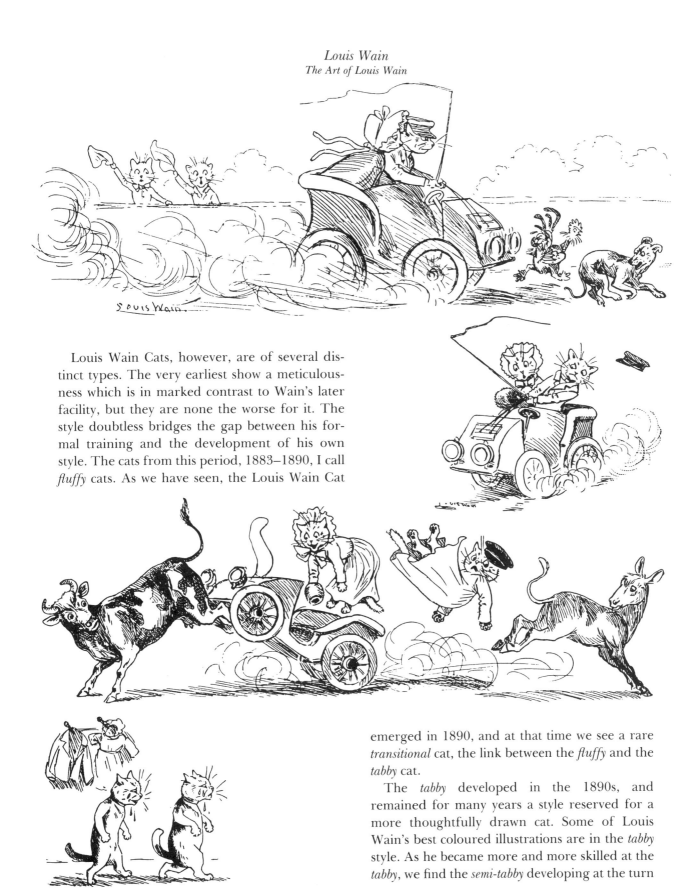

Louis Wain Cats, however, are of several distinct types. The very earliest show a meticulousness which is in marked contrast to Wain's later facility, but they are none the worse for it. The style doubtless bridges the gap between his formal training and the development of his own style. The cats from this period, 1883–1890, I call *fluffy* cats. As we have seen, the Louis Wain Cat

emerged in 1890, and at that time we see a rare *transitional* cat, the link between the *fluffy* and the *tabby* cat.

The *tabby* developed in the 1890s, and remained for many years a style reserved for a more thoughtfully drawn cat. Some of Louis Wain's best coloured illustrations are in the *tabby* style. As he became more and more skilled at the *tabby*, we find the *semi-tabby* developing at the turn

117

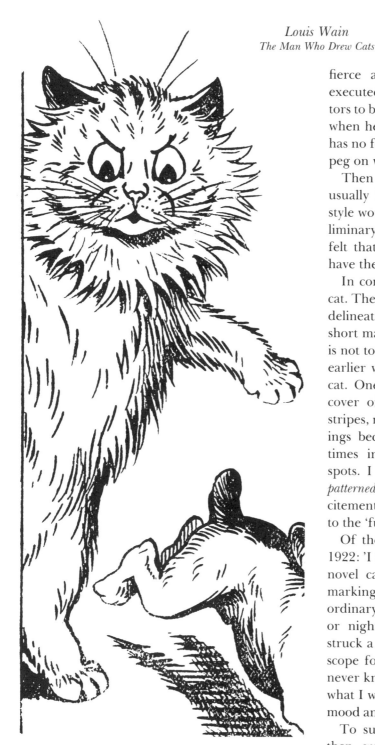

fierce appearance of some of these rapidly-executed *spiky* cats which has led some commentators to believe that Louis Wain drew 'fiendish' cats when he was 'mentally disturbed'. Such a theory has no foundation in fact, but offers a convenient peg on which to hang a 'sensational' article.

Then again, we find the *sketched* cat, which is usually built of straight lines. Drawings of this style would normally be treated as an artist's preliminary sketch, but as time went on Louis Wain felt that he could 'work them up' slightly, and have them accepted for publication.

In contrast to the *spiky* cat, we find the *smooth* cat. The outline of the *smooth* cat is continuous; its delineation does not depend upon a series of short marks to give a furry effect. The *smooth* cat is not to be confused with a type which appeared earlier with an unbroken outline – the *patterned* cat. One of the first of these appeared on the cover of the 1902 *Annual*, with stylised tabby stripes, no hint of fur. In later versions, the markings become even more stylised stripes, sometimes in bright colours, and sometimes even spots. I feel that behind the production of the *patterned* cats there is some feeling of daring excitement and experiment, which led on naturally to the 'futurist mascot cats'.

Of the design of these, Louis Wain wrote in 1922: 'I have just done a whole series of strikingly novel cats to be produced as china cats. The marking of these cats was of the most extraordinary interest, and I could not leave them, day or night, until finished. First, because I had struck a novelty; secondly, because they gave me scope for striking expression; thirdly, because I never knew from one moment to another exactly what I was going to do. It was the expression of a mood and it all came out as a surprise to me.' [54]

To summarise the types of Louis Wain Cat, then, we have: 1883–1890, Fluffy; 1890–1892, Transitional; 1892 onwards, Tabby; 1900 onwards, Semi-tabby, Sketched, Spiky, Patterned and Smooth. This classification is not to be regarded in any way as a Procrustean bed into which every Louis Wain Cat must be fitted, but it is better than no classification at all, and serves as

of the century. This cat is a *tabby* less carefully drawn and with less detailed markings. *Semi-tabbies* often appear in the background of pictures of *tabbies*.

Not long after this, appears the *spiky* cat, where the furry effect is carried to the extreme. It is the

a starting-point for the dating and description of Louis Wain's drawing.

Buildings and Landscapes

Examples of Louis Wain's architectural work drawn in the late 1880s are photographic in their accuracy and detail. But thereafter, when he uses a building as part of a picture, it is usually of a type with a timber frame and a thatched roof. I cannot offer any explanation of why Wain should prefer this type of building, unless he thought it would have nooks and crannies and mouse-holes which would appeal to cats. Taking 20 drawings at random which contain buildings, I find that no fewer than 16 of the buildings are of this type.

During his later years in mental hospitals, Louis Wain continued to draw these buildings, but his architecture tended to become more fanciful, sometimes Italianate, sometimes oriental. This seems to be a manifestation of his preoccupation with rich decoration similar to that which we see in his writing.

Now it appears in his pictures, not only in their content, but in their choice of colour. One of the

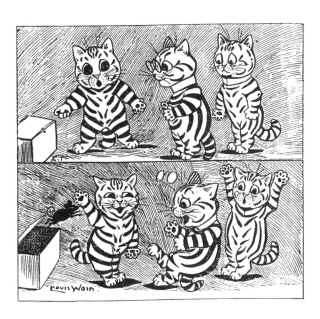

most extreme examples of this work is to be found in the Print Room at the Victoria and Albert Museum. It is described: 'Exotic land-scape, with a boat and three swans on a stream in the foreground, and a domed palace and a lake surrounded by mountains in the distance'.

Patterns

It is very rare that we find Louis Wain showing any preoccupation with pattern before 1920. Up to that time he contented himself, for example, with a simple border to a carpet, merely to show that it was a carpet. But, as we have seen, the 1921 *Annual* is full of examples of pattern for pattern's sake: wallpaper, curtains, furnishing, fabrics and carpets. Sometimes, a space is filled with pattern just to save it from being empty.

We know that this interest in pattern became more pronounced in hospital. Wain would fill up the background to pictures with 'wallpaper' designs, and at other times would just draw the wallpaper *per se*. He also produced pages and pages of 'tiles', little designs about two inches

square, no two alike. Again, he experimented with what some have called the 'disintegrating' cat, but to my mind this is nothing more sinister than a highly-coloured, two-dimensional, symmetrical cat/pattern experiment, with similar motives to those which had earlier led to the 'futurist mascot cats'.

It seems to me a distinct possibility that, with his preoccupation for pattern, his desire to experiment, his ambidextrous abilities (which would enable him to draw a symmetrical pattern with both hands simultaneously), and his memories of his mother's embroidery 'in the Eastern tradition', Louis Wain suddenly made the delighted discovery that there were catty faces hidden in the traditional carpet patterns, and he proceeded to develop this theme.

There is no doubt that Louis Wain was a competent artist. He had ability, observation and creativeness. However, he did not always make full use of his talents. Only in his earlier days, when he had to produce his best work to build up a reputation, and in his later days when he had plenty of time on his hands, did he use his skill to the full. When he was at the height of his popularity, he did not often have time to sit down thoughtfully to produce a 'good' drawing, and could dash off almost anything which would be accepted. The covers of the first *Annuals* show this.

Neither was it necessary for him to have a fresh idea every time he made a drawing. He had a number of stock expressions and stock poses which he offered time after time. Each time, they gained in speed, though, to be fair, they did not always lose in quality. This urgency of drawing, which he described as 'keen mind-impressions drawn at concert pitch', perhaps reflects his restlessness of character. He demonstrated his real skill when he was able to sit down without distraction, and become absorbed in the detail of some commission, as many of the plates in this book show.

19

Louis Wain's Illness

DIAGNOSING a psychiatric condition more than half a century after the patient's death is not easy. Even with access to the notes, one cannot be sure how far matters for the record have been selected to fit a predetermined end. It happens now, and there is no reason to believe that it did not happen then.

If schizophrenia is, as my medical dictionary tells me, 'A psychotic disorder characterised by loss of contact with the environment, by noticeable deterioration in the level of functioning in everyday life, and by disintegration of personality expressed as disorder of feeling, thought, and conduct – called also *dementia praecox*', it is hardly an inapt diagnosis of our subject's condition.

Louis Wain's illness seems to have developed gradually; he must always have seemed to be different from 'normal' people in many ways. As far as we know, the only other member of his family to show mental disturbance was his sister Marie. It will be recalled that she was admitted to Chartham Hospital (now St Augustine's) near Canterbury on 4 March 1901, having previously been under care elsewhere on account of her strange behaviour. She was at home for a few weeks before entering Chartham, but the family found themselves unable to look after her. She was then about 29 years of age and displayed a disorder which again could be diagnosed as schizophrenia. Believing that she was suffering from a severe form of leprosy she refused to let anyone come near her. At first she was difficult, resistive and taciturn, but as the years went by

and her illness advanced still further, she became happier, and would laugh as well as talk to herself in an incomprehensible fashion. She died in the spring of 1913, after an intercurrent chest infection.

Let us look at Louis Wain's peculiarities. From his own account he was a most imaginative child, haunted by horrifying visions. He had a rather solitary childhood overshadowed by medical advice, in infancy, that he was 'not to be taught or sent to school before the age of ten'. It is difficult to conceive on what basis such advice might have been given, if indeed it was given at all.

He said that he truanted from school a good deal, preferring to roam London to watch, fascinated, various craftsmen at work, visiting museums, the Docks and Woolwich Arsenal. Today such a child – especially if, as seems the case here, his school reports were bad also – would almost certainly be regarded as disturbed and referred to a child guidance clinic. But we have no record other than Wain's of these days; and, since he was writing (in 1899) as a well-known popular artist, he may well have been dramatising his childhood, as people will.

It is difficult to believe, for example, that he had 'powerful and intellectual friends' with whom, his appearance being 'irreproachable and costly', he lived it up in Mayfair. We know that later on in life he was regarded as a social oddity in Westgate, where he regularly attended dances and, though quite unable to dance, took the opportunity of giving solo turns. Coupled with

the quaint dress and habits of his sisters, this no doubt accounted for the general view that the whole family was somewhat odd.

He seems to have concentrated on certain aspects of situations in a way which suggests that he did not only fully appreciate the main features. His autobiography gives no real picture of his home and his parents; neither does it give much account of his wife. Instead there is a great deal about the family pets: the bird and the cat.

This same feature of his thinking emerges later in life, in the long letter he wrote in 1902 entitled 'The Doomed Empire' (see Appendix). Presumably, from the title and first paragraph, it is intended as a discussion of political and economic features of the nation. About halfway through the second paragraph he introduces a criticism of modern dietary habits, and the rest of this letter (which is very lengthy) is a curious mixture of his own ideas on nutrition, physiology and mental health – not to mention some feline observations

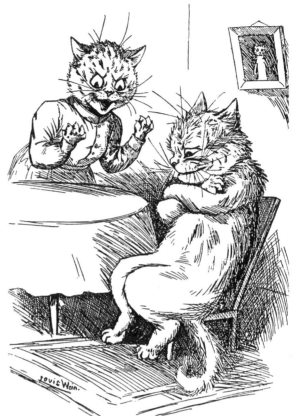

– in which, by some curious twist, the topic of the Boers is introduced. To put it mildly, this is the letter of a crank, and well illustrates his tendency to confuse minor and major issues. We must be grateful that the editor of the *Morning Post* saw fit to publish it.

Some of the ideas Wain held about the functioning of mind and body appear in his philosophising about cats, especially in relation to electrical phenomena. It seems likely that he ruminated a great deal about the physical sciences and mental functioning, and may well have read what he could about them; indeed, he went so far as to refer to some of these interests in *Who's Who*. His rich imagination did not always distinguish fact from fantasy, and this would account for his continued references to his mysterious opera. As for the mechanical inventions which he thought about but never pursued in practice, he would not be the first to have rushed to patent a 'brilliant idea'.

Collingwood Ingram's summing-up of Louis Wain – 'as eccentric as they come' – is understandable. The same observer leaves us in no doubt that Wain believed in his own fantasies. Others describe him also as shy – and humourless, presumably, from Frank Burnand's description of Wain's unsmiling face. Though Burnand calls Wain a 'neuropath' – a word much used around that time for what we would now call neurotic – Wain would be better described as a 'schizoid' individual. His shyness, fantasy life, and above all his marked fads and tendency to ramble away from the main point of his argument (as in 'The Doomed Empire') are characteristics which, when grossly developed, mark the schizophrenic, and in minor manifestation indicate a schizoid personality.

Look again at his letters to the young clergyman, the last of which was written only a fortnight before he was certified insane. There is the same digression into minor matters, and advice which seems hardly worth giving. In general this makes much the same impression as the letter of 1902 though the two are separated by 22 years. In the later letter he says that Leek is 'a town which will rise suddenly to better things once I get into touch with it', reflecting the grandiose delusions he harboured at that time. All the letters have the same strangely morbid quality.

All this illustrates the difficulty in assessing Louis Wain medically, in that his end state leading to certification developed slowly from a pre-existing eccentricity. Not surprisingly, there is a lineal connection between the delusions he displayed when certified, and the preoccupations he had when apparently well, and at the height of his fame.

The young man's speculations about electricity and polarity are succeeded by delusions that his body was charged with electricity. The young man's ideas and advice about sound health, and how to rid the body of various weaknesses are succeeded by delusions that certain drinks were harmful to him while others were necessary to his well-being. He was fascinated earlier by ether, and the speculation about the nature of space –

though such speculations were general around the turn of the century. Later delusions held that ether was the source of all evil, and was present in his food. All told, the content as well as the disordered mode of his later thinking can be traced back to similar and less evidently morbid precursors in his early life, when he was outwardly apparently normal.

What caused the change? Anyone becoming mentally ill around 60 years of age may be suspected of having some brain disease, perhaps related to degenerative changes in the tissue or blood vessels in the brain. The picture – apart from sudden crises such as the one which Wain himself sustained at the age of 76 – is usually one of a change in personality, as well as gradual loss of the general faculties of memory and perhaps comprehension. Wain did not exhibit such changes until very late in his illness, when general senile changes occurred. Generally, he maintained the characteristic old-world politeness and manner as of former years, and one of the letters he wrote while a patient in Bethlem reveals his grasp of what was going on around him.

But the most powerful sign of his state was that he continued to paint and draw for many years, arousing the admiration of his public, and calling forth the frequent comment that he retained his old skill.

The piece written in 1931 [80], when Wain was in Napsbury Hospital, of how his right hand one day suddenly seized the pencil from his left hand to draw a different kind of cat – evil as against good – is sheer journalistic invention. If it were true, it would suggest that Louis Wain suffered from hysteria, which he most certainly did not.

The basis of this account lies no doubt in a description by Morton Prince, an American professor of psychiatry who died in 1929, of a case of 'dissociated' or 'multiple' personality. Prince wrote at great length [101] of a Miss Beauchamp whom he treated for many years, frequently with hypnosis. From time to time, it appears, her body was controlled by other personalities, other aspects of her real self which normally were not in evidence, but which sometimes 'took over' so

that she behaved as quite a different person. Sometimes the take-over was complete. Sometimes the other personality took charge of one part only of Miss Beauchamp, and played tricks on her. The lay press must have heard echoes of Miss Beauchamp, and no doubt someone thought it would make a good story to attach to Wain.

To sum up, Louis Wain, like his sister Marie, was born with a susceptibility to the development of schizophrenia. In his early days this manifested itself as an abnormal personality, causing him to be regarded as odd by many of those who knew him well. This in turn made him less able than the average person to adjust to the vicissitudes of life, of which he had more than his share – the early loss of his wife, his failure in financial matters, and the changes in public taste.

In this setting, what had been merely fads, fantasies, quirks and eccentricities developed until his general behaviour became more openly deviant from normal. Nevertheless, as is generally the rule, he did not change completely; he carried into his illness the interests and skills which had been peculiarly his in his earlier days, and so continued to draw and paint as he always had, with the opportunity for his art to flower in the relaxed surroundings in which, perforce, he found himself.

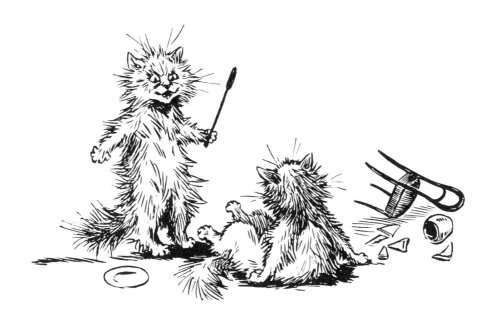

20

Art and Mental Illness

IN THE the mid-1930s the late Dr Eric Guttmann and the late the Hon Dr Walter Maclay began to collect the products of mentally ill patients. Both psychiatrists had a clinical interest in this subject, and in the effects of hallucinogenic drugs, which had been studied much more in Germany than elsewhere up to that time. They published papers on the topic in scientific journals. The collection which bears their names is now part of the Art & History Collections at the Bethlem Royal Hospital, Denmark Hill, London. It consists of some hundreds of paintings, drawings, writings, pieces of embroidery, music and other productions of mentally ill people, as well as a selection of books on the subject. Some of the material has been transferred to colour slides and film. In the collection are numerous Louis Wain pictures, postcards and books.

Interest in Louis Wain and his work was stimulated in the 1960s by speculation about art and the mentally ill. His name was coupled with Hieronymus Bosch, Goya, Van Gogh, Edvard Munch and Nijinksy, all of whom, it was averred, produced work which reflected their disturbed mental state. Louis Wain's place was assured in such eminent company because of a particular disservice to art and mental illness perpetrated by none other than Dr Maclay himself.

In a letter dated 31 July 1939, Maclay wrote: 'I found some of Louis Wain's pictures in a little shop at Camden Hill and they showed such contrasting styles that I feel that some were done before his illness and some afterwards. I know

something of his history and condition while in Bethlem . . .' Maclay arranged the eight works in an order which suggested to him a clinical progression. *Post hoc ergo propter hoc*. But let us consider the facts. There is no doubt that the eight are by Louis Wain. Two show a conventional Louis Wain pussy, one left profile with a leafy background, the other full face with a patterned background. These are executed in crayon, as are two others – an owl-like symmetrical design and a completely abstract symmetrical design in which one may discern innumerable 'faces' if one tries. Unfortunately, this drawing is unsigned, and there is no way of telling which way up it should be.

The other four works are in gouache. One is, as Curator Patricia Allderidge delightfully puts it: 'A cat surrounded by an aura of jagged coloured lines which reflects its outline, looking like nothing so much as a cat which has stuck its foot in a live electric socket and is quite enjoying the experience'. Of the other three, we identify an 'Indian' cat mask, a 'Japanese' cat mask, and an abstract design – again with faces for those who choose to see them.

With no evidence of the order of their production, Maclay arranged them in a sequence which clearly demonstrated, he thought, the progressive deterioration of the artist's mental abilities.

We know that Louis Wain painted in Springfield, Bethlem, and Napsbury. In June 1924 at Springfield his paintings and drawings

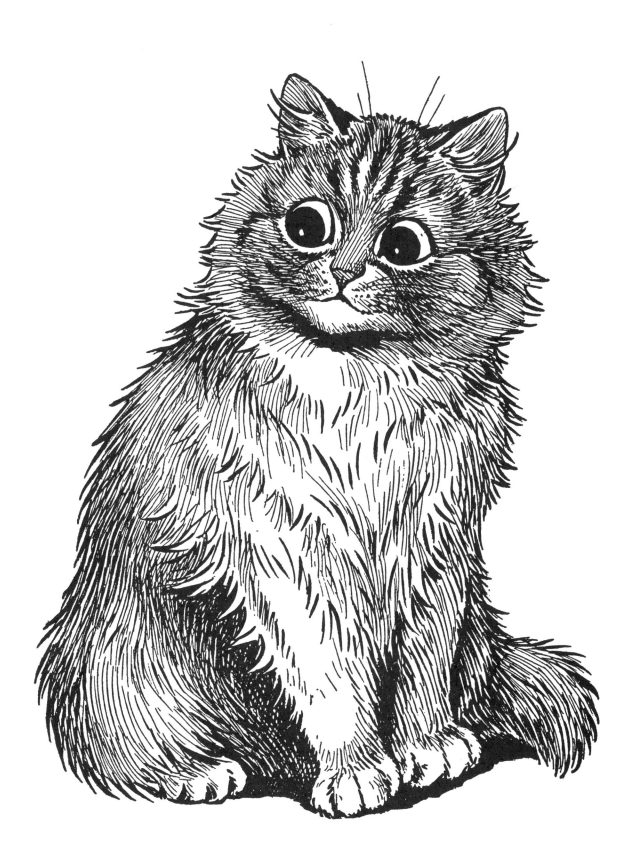

aroused the comment that his old ability was pre-
served. In Bethlem the same comment was made
initially. He was regarded as having lost little of
his technique, but mid-way through September
1926 it was noted that a change had occurred in
his art, and that his productions were sometimes
more bizarre than his earlier work.

In Napsbury Hospital at the end of 1930 his
drawing was still delighting those who saw it, who
noted that none of his skill had been lost, without
mentioning a change of style. One of those who
nursed him, Fred Deuxberry, recalls that in about
1933 Wain went off cat drawings and did nothing
but brightly-coloured floral patterns known as
'wallpaper designs'. This style may be seen in the
background of the cat in several paintings, and is
present in two of Maclay's eight pictures. It is,
however, quite different from the intricate sym-
metrical patterning in five of Maclay's pictures,
and such paintings were not recognised by Mr
Deuxberry.

It will be recalled that the Misses Wain, when
visiting their brother at Napsbury, were always
happy to have a cat painting for their collection
or sometimes, no doubt, to sell to augment their
income. They were less pleased when Louis pre-
sented them with 'wallpaper rubbish' and on their
next visit he would oblige with a more conven-
tional subject. In 1936, still at Napsbury, Louis
Wain was once again drawing cats in his old style.

Assembling what little factual knowledge we
have on Dr Maclay's eight paintings, there is
clearly no justification for regarding them as
more than samples of Louis Wain's art at differ-
ent times. Wain experimented with patterns and
cats, and even quite late in life was still producing
conventional cat pictures, perhaps 10 years after
his 'later' productions which are patterns rather
than cats. All of which is to say no more than that
the eight paintings were done at different times,
which could be said of any eight paintings by any
artist!

APPENDIX

The Doomed Empire

To the Editor of *The Morning Post*

Sir – Directly the nation gets in a slumpy mood the red rag of Free Trade is trotted out *ad nauseam* to account for the slackening of energy shown in trade generally, and the practical benefits of a wise measure are altogether forgotten. It must be remembered that when Free Trade first became a *fait accompli* our industries were almost in their babyhood in comparison to what they have become in the present day. To develop them the countryside was denuded of all who were brightest and best to meet the general and growing demand for labour. Joint-stock banking enabled men with comparatively small capital to open up fresh fields for industrial labour and enterprise, and to borrow at small interest for short periods to meet inordinate rushes or business growth. Specialised trading met a demand, and died out as the demand ended. Specialised trading in the present day has grown to enormous proportions. Businesses rise rapidly, make fortunes, flicker, then die out. Free Trade is made the bogey to account for these disasters, but it is easy to see that if we develop in one direction we must smarten up equally all round, fiscally, educationally, and what is most important of all, we cannot have at our call rapid means of bringing business about without developing rapid ways of clinching it and carrying it through. Let us bury the Free Trade bogey, for Free Trade makes us the trade and money mart of the world, and there is not a country in Europe in the present day that could directly or indirectly afford to do without our buying power, our gold. And there is no surer lever to keep the European peace than the knowledge that to tighten our pockets would mean disaster to the people of any country that dared us. Obviously to keep up our prestige and power we must make tremendous sacrifices to retain and develop the gold-producing countries within our realms, for on this depends the whole success of our fiscal system and the whole future of the nation and the Empire. Our interests for the next twenty years will centre on our African possessions, and the heart and pocket of the nation will have to open out freely to the men who will bring the blessings of refined civilisation on them, for the return they will bring us will save us at the right moment from the chance of financial collapse, and also bind our colonies closer to us for the general good.

At home we have all undergone much with the last three years. The temper of the nation has been sorely tried. Specialised trading and the arts have suffered severely, and an unnatural excitement is giving place to some disappointment and grumbling, for although activity is the dominant feature of our everyday life, it has brought with it all the penalties arising from our keenly appreciative temperament. There has been a general slackening of effort all round and everyone is waiting for everyone else to make a move. Our King, with a year's hard work, implanted an incentive in the whole nation to go forward, but little is as yet being done by our large body of leaders to help our King to stimulate a general feeling of confidence in the future, and to help the country towards the really strong financial movement which is necessary to carry us beyond the present pessimistic tendency which threatens to attack the very foundations of our commercial prosperity. There is something more than a chance mood at the back of the present dissatisfaction. Modern-day methods of living are not conducive to progress. Too often nature's call for sustenance is forgotten altogether, and the first unnatural stimulant to hand is resorted to to temporarily bridge over lapsed food interval; the habit grows, energy slackens, and it is

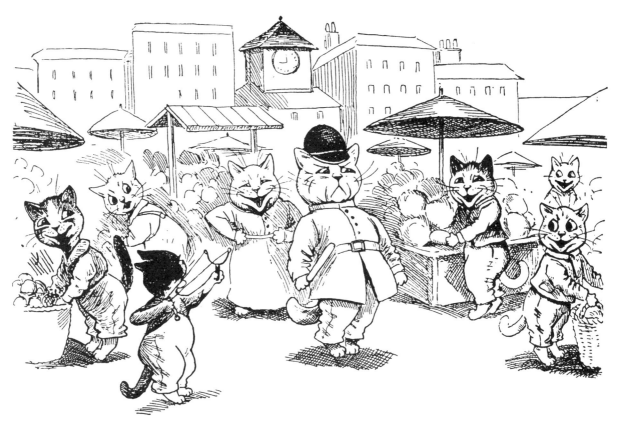

difficult to get rid of the acquired habit. If a full-blooded man misses a meal occasionally he can afford to live on himself, but if a bloodless individual, anaemic to his finger tips, oversteps the limits of nature I want to know how much he is reducing the end of his days by his fatuity, for though a little light vegetable food may stimulate nervous disorder to a pitch of mental working excitement, his physical framework has to bear the strain and wear and tear of it all, but is too bloodless to respond to help in restoring the mental equilibrium, and too numb physically to make the need felt of a want of proper animal food. This is too often the case with the prosperous City man and the vastly greater realm of thought workers, both men and women, who will go through the working day on a bun or a scone, with a cup of tea or coffee, or perhaps an alcoholic stimulant, relying on a heavy meal on arriving home in the evening, when the digestive organs are asked to perform work they have lost the power to do properly during the day.

It is forgotten that mortal death is not the only form of mental destruction. There is the mental death, which though not akin to madness leaves the subject entirely incapable of conceiving for himself, originating thought, or storing up energy; his senses are keenly alive and capable of being receptive to outside im-

pressions; his faculties, from long practice, lead him in cultivated directions, and to the selection of methods his senses are most sensitised to be receptive to. He can derive considerable pleasure from a constant appeal to his senses in different ways, and can argue with considerable force and power in a brute instinct way, with a mind that is already fixed or made up unalterably, but all the same he has passed through intellectual death, the inner man is dormant, and only some powerful influence can wake it up again from its lethargic state back to unite with mortal existence again, because inattention to proper feeding has nulled the nerve action of the body, and all the finer instincts are never called into nervous play and into active life. The intimate association of brain, nerve, and digestion is so apparent to all that one needs to point to a few warnings which will direct attention to the dangers professional and commercial life is exposed to under the modern artificial conditions of town existence. Take the analogous case of the cat, which I have studied for many years. Here is an animal whose brain is in a transitory condition of development, whose sensorium in most specimens is not in a condition to withstand the shock of rapidly changing impressions without a severe mental strain which immediately reacts on the digestive organs. As a consequence the cat will cling to the orig-

inal home, to the set of impressions the sensory nerve is most used to convey to the mind without effort, while it will suffer severe and obvious distress to the sensory organs when the sight is made to convey a number of strange and unusual scenes to them. The digestion suffers, the cat cannot eat well, and very often dies before the brain can recover its equilibrium.

Human beings, no less, are subject to mental shocks which upset both the brain and the digestion just as severely. There is the case of the person living on a level plane, whose sight is tutored to gathering in all impressions in front, around, and above him, but who becomes faint and giddy when looking down from a high window, hill, or mountain for the first time, and often such a one becomes violently sick with shock to the brain, until by continual practice the brain is strengthened to resist the novel conditions it is asked to absorb. I have known a man who was a deadly shot on the level miss every shot he made downhill through the same cause. The Boers, too, are recent examples of this, all reports pointing to the fact that their shooting from mountain sides was very bad. Yet in war all make for the hilly ground, and should be able to shoot downward. Again, many people suffer a shock mentally and bodily if a pistol or gun is fired near them. I give these cases that the man in the street may realise for himself a very simple factor which makes for degeneration and enables me to point a moral in the matter of food, for just as surely bad feeding leaves a mind subject to many minor shocks which may be the production of an outraged digestive organisation, and leading to all those difficult cases which a doctor is only called on to attend at the eleventh hour. By a wise dispensation of Providence babies are, for some period at least after birth, blind, and thus preserved from serious shocks, before they are sufficiently strong to withstand the mental impressions that crowd on the baby mind. Bad feeding habits have more to do with the present general slackening than the tightening of pockets or loss of trade. It is not the momentary spasm or a chance conceit which we are passing through. The country is in real need of the strong masterful spirit which underlies the whole character of the English nature, in real need of a more active and united support of the great King who has already sacrificed so much for the good of his people. Given this we shall hear no more of the Doomed Empire.

Yours &c, Louis Wain
Westgate-on-Sea, Oct 14. [1902]

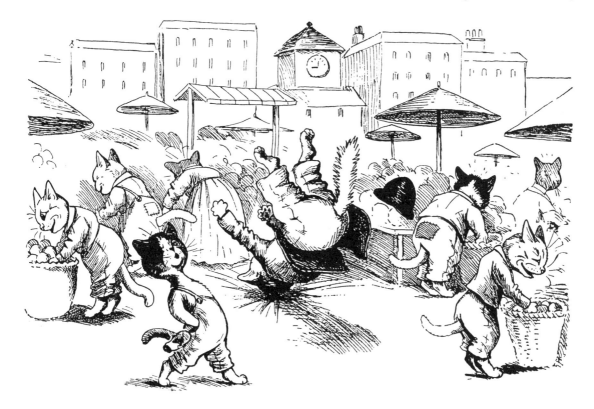

References and Sources

This list of Wainiana naturally makes no claim to completeness. It contains, however, most of the sources on which the text is based. Some publications such as the *Illustrated London News*, *Boys Own Paper*, *Chatterbox* and so on are particularly rich in Louis Wain drawings, some volumes more than others. *Our Cats*, which appeared weekly from 1899 to 1913, is also a fruitful source of Louis Wain's doings, though the reports are often his hopes recorded as accomplishments.

ABBREVIATIONS

pic	picture	edn	edition
v	volume	p	page
ed	edited by		

1881

1. *Illustrated Sporting and Dramatic News* Christmas Number, 'Robin's Breakfast'

1883

2. *Illustrated London News* v 83 p 392, 'Odd Fish at the International Fisheries Exhibition'

1884

3. *ILN* v 84 p 5, 'A New Dog-Fancy: The Basset Hounds'
4. *ILN* v 85 p 365
5. *ILN* v 88 p 570, 'Dachshund and Basset Hound Show'

1886

6. *ILN* Christmas Number pp 24–25, 'A Kittens' Christmas Party'

1888

7. *ILN* v 93, particularly rich in Louis Wain drawings

1890

8. *The Year's Art* (J.S. Virtue & Co). See also 1891,95 (pic), 1896–1900, 1940 (obituary)
9. *The Rosebud Annual* contains many drawings by Louis Wain and a few by Felicie Wain
10. *English Illustrated Magazine* v 7 p 450, 'Cats and Kittens' by J.E. Panton, illus. Louis Wain
11. *Holly Leaves* (2nd Supplement) 6 December, 'A Cats' Christmas Dance'
12. *ILN* v 97 p 815, 'A Cats' Party'

1891

13. *Henriette Ronner: The Painter of Cat Life and Cat Character* by M.H. Spielmann (Cassell)

1894

14. *Illustrated Official Journal of Patents* 12.9.1894 p 918, Patent No 17155, Louis Wain, 16 Adrian Square, Westgate-on-Sea: Steady Cycle. See also 9.10.1895 p 1062, Patent No 18660, Louis Wain, 7 Collingwood Terrace, Westgate-on-Sea: New attachment to bicycles. 10.11.1915 p1255, Patent No 15577, Louis Wain: Rangefinder

1895

15. *Leisure Hour* v 44 p 107, 'Cats' by Hopkins Tighe, illus. Louis Wain
16. *Windsor Magazine* v 1 p 243, 'The Duchess of Bedford's Pets' by Louis Wain
17. *Windsor Magazine* v 2 p 661, 'The Hon. Walter Rothschild's Pets: A Visit to Tring Museum' by Louis Wain

18. *Chums* Nov p 204, 'A Celebrated Cat Artist. Mr Louis Wain Chats with "Chums." '

1896
19. *The Idler* v 8 No 48 p 550, 'Canine and Sublime: A Chat with Mr Louis Wain' by Roy Compton
20. *Strand Magazine* v 10 p 800, 'Waiter, This Cats' Meat is Tough'

1897
21. *Strand Magazine* v 13 p 425, 'Pictures on the Human Skin' by Gambier Bolton FZS

1898
22. *Cassell's Magazine* p 563, 'Louis Wain's Method of Work' by Stanhope Sprigg

1899
23. *MAP* 9 September p 228, 'In the Days of My Youth: Chapters of an Autobiography LXV' by Louis Wain

1901
24. *Confessions of a Caricaturist* by Harry Furniss (2 v, T Fisher Unwin)
25. *The Living Animals of the World* (2 v, Hutchinson) p68, 'The Domestic Cat' by Louis Wain

1902
26. *The Lady's Magazine* v 3 pp 82, 188, 297, 397, 444, 'The Kit-Cats' written and illustrated by Louis Wain
27. *Morning Post* 15 October, 'The Doomed Empire' (see Appendix III)

1903
28. *Discoveries and Inventions of the Nineteenth Century* (Routledge, 14th edn)
29. *Crampton's Magazine* January, 'The Cat of Today and Tomorrow' by Louis Wain
30. *The Book of the Cat* by Frances Simpson (Cassell). See also 1909 edn. Pictures by Louis Wain, J.A. Shepherd and others
31. *The Jabberwock* v I – v 4 1904–1907, ed. Brenda Girvin

1905
32. *The Times* 20 January, on the Dogs' Home at Battersea
33. *Smith's Weekly* 15 July p 84, 'Have Animals a Hereafter? What Mr Louis Wain Thinks'

1907
34. *The Times* 2 January, on the Child Hawkers of Ludgate Hill

1908
35. *Chicago Evening American* 4 February, 'Most Famous Cat Artist in World says Puss is Less Vain Than Woman'

1909
36. *Bristol Times and Mirror* 21 August, 'Painter of Cats. Mr Louis Wain Talks of his Art'

1911
37. *Pearson's Weekly* 16 February p489, 'Making Cats Obey', specially illustrated for 'PW' by Louis Wain
38. *Evening Times* 10 March, 'In Defence of the Cat' Mr Louis Wain's pen-and-picture reply to Dr Lyttleton
39. *The Times* 19 September, on the Question of the Rules

1912
40. *Truth* v 72 pp 1043, 1105, 1167, 1230, 1295, 1357, 1416, 1486, 1546, 'Scrutator: A Vagabond in New York'

1913
41. *Truth* v 73 pp 14, 72, 194, 'Scrutator: A Vagabond in New York'
42. *Truth* v 73 p 199, 'Englishry in New York'
43. *Chicago Sun* 25 January, 'Cat Fancier a Critic of Men'
44. *Truth* v 73 p 257, 'Englishry in New York from "A Vagabond" '
45. *Truth* v 73 p 323, 'Englishry in New York'
46. *The Times* 11 December, on the Control of Professional Boxing
47. *The Times* 22 December, on Performing Animals

1914
48. *The Times* 10 June, on Shipping – Curtailment of Watches During Fogs
49. *Daily Express* 13 June, 'Futurist Cats: Fun-makers that Out-Billiken the Billiken'
50. *Daily Mirror* 13 June, 'Mr Louis Wain Designs Futurist Cats and Dogs'
51. *The Times* 29 August, on Foul Boxing

52. *The Times* 10 October, 'Accident to Mr Louis Wain'
53. *The Times* 12 October, 'Mr Louis Wain'

1922

54. *The Schoolgirls' Annual* VI p 43, 'How I Draw My Cats' by Louis Wain; p 47, 'How Animals Study Their Appearance' by Louis Wain

1925

55. *Animals 'Xtra' and Louis Wain's Annual* (Louis Wain Fund)
56. *Daily Express* 11 August, 'Louis Wain's Plight: Famous Cat Artist in Pauper Asylum'
57. *The Times* 12 August, Mr Louis Wain
58. *Daily Graphic* 17 August p 2, 'Voting for Pictures: DG Plan to Help Cat Artist'; p 5, 'Saints Before Cats'; p 8, 'Louis Wain at a Cat Show in Happier Days'
59. *The Times* 18 August, 'News in Brief'
60. *Daily Graphic* 18 August, 'A Chance for Cat Lovers'
61. *Daily Graphic* 19 August, 'Man Who Made the World Smile'
62. *Daily Graphic* 20 August, 'Artist's Fight with Fate'
63. *Daily Mail* 20 August, 'Louis Wain Fund'
64. *Daily Graphic* 21 August, 'Final Day in Cat Contest'
65. *Daily Graphic* 22 August, 'Smile that Hid a Heartache'
66. *The Times* 24 August, 'The Louis Wain Fund'
67. *Daily Graphic* 25 August, 'Louis Wain Fund'
68. *Daily Graphic* 26 August, 'Louis Wain Fund'
69. *Daily Graphic* 28 August, 'Louis Wain Fund Success'
70. *The Times* 9 September, 'The Louis Wain Fund'
71. *The Times* 16 October
72. *The Times* 28 October, 'Art exhibitions . . . Mr Louis Wain'

1927

73. *Daily Express* 21 September, 'Effect of Broadcasting on Cats'

1929

74. *Daily Mail* 22 April, 'Louis Wain Fund Muddle'
75. *Daily Mail* 23 April, 'Mr Louis Wain's Sisters Appeal for Help by Mr MacDonald'

1930

76. *Willesden Quarterly Record and Guide*, new series v5 no 19 January

1931

77. *Daily Express* 23 May, 'A Louis Wain Exhibition'
78. *Daily Express* 20 July, 'Louis Wain's Brilliant Show Today'
79. *Daily Express* 20 October, 'Louis Wain's Home Saved: Devoted Sisters' Gratitude'
80. *New York American* 25 October, 'Louis Wain's Fiendish Cats'

1934

81. *Daily Express* 2 October, 'Louis Wain Still Draws Cats but his Studio is an Asylum'

1937

82. *Daily Express* 1 June, 'Artist in Asylum Paints On: Gives Exhibition'
83. *Willesden Monthly Illustrated* 5 June, 'World Famous Cats: Louis Wain Still at His Unique Work'
84. *Sunday Referee* 6 June, 'Mickey Mouse had a Cat for Ancestor'
85. *British Journal of Medical Psychology* v16 p184, 'Clinical Observations on Schizophrenic Drawing' by Drs Guttmann and Maclay

1937

86. *Everybody's Weekly* 31 July, 'He Laughed at Cats – Until they Robbed Him of Wealth, Health and Reason'

1939

OBITUARIES
87. *Daily Express* 6 July
88. *New York Times* 6 July, 'Louis Wain, Creator of Cat Drawings'
89. *Daily Telegraph* 6 July
90. *Daily Mail* 6 July, 'Man Who Drew Cats Dies'
91. *Daily Sketch* 6 July, 'He Drew Cats Because He Loved Them'
92. *Daily Mirror* 7 July, 'His Cats Live On'
93. *The Times* 7 July, 'Mr Louis Wain'
94. *New York Herald Tribune* 7 July, 'Wain Dies at 78: Drew Pictures of 150,000 Cats'
95. *Notes and Queries* v 177 97 (refers to letter in V & A)

96. *New York Journal-American* 29 July, 'New Thunder For the Woman who Screams: "I Hate Cats" '
97. *Art Digest* 1 August, obituary
98. *The Times* 25 September, 'Louis Wain Cats. A Memorial Exhibition'

1950

99. *Vancouver Daily Province* 18 March, 'Did Cats Drive Louis Wain Mad?'
100. *Flashback: The Autobiography of a British Filmmaker* by George Pearson OBE (George Allen and Unwin)

1957

101. *The Dissociation of Personality* by Morton Prince (NY Meridian Books)

1960

102. *Guardian* 5 August, 'The Man Who Drew Cats: Sidney Denham Writes on Louis Wain on the Centenary of his Birth'
103. *Guardian* 9 August
104. *Daily Telegraph* 12 October, 'Louis Wain Drawings Found by Publishers'
105. *Daily Telegraph* 12, 16, 17, 19, 22, 23, 26 November, 1 December

1963

106. *Abbottempo* 3, G.M. Carstairs: 'Art and Psychotic Illness'

1966

107. *Observer* 12 June Colour Supplement, 'The Madness of Art'

1968

108. *Louis Wain – The Man Who Drew Cats* by Rodney Dale (William Kimber)

Since then, there has been a growing flood of articles aboout Louis Wain too numerous to catalogue. They may make qualitative observations about his art, but add little or nothing to what is known of his life. More substantial works are:

1972

109. *Louis Wain* by Brian Reade (Victoria and Albert Museum)

110. *Cats of Fame and Promise* An exhibition catalogue with introduction by Michael Parkin (Michael Parkin Gallery)

1973

111. *More Cats of Fame and Promise* An exhibition catalogue with introduction by Michael Parkin (Michael Parkin Gallery)

1974

112. *Still More Cats of Fame and Promise* Exhibition catalogue (Michael Parkin Gallery)

1977

113. *Catland* A commentary by Rodney Dale with 14 Louis Wain colour plates (Duckworth)

1982

114. *Louis Wain – King of the Cat Artists* A dramatised biography by Heather Latimer (Papyrus)

1983

115. *Louis Wain's Cats* by Michael Parkin (Thames and Hudson)
116. *Louis Wain* An exhibition catalogue with brief introduction by Chris Beetles, bibliography and 24 colour plates

1985

117. *Especially Cats: Louis Wain's Humorous Postcards* by Cynthia Christopher Delulio and Elsa Speedby Ross (published by the authors)

1986

118. *Cats! An Exhibition of the Works of Louis Wain (1860–1939)* (York City Art Gallery) With an extract of Michael Parkin's biography of Louis Wain and an essay by Patricia Allderidge, Archivist and Curator, Art and History Collection, the Bethlem Royal Hospital. Includes 43 colour plates (Chris Beetles Ltd)

1989

119. *Louis Wain (1860–1939)* An exhibition catalogue with an extract from Michael Parkin's biography and 29 colour plates (Chris Beetles Ltd)

1990

120. *Louis Wain: A Short Checklist of Illustrated Books* by Elizabeth Gant (published by the author)

A LIST OF BOOKS ILLUSTRATED BY LOUIS WAIN

Compiled by Ellery Yale Wood

I would like to thank all who have given me assistance in compiling this check-list, but especially Elizabeth Gant who of her knowledge and time gave most generously, and who supplied details of a number of Louis Wain items either unknown to me or unseen by me. As no researcher into Louis Wain's output ever feels confident he (or she) has come to the end of Wain discoveries, I should be glad to have reported to me any titles not included on my List.

Ellery Yale Wood
January 1991

1. *Adventures of Friskers and His Friends, The.*
 Marion Isabel Hurrell, illustrated by Louis Wain, London, Robert Culley, 16mo, (1907).

2. *All Sorts of Comical Cats.*
 Clifton Bingham, illustrated by Louis Wain, London, Ernest Nister/New York, E.P. Dutton, No. 747, 4to, (1902).

3. *Animal Antics: Funny Pictures; Merry Rhymes.*
 Anon., illustrated by Louis Wain *et al.*, London, S.W. Partridge, 4to. (1905).

4. *Animal Fancy-Land.*
 A.W. Ridler, illustrated by Louis Wain *et al.*, London, James Clarke, 4to, (1915).

5. *Animal Frolics.*
 Anon., illustrated by Louis Wain *et al.*, London, Collins, 4to, (1919).

6. *Animal Fun.*
 Anon., illustrated by Louis Wain *et al.*, London, James Clarke, 4to, (1906).

7. *Animal Gambols.*
 Anon., illustrated by Louis Wain *et al.*, London, James Clarke, 4to, (1907).

8. *Animal Happyland.*
 A.W. Ridler, illustrated by Louis Wain *et al.*, London, James Clarke, 4to, (1913).

9. *Animal Jollities.*
 E.H. Jeffs, illustrated by Louis Wain *et al.*, London, James Clarke, 4to, (1919?).

10. *Animal Joy-Book, The.*
 E.H. Jeffs, illustrated by Louis Wain *et al.*, London, James Clarke, 4to, (1919?).

11. *Animal Picture-Land.*
 A.W. Ridler, illustrated by Louis Wain *et al.*, London, James Clarke, 4to, (1914).

12. *Animal Playtime.*
 Anon., illustrated by Louis Wain *et al.*, London, James Clarke, 4to, (1908).

13. *Animal Pranks ABC.*
 Anon., illustrated by Louis Wain and 'L.R.', London, W.S. & Co., large 4to, nd.

14. *Animals in Fun-Land.*
 A.W. Ridler, illustrated by Louis Wain *et al.*, London, James Clarke, 4to, (1911).

15. *Animals 'Xtra' and Louis Wain's Annual,* (Fourth edition of "Souvenir of Louis Wain's Work").
 Anon., illustrated by Louis Wain, London, Louis Wain Fund, narrow 8vo, (1925).

16. *At the Pantomime with Louis Wain.*
 Grace C. Floyd, illustrated by Louis Wain, London, Raphael Tuck, No. 6788, folio, (*c.* 1906).

17. *Big ABC Book, The.*
 Anon., illustrated by Louis Wain *et al.*, London, Blackie, folio, (1921).

18. *Big Dogs, Little Dogs, Cats and Kittens.*
 Anon., illustrated by Louis Wain, London, Raphael Tuck, No. 5163, folio, (1903).

19. *Bird Pictures.*
 Laura Jewry Valentine, illustrated by Louis Wain *et al.*, London, Warne, 4to, (1892).

20. *Book of Drawings, A.*
 Illustrated by Louis Wain *et al.*, London, privately printed for Mr. and Mrs. F.T. Davies, folio, 1891.

21. *Busy Pussies.*
 Anon., illustrated by Louis Wain, London, Blackie, 4to, (1920s?).

22. *Cat Alphabet, A, and Picture Book for Little Folk.*
 Anon., illustrated by Louis Wain, London, Blackie, 8vo, (1913).

23. *Cat Life by Louis Wain.*
Anon., illustrated by Louis Wain, London,
Raphael Tuck, No. 6572, 4to, (1903).

24. *Cat Pictures.*
Laura Jewry Valentine, illustrated by Louis
Wain, Henriette Ronner *et al.*, London, Warne,
4to, (1892).

25. *Cat Scouts, The: A Picture Book for Little Folk.*
Jessie Pope, illustrated by Louis Wain, London,
Blackie, 8vo, (1912).

26. *Cat Stories: Tales for Little People*, No. 402.
Ann Stephenson *et al.*, illustrated by Louis Wain,
London, Aldine, 8vo, (1915).

27. *Cat Tales.*
W.L. Alden, illustrated by Louis Wain, London,
Digby, Long, 8vo, (1905).

28. *Catland.*
'Father Tuck' (pseud.), illustrated by Louis
Wain, London, Raphael Tuck, No. 4636, folio,
(1901).

29. *Catland ABC.*
Anon., illustrated by Louis Wain, London,
Raphael Tuck, No. 6569, folio, (1903).

30. *Catland "Panorama"* (Board Book).
Anon., illustrated by Louis Wain, London,
Raphael Tuck, folio, a multi-hinged folding
board book, (*c.* 1903).

31. *Cats.*
'Grimalkin' (pseud.), illustrated by Louis Wain,
London, Sands, 4to, (1901).

32. *Cats and Dogs.*
Anon., illustrated by Louis Wain and Harry
Rowntree, London, Children's Press, 4to, nd.

33. *Cats and Kittens: Stories and Pictures.*
Edited by Mabel Mackintosh, illustrated by Louis
Wain, London, John Shaw, Large 8vo, nd.

34. *Cats at Play.*
Anon., illustrated by Louis Wain, London,
Blackie, 4to, (1917).

35. *Cats at Play.*
Anon., illustrated by Louis Wain, London,
Alexandra Publishing Company, large 8vo, (*c.*
1920).

36. *Cats at School.*
S.C. Woodhouse, illustrated by Louis Wain,
London, George Routledge, 4to, (1911).

37. *Cats Cradle: A Picture-Book for Little Folk.*
May Byron, illustrated by Louis Wain, London,
Blackie, 8vo, (1908).

38. *Cat's Diary, A.* (cover), *A Pussie's Diary* (title page).
Anon., [Edith Warry], illustrated by Louis Wain,
London, Dean's Pinafore Series, No. 62, 4to,
(1907).

39. *Cats of All Sorts.*
Anon., illustrated by Louis Wain, London,
'Geographia', oblong 4to, (*c.* 1916).

40. *Cats of Many Lands.*
Norman Gale, illustrated by Louis Wain,
London, Raphael Tuck, No. 9972,
"Wonderland" Series, folio, (*c.* 1912).

41. *Charlie's Adventures.*
Anon., illustrated by Louis Wain, London,
Valentine, 8vo?, (1922).

42. *Children's Peepshow, The.*
Clifton Bingham, illustrated by William Foster,
Louis Wain *et al.*, London, Ernest Nister/New
York, E.P. Dutton, oblong 4to, (*c.* 1896).

43. *Children's Tableaux, The: The Three Little Kittens.*
Many authors, illustrated by Louis Wain *et al.*,
London, Ernest Nister/New York, E.P. Dutton,
folio with five 'tableaux'. (1896).

44. *Cinderella and Other Fairy Tales.*
Anon., illustrated by Louis Wain, London, Gale
and Poleden, 4to, (1917).

45. *Claws and Paws: Stories and Pictures from
Kittenland and Puppyland.*
Anon., [Clifton Bingham], illustrated by Louis
Wain *et al.*, London, Collins, large 4to, (1904),
re-issued (1916).

46. *Claws and Paws.*
Anon., illustrated by Louis Wain, London,
Ernest Nister, 4to, (1905).

47. *Comic Animals ABC: Verses and Pictures.*
Anon., illustrated by Louis Wain, London,
Collins, 4to, (1903).

48. *Comical Customers at the New Stores of Comical
Rhymes and Stories.*
Many authors, illustrated by William Foster,
Louis Wain *et al.*, London, Ernest Nister/New
York, E.P. Dutton, No. 655, 4to, (1896).

49. *Comical Doings.*
Many authors, illustrated by Louis Wain *et al.*,

London, Ernest Nister/New York, E.P. Dutton,
No. 3802, 4to, *c.* 1900).

50. *Daddy Cat.*
Anon., illustrated by Louis Wain, London,
Blackie/New York, Dodge, 8vo, (1914).

51. *Daddy Cat* (new edition).
Anon., illustrated by Louis Wain, London,
Blackie, 4to, (1925).

52. *Dandy Lion, The.*
Clifton Bingham, illustrated by Louis Wain,
London, Ernest Nister/New York, E.P. Dutton,
4to, (1900).

53. *Days in Catland with Louis Wain "Panorama".*
Arthur Barnaby, illustrated by Louis Wain,
London, Raphael Tuck No. 8595, oblong 4to,
four panel panorama with 14 slot-in figures, (*c.*
1912).

54. *Distractions de Minet, Les.*
Anon., illustrated by Louis Wain, Paris, Raphael
Tuck, No. 9003, 8vo, nd.

55. *Dog Pictures.*
Laura Jewry Valentine, illustrated by Louis Wain
et al., London, Warne, 4to, (1892).

56. *Dreams by French Firesides: Stories.*
Richard Leander (pseud.), translated by
J. Raleigh from the German, illustrated by Louis
Wain, Edinburgh, A. & C. Black, 8vo, (1890).

57. *Every Child's Own Picture Book by Louis Wain.*
Grace C. Floyd, illustrated by Louis Wain,
London, Raphael Tuck, No. 605, "Wonder"
series, with 24 perforated coloured picture labels
for child to paste in, 8vo, (*c.*1920).

58. *Fairy Tales.*
Grace C. Floyd, illustrated by Louis Wain,
London, Raphael Tuck, No. 5567, 4to, (*c.* 1903).

59. *Faithful Friends: Pictures and Stories for Little Folk.*
Anon., illustrated by Louis Wain *et al.*, London,
Blackie, 4to, (1901).

60. *Farmyard Pussies, The: Tales for Little People*
Edited by Lady Kathleen, illustrated by Louis
Wain, London, No. 602, Aldine, 8vo, (*c.* 1919).

61. *Father Tuck's Postcard Painting Book.*
Anon., illustrated by Louis Wain, London,
Raphael Tuck, No. 2530, 4to, (1903).

62. *Favourite Fairy Tales Painting Book: Post Cards to
Paint.*

Anon., illustrated by Louis Wain, London,
Valentine, 8vo, nd.

63. *Flossy and Fluffy* (Shape Book).
Anon., designed and pictured by Louis Wain,
Valentine, Book Toys B353, 8vo, (1919).

64. *Frolics in Fairyland.*
Grace C. Floyd, illustrated by Louis Wain,
London, Raphael Tuck, No. 5592, folio, (*c.*
1905).

65. *Frolicsome Friends.*
Jessie Pope, seemingly illustrated by Louis Wain,
London, Blackie, 8vo, (1915).

66. *Full of Fun.*
Clifton Bingham, illustrated by Louis Wain,
London, Ernest Nister/New York, E.P. Dutton,
No. 2000, 4to, (1908).

67. *Full of Fun* (new edition).
Clifton Bingham, illustrated by Louis Wain,
London, Scott and Sleeman, 4to, (*c.* 1916).

68. *Fun and Frolic.*
Clifton Bingham, illustrated by Louis Wain,
London, Ernest Nister/New York, E.P. Dutton,
No. 589, 4to, (1900).

69. *Fun and Frolic "Panorama"* (Board Book).
Anon., illustrated by Louis Wain, London,
Raphael Tuck, No. 6775, "Panorama" series, ten
panel hinged board book, 8vo, (*c.* 1906).

70. *Fun and Frolic.*
Anon., illustrated by Louis Wain, London,
Collins, 4to, nd.

71. *Fun at Zoo.*
Clifton Bingham, illustrated by Louis Wain,
London, Collins, oblong 8vo, (1906).

72. *Funny Animals and Stories about Them.*
Anon., illustrated by Louis Wain *et al.*, London,
James Clarke, 4to, (1904).

73. *Funny Favourites.*
Clifton Bingham, illustrated by Louis Wain,
London, Ernest Nister/New York, E.P. Dutton,
No. 1056, 4to, (1904).

74. *Funny Folk in Animal Land.*
'Uncle Frank' (pseud.), illustrated by Louis Wain
et al., London, S.W. Partridge, 4to, (1910).

75. *Happy Family, The.*
Edric Vredenburg *et al.*, illustrated by Louis
Wain, London, Raphael Tuck, 4to, (1910).

76. *Happy Hours with Louis Wain.*
Anon., illustrated by Louis Wain, London, John
F. Shaw, 4to, (1913).

77. *Happy Schooldays.*
'Freckles' (pseud.), illustrated by Louis Wain,
London, Gale and Poleden, Large 8vo, (*c.* 1917).

78. *Holiday Stories and Rhymes.*
Clifton Bingham, illustrated by Louis Wain *et al.*,
London, Ernest Nister/New York, E.P. Dutton,
No. 2002, 4to, (*c.* 1909).

79. *Holidays in Animal Land.*
A.W. Ridler, illustrated by Louis Wain *et al.*,
London, James Clarke, 4to, (1909).

80. *I'll Tell You a Tale.*
Edited by Edric Vredenburg, illustrated by Louis
Wain, London, Raphael Tuck, "Furry Mascot"
series, black furry cat with movable tail on cover,
4to, (1920s).

81. *In Animal Land with Louis Wain.*
Anon., illustrated by Louis Wain, London, S.W.
Partridge, 4to, (1904).

82. *In Cat and Dog Land with Louis Wain.*
Anon., illustrated by Louis Wain, London,
Raphael Tuck, No. 6256, Folio, (*c.* 1906).

83. *In Catland.*
Anon., illustrated with unsigned Louis Wain
pictures, 4to, neither publisher nor date given.

84. *In Catland.*
Anon., illustrated by Louis Wain, London, John
F. Shaw, (*c.* 1914).

85. *In Louis Wain Land.*
Anon., illustrated by Louis Wain, London, John
F. Shaw, 8vo, (*c.* 1913).

86. *In Nursery Land with Louis Wain.*
Edited by Edric Vredenburg, illustrated by Louis
Wain, London, Raphael Tuck, No. 827, "Golden
Gift" series, 4to, (*c.* 1916), re-issued (*c.* 1930).

87. *In Story Land with Louis Wain.*
Anon., illustrated by Louis Wain, London,
Raphael Tuck, 4to, (1912).

88. *In Wain Land.*
Anon., illustrated by Louis Wain, London, John
F. Shaw, 8vo, (1919).

89. *Jingles, Jokes, and Funny Folks.*
Clifton Bingham, illustrated by Louis Wain but
cover and frontispiece are by other artists,

London, Ernest Nister/New York, E.P. Dutton,
No. 277, large 8vo, (1898).

90. *Jingles, Jokes, and Funny Folks.*
Clifton Bingham, illustrated by Louis Wain, New
York, McLoughlin, a pirate edition, 8vo, (1898).

91. *Jock the Bow Wow* (Shape Book).
Anon., designed and pictured by Louis Wain,
London, Valentine Book Toys B354, 8vo, (1919).

92. *Joy Book 1922, The: A Picture and Story Annual for
Little Folk.*
Many authors, one long story, "The Adventures
of Patrick Persian", illustrated by Louis Wain,
London, Hulton, 4to, 1921.

93. *Kings and the Cats, The: Munster Fairy Tales for
Young and Old.*
John Hannon, illustrated by Louis Wain,
London, Burns and Oates, large 8vo, 1908.

94. *Kit-Cats.*
Anon., illustrated by Louis Wain, London?,
imprint "W", 8vo, nd.

95. *Kits and Cats.*
Anon., illustrated by Louis Wain, London,
Raphael Tuck, No. 8838, "Little Pets" series,
small 4to, (1904).

96. *Kits and Cats* (on cover) *With Louis Wain in
Pussyland* inside (Shape Book).
Anon. [Norman Gale], illustrated by Louis Wain,
London, Raphael Tuck, No. 9080, "Hurrah"
series, folio, (*c.* 1930s).

97. *Kittenland.*
Clifton Bingham, illustrated by Louis Wain,
London, Collins, folio, (1903).

98. *Kittenland Holidays.*
Anon., illustrated by Louis Wain *et al.*, London,
Collins, large 8vo, (*c.* 1908).

99. *Kitten's House, The.*
Anon., illustrated by Louis Wain, London,
Valentine, 8vo?, (1922).

100. *Lament of Billy Villy, after a Long Fellow.*
Emily Rowley Watson, illustrated by Louis Wain,
London, Raphael Tuck, No. 1204, 8vo, (1894).

101. *Life in Catland.*
Norman Gale, illustrated by Louis Wain,
London, Raphael Tuck, No. 8546, "Nursery"
Series, oblong 4to, (*c.* 1912).

102. *Little Book of Pussy Cats, A*
Anon., illustrated by Louis Wain, The Little
Folks Library, small 8vo, (1908).

103. *Little Red Riding Hood and Other Tales.*
Anon., illustrated by Louis Wain, London, Gale
and Poleden, 4to, (1917).

104. *Little Soldiers.*
May Crommelin, illustrated by Louis Wain,
London, Hutchinson, 4to, (1916).

105. *Louis Wain's Animal Book.*
Anon., illustrated by Louis Wain, London,
Collins, 4to, (1928).

106. *Louis Wain's Animal Show.*
Anon., illustrated by Louis Wain, London,
James Clarke, 4to, (1905).

107. *Louis Wain's Annual.*
Edited by Stanhope Sprigg, illustrated by Louis
Wain, London, Anthony Treherne, 4to, (1901).

108. *Louis Wain's Annual for 1902.*
Illustrated by Louis Wain, London, Anthony
Treherne, 4to, 1902.

109. *Louis Wain's Annual 1903.*
Edited by T.F.G. Coates, illustrated by Louis
Wain, London, Hutchinson, 4to, 1903.

110. *Louis Wain's Annual 1905.*
Edited by R.S. Pengally, illustrated by Louis
Wain, London, P.S. King, 4to, 1905.

111. *Louis Wain's Annual for 1906.*
Illustrated by Louis Wain, London, John F.
Shaw, 4to, 1906.

112. *Louis Wain's Annual 1907.*
Illustrated by Louis Wain, London, Bemrose,
4to, 1907.

113. *Louis Wain's Annual 1908.*
Illustrated by Louis Wain, London, Bemrose,
4to, 1908.

114. *Louis Wain's Annual 1909–10.*
Illustrated by Louis Wain, London, George
Allen, 4to, 1909.

115. *Louis Wain's Annual 1910–11.*
Illustrated by Louis Wain, London, George
Allen, 4to, 1910.

116. *Louis Wain's Annual 1911.*
Illustrated by Louis Wain, London, John F.
Shaw, 4to, 1911.

117. *Louis Wain's Annual 1911–12.*
Illustrated by Louis Wain, London, John F.
Shaw, 4to, 1911.

118. *Louis Wain's Annual 1912.*
Illustrated by Louis Wain, London, John F.
Shaw, 4to, 1912.

119. *Louis Wain's Annual 1913.*
Illustrated by Louis Wain, London, John F.
Shaw, 4to, 1913.

120. *Louis Wain's Annual 1914.*
Illustrated by Louis Wain, London, John F.
Shaw, 4to, 1914.

121. *Louis Wain's Annual 1915.*
Illustrated by Louis Wain, London, John F.
Shaw, 4to, 1915.

122. *Louis Wain's Annual 1921.*
Illustrated by Louis Wain, London, Hutchinson,
4to, 1921.

123. *Louis Wain's Baby Picture Book.*
Anon., illustrated by Louis Wain, London,
James Clarke, 4to, 1903.

124. *Louis Wain's Cat Mascot Postcard Painting Book.*
Anon., illustrated by Louis Wain, London,
Raphael Tuck. No. 4091, "Little Artist" series,
4to, (nd.).

125. *Louis Wain's Cat Painting Book.*
Anon., illustrated by Louis Wain, London,
Raphael Tuck, "Little Artist" series, 4to, (1903).

126. *Louis Wain's Cats and Dogs.*
Anon., illustrated by Louis Wain, London,
Raphael Tuck, No., folio, (1902).

127. *Louis Wain's "Cats" Painting Book* (Shape Book).
Anon., illustrated by Louis Wain, London,
Valentine, No. B359, narrow 4to, (1919).

128. *Louis Wain's Children's Book.*
Anon., illustrated by Louis Wain, London,
Hutchinson, 4to, (1923).

129. *Louis Wain's Dog Painting Book.*
Anon., illustrated by Louis Wain, London,
Raphael Tuck, No., "Little Artist" series, 4to,
(1903).

130. *Louis Wain's "Doggies" Painting Book* (Shape
Book).
Anon., illustrated by Louis Wain, London,
Valentine, No. B360, narrow 4to, (1919).

131. *Louis Wain's Father Christmas.*
Anon., illustrated by Louis Wain, London, John F. Shaw, 8vo, (1912).

132. *Louis Wain's Great Big Midget Book.*
Anon., illustrated by Louis Wain assisted by Claire Wain, London, Dean, 16mo, (1934).

133. *Louis Wain's Happy Land.*
Anon., illustrated by Louis Wain, London, John F. Shaw, 4to, (1912).

134. *Louis Wain Kitten Book, The.*
Anon., illustrated by Louis Wain, London, Anthony Treherne, 16mo, 1904.

135. *Louis Wain's "Kittens" Painting Book* (Shape Book).
Anon., illustrated by Louis Wain, London, Valentine, No. B358, narrow 4to, (1919).

136. *Louis Wain's Merry Mascot Postcard Painting Book.*
Anon., illustrated by Louis Wain, London, Raphael Tuck, No., "Little Artist" series, 4to, (nd.).

137. *Louis Wain Nursery Book, The.*
Anon., illustrated by Louis Wain, London, James Clarke, 4to, (1902).

138. *Louis Wain's Painting Book.*
Anon., illustrated by Louis Wain, London, John F. Shaw, 4to, (*c.* 1912).

139. *Louis Wain's Summer Book for 1903.*
Anon., illustrated by Louis Wain, London, Hutchinson, 4to, 1903.

140. *Louis Wain's Summer Book for 1906.*
Anon., illustrated by Louis Wain, London, P.S. King, 4to, 1906.

141. *Madame Tabby's Establishment.*
'Kari' (pseud.), illustrated by Louis Wain, London, Macmillan, 8vo, 1886.

142. *"Mephistopheles" The Autobiography of a Tabby Cat.*
Keiro (Charles Yates Stephenson), illustrated by Louis Wain and with photos, London, Jarrold, 8vo, (1907).

143. *Merry Animal Picture Book, The.*
A.W. Ridler, illustrated by Louis Wain *et al.*, London, James Clarke, 4to, (1910).

144. *Merry Times in Animal-Land.*
A.W. Ridler, illustrated by Louis Wain *et al.*, London, James Clarke, 4to, (1912).

145. *Merry Times with Louis Wain.*

Dorothy Black *et al.*, illustrated by Louis Wain, London, Raphael Tuck, No. 839, "Golden Gift" series, 4to, (1916).

146. *Miss Lovemouse's Letters.*
Miss Lovemouse (pseud.), illustrated by Louis Wain, London, Thomas Nelson, oblong 4to, 1896.

147. *Mixed Pickles Bottled by Louis Wain.*
Edited by Edric Vredenburg, illustrated by Louis Wain, London, Raphael Tuck, No. 400, "Welcome Gift" series, 8vo, (*c.* 1906).

148. *Monkey That Would Not Kill, The.*
Henry Drummond, illustrated by Louis Wain, London, Hodder and Stoughton/New York, Dodd, Mead, 8vo, 1898.

149. *Monkey That Would Not Be Killed, The* (a new edition of the preceding book).
Henry Drummond, illustrated by Louis Wain, London and New York, Andrew Melrose, 8vo, 1923.

150. *More Jingles, Jokes, and Funny Folks.*
Clifton Bingham, illustrated by Louis Wain but with cover and frontispiece by other artists, London, Ernest Nister/New York, E.P. Dutton, No. 442, large 8vo, (1899).

151. *More Jingles, Jokes, and Funny Folks.*
Clifton Bingham, illustrated by Louis Wain, New York, McLoughlin, a pirate edition, 8vo, (1899).

152. *My Cat and Dog Book.*
Anon., illustrated by Louis Wain *et al.*, London, Charles H. Kelly, 8vo, (1905) and (1914).

153. *My Cat Book.*
Anon., illustrated by Louis Wain *et al.*, London, Charles H. Kelly, 8vo, (1905) and (1914).

154. *My Doggie Book.*
Anon., illustrated by Louis Wain, London, John F. Shaw, 8vo, nd.

155. *Novel Notes.*
By Jerome K. Jerome, illustrated by Louis Wain *et al.*, (Chapter VI has 18 text illustrations by Louis Wain), London, The Leadenhall Press/New York, Henry Holt, 8vo, 1893.

156. *Nursery Cats* (Board Book).
Anon., illustrated by Louis Wain, London, Raphael Tuck, No. 6758, "Indestructible" series, 8vo, (*c.* 1906).

157. *Nursery Rhymes Painting Book: Post Cards to Paint.*

Anon., illustrated by Louis Wain, London, Valentine, 8vo, nd.

158. *Nursery Rhymes Pictured by Louis Wain.*
Anon., illustrated by Louis Wain, London, Raphael Tuck, No. 5632, 4to, (*c.* 1905).

159. *Old Rabbit, The Voodoo and Other Sorcerers.*
Mary Alicia Owen, illustrated by Louis Wain and Juliette A. Owen, London, T. Fisher Unwin, 8vo, 1893.

160. *Our Farm: The Trouble and Successes Thereof.*
F.W. Pattenden, illustrated by Louis Wain, London, James Clarke, square 4to, (1888).

161. *Pa Cats, Ma Cats, and Their Kittens.*
'Father Tuck' (pseud.), illustrated by Louis Wain, London, Raphael Tuck, No. 4649, folio, (1901).

162. *Pages of Fun.*
Anon., Cover by Wain and Wain-like illustrations inside, London, Ernest Nister/New York, E.P. Dutton, 8vo, (1913).

163. *Pages to Please You.*
Anon., illustrated by Louis Wain, London, Raphael Tuck, "Golden Gift" series, 4to, (*c.* 1916).

164. *Pantomime Pussies.*
Grace C. Floyd, illustrated by Louis Wain, London, Raphael Tuck, No. 6766, folio, (*c.* 1906).

165. *Pet Pussy, The.*
Anon., illustrated by Louis Wain *et al.*, London, Raphael Tuck, "Tiny Tots" series, 8vo, nd.

166. *Peter, A Cat O'One Tail: His Life and Adventures.*
Charles Morley, illustrated by Louis Wain, London, "Pall Mall" Gazette, large 8vo, (1892).

167. *Picture Book of Kittens, The.*
Jessie Pope, illustrated by Louis Wain *et al.*, London, Ward, Lock, large 8vo, (1935).

168. *Pictureland Fun.*
Anon., illustrated by Louis Wain *et al.*, London, Ernest Nister/New York, E. P. Dutton, 4to, (1913).

169. *Ping-Pong as Seen by Louis Wain.*
Clifton Bingham, illustrated by Louis Wain, London, Raphael Tuck, oblong 8vo, (1902).

170. *Ping-Pong Calender for 1903.*
Clifton Bingham, illustrated by Louis Wain, London, Raphael Tuck, (1902).

171. *Playtime in Pussyland.*
Clifton Bingham, illustrated by Louis Wain, Leeds and London, Alfe Cooke, 4to, (*c.* 1906).

172. *Pleasures in Pussytown.*
Norman Gale, illustrated by Louis Wain, London, Raphael Tuck, No. 8643, "Nursery" series, oblong 4to, (*c.* 1912).

173. *Pranks and Purrs in Pussyland* (on cover), title page reads *Pussies Purrs and Pranks.*
Anon., illustrated by Louis Wain *et al.*, London, Charles H. Kelly, 4to, (1906).

174. *Puppy Dogs' Tales.*
'Puppy Dogs' (pseud.), illustrated by Louis Wain, London, Thomas Nelson, oblong 4to, 1896.

175. *Puppy Rocker, The: Peter Pup* (Shape Book with rolling eyes).
Cecily M. Rutley, illustrated by Louis Wain, London, Valentine Rocker Book, 8vo, (1921).

176. *Puppyland: Pictures and Play.*
Clifton Bingham, illustrated by Louis Wain, London, Collins, large 4to, (1903).

177. *Puss in Boots* (Stump Book).
Anon., illustrated by Louis Wain, London, Anthony Treherne, long, narrow, tiny folio, 1904.

178. *Puss in Boots, The Marvellous Story of.*
Anon., illustrated by Louis Wain, Chicago, M.A. Donohue, "Pixie" series, possibly a pirate edition, 8vo, 1908.

179. *Pussies and Puppies.*
Anon., illustrated by Louis Wain, London, S.W. Partridge, 4to, (1899).

180. *Pussie's Diary, A.*
Anon. [Edith Warry], illustrated by Louis Wain, London, Dean, No. 42, "Diploma" series, 4to, (1902).

181. *Pussy Cats ABC.*
Anon., illustrated by Louis Wain, but cover design by A.E. Kennedy, London, S.W. Partridge, 4to, (1916).

182. *Pussy Land* (Shape Book).
Anon., illustrated by Louis Wain, London, "Geographia", oblong 4to, (1920).

183. *Pussy Rocker, The: Polly Puss* (Shape Book with rolling eyes).

Cecily M. Rutley, illustrated by Louis Wain, London, Valentine Rocker Book, 8vo, (1921).

184. *Pussyland Pictures by Louis Wain.*
Anon., illustrated by Louis Wain, London, Raphael Tuck, No. 9002, "Playtime" series, 8vo, (*c.* 1912).

185. *Pussy's Mixture of Verse and Picture.*
Clifton Bingham, illustrated by William Foster, Louis Wain *et al.*, London, Ernest Nister/New York, E.P. Dutton, No. 845, large 8vo, (1898).

186. *Round the Farmyard Painting Book: Post Cards to Paint.*
Anon., illustrated by Louis Wain, London, Valentine, Narrow 8vo, nd.

187. *Some Cats for Painting: Postcard Painting Book.*
Anon., illustrated by Louis Wain, London, Raphael Tuck, No. 4082, "Little Artist" series, nd.

188. *Somebody's Pussies* (Board Book).
Anon., illustrated by Louis Wain, London, Raphael Tuck, 4to, (1925).

189. *Souvenir of Louis Wain's Work.*
Anon., illustrated by Louis Wain, London, Louis Wain Fund, narrow 8vo, (1925). (This went through several editions.)

190. *Stories from Lowly Life.*
C.M. Duppa, illustrated by Louis Wain, London, Macmillan, small 4to, 1898.

191. *Stories from Pussyland.*
S. Sutton Smith, illustrated by Louis Wain and M.Y. Shuter, London, Sands, The Piccaninnies Picture Pocket Book series, one of five issued in red cloth case, tiny oblong 16mo, (1904).

192. *Story of Tabbykin Town, The, In School and At Play.*
'Kittycat' (pseud.), illustrated by Louis Wain, London, C.N. Faulkner, 8vo, (1920).

193. *Such Fun with Louis Wain.*
Norman Gale *et al.*, illustrated by Louis Wain, London, Raphael Tuck, No. 1630, 4to, (1930).

194. *Tale of Little Priscilla Purr, The.*
Cecily M. Rutley, illustrated by Louis Wain, London, Valentine, No. B439, 16mo, (1920).

195. *Tale of Naughty Kitty Cat, The.*
Cecily M. Rutley, illustrated by Louis Wain, London, Valentine, No. B436, 16mo, (1920).

196. *Tale of Peter Pusskin, The.*
Cecily M. Rutley, illustrated by Louis Wain,

London, Valentine, No. B437, 16mo, (1920).

197. *Tale of the Tabby Twins, The.*
Cecily M. Rutley, illustrated by Louis Wain, London, Valentine, No. B438, 16mo, (1920).

198. *Tatters The Puppy* (Shape Book).
Anon., designed and pictured by Louis Wain, London, Valentine, Book Toys B355, 8vo, (1919).

199. *Teddy Rocker, The: Naughty Teddy Bear* (Shape Book with rolling eyes).
Cecily M. Rutley, illustrated by Louis Wain, London, Valentine, Rocker Book, 8vo, (1921).

200. *Terrier, V.C., A Black and Tan Hero . . .*
Julia Lowndes Tracey, illustrated by Louis Wain, London, Aldine, 8vo, (1916).

201. *Tinker, Tailor.*
Edric Vredenburg, illustrated by Louis Wain, London, Raphael Tuck, 4to, (1914).

202. *To Nursery Land with Louis Wain.*
Edited by Edric Vredenburg, illustrated by Louis Wain, London, Raphael Tuck, No. 805, "Golden Gift" series, 4to, nd.

203. *Tommy's Fright, The Story of a Persian Kitten. . . .*
Anon., illustrated by Louis Wain, London, "Home Chat" Bedtime Booklets, one of six in envelope, 16mo, nd.

204. *Two Cats At Large: A Book of Surprises.*
S.C. Woodhouse, illustrated by Louis Wain, London, George Routledge, 4to, (1910).

205. *Very Funny.*
Anon., illustrated by Louis Wain, London, Scott and Sleeman, 8vo, (1920).

206. *Who Said Cats?*
Anon., illustrated by Louis Wain, New York, The International Art Publishing Company, No. 51, "Favourite" series, folio, (*c.* 1910).

207. *With Father Tuck to Animal Land.*
Edited by Edric Vredenburg, illustrated by Louis Wain, London, Raphael Tuck, 4to, (1903).

208. *With Louis Wain in Pussyland* (Shape Book).
Norman Gale, illustrated by Louis Wain, London, Raphael Tuck, "Hurrah" series, folio, (*c.* 1912).

209. *With Louis Wain to Fairyland.*
Nora Chesson, illustrated by Louis Wain, London, Raphael Tuck, No. 5674, folio, (1903).

Acknowledgements

I thank the following for their Wainiana. Mrs June Astle-Fletcher; Leslie Bearock; Mrs E.N. Briggs; Miss Rosa Cheyney; Mrs C.H. Clark; Mrs Paddy Clark; Fred Deuxberry; Mrs Janet Dyer (sketch); Mrs Dorothy Hinde; Mrs D.R. Home; P. Lambert; F. McDermott; Miss Olive McKay; George Pearson OBE; Mrs Felicia M. Phillips; E.M. Russell; Rev. J.R. Windsor-Garnett; the London Electrotype Agency; Raphael Tuck; and the Trustees of the Guttmann-Maclay Collection.

There are many others whose contributions, large and small, have all played their parts. They are: Miss A.E. Allen, Alderman W.P. Anderson, Mrs C.H. Andrew, Colin J. Ashford, Mrs N. Bangnell, Mrs Audrey Barrett, Eric Barton, Mrs D.M. Barwell, Miss Eileen Beck, Harold Beck, Mrs M.A. Beehag, Mrs W.R. Biddle, High Biron, H.L. Boiteux, Rev. I.H. Brash Bonsall, Mrs Mary Bowyer, A.F.B. Bridges, Mrs M. Briggs, E. Brenchley, Mrs. D. Brennan, Miss Edith Brierley, H.L. Brook, Mrs Kitty Broom, Miss Caroline Brown (National Portrait Gallery), Miss Christine Bryce, Miss L.M. Catt, Miss Mollie Chandler, M. Chapman, A.B. Chittick, Miss Gillian Clarke, R.H. Clarke, Miss G. Clay, Christopher and Paula Cook, J.S.S. Cooper, Mrs R.F.M. Coppen, F.J. Cornford JP, E.A. Cullen, J.R.L. Cunningham, Arthur W.P. Dade, Miss Zillah Daly-Hunter, Mrs L.M. Daniel, Brenda Davies (National Film Archive), Mrs Eva Davies, A.W. Denne, R.S. Denne, George de Partos, H.W. Dermott, Dr Caroline Deys, S.N. Dixon (Superintendent, St Mary's Cemetery, London, NW10), Miss J.A.A. Drew, Mrs G.E. Durrant, A. Eason, Miss Beatrice Edge, Gordon Edge, Tim Eiloart, Miss C. Elliott, John Forster, Elna Forsyth, Miss Isobel Francis, R. Gates, Fr. Joseph Geraerts, Mrs Dorothy H. Gilbert, J.T. Gillett FLA, Miss Brenda Girvin, G.A. Gisborne, E.S. Golding, Neville Golding, Faith M. Gough, Miss Grace M. Gould, Miss Ida Gray, Miss G.B.C. d'Oyley Goddard, Miss Olga C. Grace, Helen Grieve, E.P. Griffith, Mrs Griffiths, Mrs Florence Gyde, Nicky, Suzy and Teresa Hackett, Mrs Rebecca Hall, A. Ham, Henry Hambidge, Miss S.M. Hartigan, Miss Janet Hawkins, Mrs D. Hayward, Miss C. Henman, Rodney Hill, Mrs E.M. Hinton, Mike Hoare, Mrs M.E. Holdstock, Mrs A. Holland, Miss Vera Holton, Adrian Horne, Cifford Hubbard FIAL, Roger Hudson (Hutchinson Publishing Group), Prof. Roger Hull, Miss D.M. Hutchings, Mrs Beatrice Inglis, Mrs S.P. Jackson, A.

Alec Jones, Milton L. Kaplan (Hearst Newspapers), Miss Anne Keble, Mr and Mrs Leo Kelly, Jean Kempton (BBC), Miss Edith Kidman, Mrs E. Kiff, George F. Ladd, S.G. Laws, Mrs M.G. Leader, W.A.R. Lewis, Mrs M.J. Lewis, Valda Lynd, Miss M. Marchment, C.A. Masters, Alister Matthews, Mrs Joyce M. Measday, Basil Merritt, Miss Maureen Metcalf, Mrs C.M. Miller, T.G. Miller, Percy L. Morgan, F. Morriss (Napsbury Mental Hospital), Mrs Mabel Morris, R.C. McDermott, Mrs H.J. Mackenzie, Mrs Norah Mackenzie, Miss Belle McKilgour, Mrs Nan MacPhee, Mrs E. Neale, F. Nixon, Mrs M. Noble, Rev. E.C. Norris, Douglas Oliver, Mrs Beth Ord, Lawrence O'Toole, Hugh Owen, Keith Padbury, H. Parrott, Barbara Passmore, Miss N.B. Penhaligon, Mrs M. Perkins, Miss A. Pierce, Deric Platt, Kitty Platt, Dr Malcolm Potts, Ethel M. Pounce, V.S. Pratt, Mrs M.H. Price, Mary Proger, Wm A. Ramsay, Mrs M. Rattue, Brian Reade (Victoria and Albert Museum), Douglas Rees, Grace A. Rees, L. Rigelsford, Miss P. Roberts, C.L. Robertson, Rev. H.C.B. Roden, Mervyn Rowe, Lady Runcorn, Cyril Rundle, Mrs G. Shepherd, J.C. Sibley, F.C. Sillar, Mrs Vera Silvester, Miss D. Skiffins, Miss Bertha F. Smith, Mrs M.A. Smith, Dr Norman Smith, Peter Soar, David Southward, B.A. Stapleton, Mrs. R.D. Starley, Don Steel, Judy Steele (SFTA), Dr J. Stephens, Mrs G.M. Stevens, Barry and Carole Stevenson, Prof. Sir Richard Stone, Bob Taylor, Mrs Sally Taylor, Wm D. Taylor, Dame Sybil Thorndike, Eric S. Tozer, Lady Trelawny, Miss Olive Turney, Rev. Frank Wain, Prof. R.L. Wain, Mrs Waldock, Mrs Sylvia Ward, Ken Warner, E. Watney, Diane Watts (Observer Magazine), Ernest Weierter, Rev. William G. West, Rev. C.N. White, Mrs May White, Mrs Barbara Wilks, R.E.B. Williams, Mrs Sylvia Willmott, Mrs Betty Woodhead-Smith, George M. Woolford, Mrs Marie Worsley, Robert Wraight, Miss Constance Wright, Rosz Yeowart, Miss Fay Yerrell, James A. Young, the Editor of the *Daily Telegraph*, the Staffs of the British Museum Reading Room, the British Museum Newspaper Library, Cambridge City Library, the Designs Registry, Margate Public Library, the National Gallery, the National Library of Science and Invention (Holborn Division), Somerset House, the Tate Gallery, and the University Library, Cambridge.

I apologise for any omissions from my list, and regret that lack of space prevents my explaining how each has helped. Suffice it to say that I am sincerely grateful to you all.